The
Phallus
Palace

FEMALE TO MALE TRANS SEXUALS

THE
PHALLUS
PALACE

DEAN

CONSULTING EDITOR WILLIAM E. PARKER

KOTULA

MANUFACTURED IN THE UNITED STATES OF AMERICA.

THIS TRADE PAPERBACK ORIGINAL IS PUBLISHED BY ALYSON PUBLICATIONS,
P.O. BOX 4371, LOS ANGELES, CALIFORNIA 90078-4371.
DISTRIBUTION IN THE UNITED KINGDOM BY TURNAROUND PUBLISHER SERVICES LTD.,
UNIT 3, OLYMPIA TRADING ESTATE, COBURG ROAD, WOOD GREEN,
LONDON N22 6TZ ENGLAND.

FIRST EDITION: JULY 2002

04 05 06 07 08 **a** 10 9 8 7 6 5 4 3

ISBN 1-55583-654-2

LIBRARY OF CONGRESS CATALOGING-IN-PUBLICATION DATA
KOTULA, DEAN.
 THE PHALLUS PALACE : FEMALE TO MALE TRANSSEXUALS /
DEAN KOTULA ; CONSULTING EDITOR, WILLIAM E.
PARKER. — 1ST ED.
 INCLUDES BIBLIOGRAPHICAL REFERENCES AND INDEX.
 ISBN 1-55583-654-2
 1. TRANSSEXUALS. 2. TRANSSEXUALS — IDENTITY.
I. TITLE: FEMALE TO MALE TRANSSEXUALS. II. TITLE.
HQ77.9.K68 2002
305.9'066 — DC21 2002071105

CREDITS
COVER DESIGN BY MATT SAMS.
ALL INTERIOR PHOTOS BY DEAN KOTULA UNLESS OTHERWISE INDICATED.

Dedication

This book is dedicated to the memory of Aaron Michael Robinson, an FTM who was found dead in his apartment on September 17, 1994, from an overdose of amitriptyline. This was 11 days after I last saw him. I had returned to Minnesota from Oregon and paid him a visit. He had a Christmas tree standing and decorated in his living room at this early date since he was celebrating the fact that he would finally, after countless years, be able to have sex-assignment surgery. I rummaged through the Christmas ornaments I had left in storage and found ones that were particularly special, which I hung on his tree. He in turn gave me an illustration of the main character in the children's science fiction story he was writing; he wanted to communicate transsexual issues by presenting them in a way that might be readily acceptable. Our meeting was intensely gratifying, as Aaron was a man of warmth and creative intelligence. He said, "Don't be surprised if there is a letter waiting for you upon your return to Oregon." I never received that letter, and when I called, the telephone had been disconnected. I wasn't able to return to Minnesota for another year, and when I did I went to his apartment, only to learn from a stranger's voice over the intercom that he was dead. The University of Minnesota Center for Sexual Health, where Aaron had gone for treatment, refused to give me any information regarding his death. The only person I knew who also knew Aaron refused to return my calls. The illustration he had given me and a copy of his death certificate are all I have left of him. I can only surmise that he committed suicide upon being refused surgery because of a respiratory problem he had. Aaron was a 55-year-old African-American man who served as a deacon in Minneapolis. The world lost an amazing human being, and I believe his manuscript is lost to us as well. I am pleased that my last memory of him is one of triumph and hope.

Contents

Acknowledgments ix

Preface, by Cherie Hiser, BA, CADC xiii

Introduction, by Dean Kotula xvii

Part One: Perspectives and Viewpoints I **1**

"FTM 101: Dispelling Myths About the Invisible and the Impossible," by Katherine Rachlin, Ph.D. 3

"Seeking Manhood: An Introductory Guide to Assessment of the Female-to-Male Adolescent," by Diane Ellaborn, LICSW 21

A Conversation With Milton Diamond, Ph.D. 35

Part Two: The Men (Post-Transition Photographs by Dean Kotula) **57**

Ken

Jericho

B.J.

Chris

Adam

Drew

Nathan

Dana

David

Jerry

Alec

James

Hap

Adrian

Kim

Max

Michael

Scott

Jeff

Part Three: Perspectives and Viewpoints II **129**

"The Transsexual Book of the Dead: Osiris and the Trance Man," by Rachel Pollack 131
"We Were There: Female-to-Male Transsexuals in the Civil War," by Ken Morris 147
"Alan Hart," by Margaret Deirdre O'Hartigan 157

Part Four: The Surgeries **167**

Introduction, by Dean Kotula 169
Interview With Toby R. Meltzer, MD 173
Liposuctioning Breast Tissue 179
Bilateral Mastectomy 181
Metoidioplasty 185
Radial Forearm Phalloplasty 193
Interview With James J. Reardon, MD 201

Part Five: Gender Memories **207**

"Perceptions and Plights," by Dean Kotula 209
"Metamorphosis of a Sibling: When History Changes," by Sharon E. Kotula 231

Part Six: Perspectives and Viewpoints III **235**

"The Female-to-Male Transsexual Transition as a Creative Act," by Jeff Brody, MPS, ATR 237
A Parent's Perspective, by E.C. 245
Self-portrait drawing and a poem written at age 10, by L.C. 248
Postscript, by Emily Yoffe 251

Acknowledgments

I am pleased to have this opportunity to recognize and thank the many people who have made this book possible. I include on this list people from my distant past who may never even know of the book's existence. I do this because I am constantly aware of the many people who have profoundly impacted my life—shown me love, given me strength, and taught me self-respect. While this book is a collective effort with many contributors, there are far more people involved than we'll ever realize; each of us has been influenced by a multitude of voices throughout our lives, and I'd like to pay tribute to those people crucial to sustaining my life during my most trying times, for in some way, however obscure, they have also had a hand in the development of this book.

First, I wish to thank my mother, who gave birth to me and six other children. Along with my father, she had the often daunting task of raising us, and though my parents may not have done this perfectly, they performed this task with grace and proved that the giving of unconditional love results in the making of children who are kind, empathetic, and sure of their own worth. I want to thank my siblings, Marcy, Terry, Sharon, John, and Carol—whatever our differences, our relationships to one another have remained intact. I thank my extended family as well—Al and MaryJo Koering, Sue Walker, Marvin and Gloria Koering, and others who have joined me on the other side. My most troubled times were those in which I rejected my family—for fear they would reject me.

I thank Holly Franzen, my most devoted and complex friend, whose presence in the world gives me equilibrium. I owe a tremendous debt to Carol and Lee Colby, who never failed to be available in dark times and could always be depended on for comfort and practical advice. I owe thanks to Birgetta Johnson, my probation officer during my early years of delinquency, for her tenderness and respect. I thank the caregivers at St. Joseph's Children's Home, Minnesota Manor, Jamestown Treatment Center, and Chrysalis. My gratitude goes to Margaret O'Hartigan, probably the most courageous person I know, for her friendship and guidance in battling the state of Oregon and my past employer. Thanks to Rachel Koteles for her support and courage, Barry Blackwood for his kind compassion, Rick Kulbe for his independence, compassion, sense of justice, and for speaking the truth regardless of the consequences. I thank Nancy Spitzack for her sense of humor, good taste, and humanity. Thanks to Tamara Froman for her love and sense of the absurd, Sara Colvin for lasting mem-

ories, and Sherry Brec for her encouragement and persistence in keeping our friendship alive. I thank Marina for the best untold story. Much love and thanks goes to my deceased friend, Augustine McDonough, who accepted me exactly as I was. I thank Emma Eskelson for recognizing me as a transsexual long before I vocalized it or made physical changes, and for tactfully referring me to a group to meet others. Thanks goes to Doug Sigea, who discovered me in the bowels of a ship, for introducing me to the key players that made my transition possible. I thank Kathy Francis for her sense of fun and adventure, and Micah Kieffer, to whom I felt dangerously close. Gratitude goes to Suzanne Peterson for her willfulness. Thanks to Bonnie Robinson, who taught with such vitality and rigor, and David Palmer, who let me run rampant in the college darkroom. Remembrance goes to Karen Stenback, who loved me at a most critical time. Thanks to Jackie Anton for the thrill and lessons heartbreak brings, and to friends Kathy DeMarinis, Will Chandler, Rita Germano, Lisa Beller, and Leasha Barnes for their warmth and genuine humanity. Thanks to Chris Burke for allowing me to remain a mystery, and to Bob Dylan, whose music I have relied on to bring me back from multiple lapses of sanity. And of course, Vanessa Redgrave, my ultimate fantasy, for your talent, integrity, and sense of social justice—never mind your beauty.

Now, I want to extend my thanks to those directly linked to the project. First, I thank my close friend Cherie Hiser, whose creative genius and awe-inspiring accomplishments directed me to this project. I would like to extend a special thanks to William E. Parker, who, I am honored to say, volunteered his broad-based talent and expertise to serve as contributing editor. With his exhaustive efforts, the manuscript has not only vastly improved but has expanded 10-fold. I deeply value and cherish the friendship we've come to have; I never imagined I would come to know such an impressive human being. My gratitude and respect also goes to Tim Parker, who provided amusing tales, fresh insights, and delicious meals during breaks from the manuscript. A heartfelt thanks to my partner, Diane Ellaborn, for her continuous support of the project, for adroitly handling my fluctuating moods, and for nurturing my well-being throughout. A huge thanks to Scott Brassart, editor in chief at Alyson Books, for having the vision to recognize the importance of this book and for taking a chance. I appreciate the faith shown in me and the diligent care with which the manuscript was treated. Also at Alyson, thanks to Mike Grippi, copy editor, for his thoroughness, and Matt Sams, designer, for his hard work and striking cover design. I thank Frank DeSantis for his marvelous work in creating an initial mock-up for the book, which ultimately helped to sell it, and Michelle Garcia, Kayoake, Jane Schiffhauer, Diane Ellaborn, Shelley Heilweil, Nancy Hill, Joni Kabana, and Jim Vegher for their fund-raising efforts. I thank the Equity Foundation, Portland Photographer's Forum, Oregon Regional Arts and Culture Council, PhotoWorks Northwest, and the Boston FTM Conference Committee for their grant support. I thank Mariette Pathy Allen, Dennis Brinkman, Stuart Chipkin, Toby Meltzer, Diane Ellaborn, Randi Ettner, Ricki K. Swinn, Andy Altman, Kit Rachlin, Jacob Webb, and James

Reardon for their financial contributions and project support. I thank Dana Montgomery for her insights and stimulating conversation, and Jennifer Webb, my niece, for showing such enthusiasm for the work. I thank Alex Sweetman for an opportunity to lecture on the material and for introducing me to Bill Parker, Jasmine Sterling for her role as model and for the use of her property, Natalie Stetner for her secretarial services, and Ken Morris for assistance in creating exhibitions.

Lastly, and most importantly, I thank all the contributors who made this book a reality. I realize the risk and vulnerability associated with publicly outing oneself as a transsexual, and I feel particularly grateful to those FTMs who have allowed themselves to be presented in this book. I thank Rachel Pollack for her fascinating article and personal courage, Kit Rachlin and Diane Ellaborn for their articles and dedication to the transsexual population, Doctors Meltzer, Reardon, and Brownstein for allowing me into their operating rooms to photograph surgeries, Jeff Brody for his friendship and excellent contribution, and Ken Morris for his friendship, advice, and skills as a graphic artist. I thank Emily Yoffe, who as a journalist brought appropriate attention to the subject of FTMs in a national magazine and agreed to write the postscript. I thank Dr. Milton Diamond for his brilliant research, for volunteering to submit to a video conference interview, and for his help in editing the final draft. I thank E.C. and L.C. for their important message, and Sharon Kotula, my sister, for her article and loving attention throughout the years.

Finally, I thank the reader for attempting to learn the heart of the matter from an appropriate source.

Preface

By Cherie Hiser, BA, CADC

"What are little boys made of…"

They were all baby girls when they were born! They wore pink hospital bracelets inscribed with names like Tammy and Elizabeth and Kathryn. They entered this world receiving the projected expectations of family and society to be always "sugar 'n spice 'n everything nice!" Twenty, 30, even more years later, they became men with names like Tom or Ernie or Joe. Their passports and driver's licenses identify them as male; *female* as a gender specifier is gone. Now they are sons, brothers, boyfriends, partners, husbands, and dads. They are executives, shipyard workers, pilots, truck drivers, athletes, actors, writers, artists, mountain climbers—every imaginable occupational or lifestyle identification.

Most believe they were born with an erroneous genetic code. Their chromosomes are XX—female—but their brain chemistry and neurotransmitters, since early childhood, sent them XY urgings and commands that always made them want to shout, *I am male! I am trapped in the wrong body!* They matured with the hope that others would honor their unassailable conviction that they were, prior to and following birth, intrapsychically males, that everyone would realize they were not transgenderists, transvestites, butch lesbians, or self-mutilators. They continue to seek global recognition that authentic FTM (female-to-male) transsexuals are *real men,* that they have achieved or are evolving toward male-sex identification primarily through hormonal chemistry and surgery, which enable the physical body to dance in sync with mind.

I have worked in the field of psychology for two decades, mostly in psychiatric hospitals. I have always assumed my colleagues were fairly sophisticated in their understanding of and therapeutic assistance to "mysteries of the Creator's meanderings"—those clients whose lives have been unhealthily marginalized, disturbed, or disfranchised by not being able to accommodate or adjust to so-called normative identities and psychosocial behaviors established in society. Despite the fact that all of my coworkers have always been aware and accepting of male-to-female transsexuals, I have been astounded that there are many among them whose statements about FTMs reveal either utter disbelief or dismay: Most frequently, "I've never even heard of that! I can't understand why any female would want to change sex. Why don't they just learn to cope with being a woman?" Cope? It's not that easy for an FTM when there are cells, brain functionings, and chemicals combining to define powerful and mysterious sex-identity demands that totally oppose their designated biological sex at birth.

As a therapist, I have again and again witnessed people, myself included, reacting negatively to other persons and issues because we are afraid of their *differentness* within the perspectives of our lives. I remember my own father begrudging the fact that he had to attend "sensitivity training" within a large corporation in the 1950s. He talked about the difficulty he had with the "new politically correct thought" and with referring to people he had always called "colored" as "black." It wasn't until his 80s that he overcame his prejudices and became unconditionally loving to those who were different: He was "tired of fighting." I have also learned that we unconditionally love when we understand such fears and do not enable them to exclude others from our care and respect. Dean Kotula has painfully, poignantly, and poetically documented his own FTM identity and others' in this book. We are fortunate to read his and others' words about the realization of profound gender dysphoria early on in their lives and their commitment to transsexual transformation. And we are privileged to view Kotula's honorific, splendidly achieved photographic portraits of FTMs. The portrait images accompanied by personal testaments are a major contribution to the understanding and acceptance of the FTM individual and his life experience.

It is important to realize that none of the men received money to pose for their portraits, to spend hours talking to Kotula, or to travel to participate in the development of this book. Their images and textual "presences" here reveal a courageous disclosure of their reclaimed gender integrity, a fearless willingness to share their feelings with others. Some very special physicians and their FTM patients permitted Kotula to enter operating rooms and to document the most beneficial (and most terrifying) aspects of FTM surgeries.

It is quite common for transsexuals upon transitioning to have their jobs, careers, relationships, homes, and positions in society jeopardized or lost—even to be themselves maimed or murdered—because of their *differentness* as perceived by representatives of an essentially non-transsexual community. I trust that all who encounter *The Phallus Palace*

shall recognize that those FTMs who have "come out" publicly in a book, which has the potential for international distribution, have accepted great risks, not least of which are possibilities for rejection or misunderstanding by family, personal friends, and professional associates.

Many FTMs are constantly, vigilantly, sometimes joyfully, sometimes painfully, striving to survive as males both externally (visibly) and internally (emotionally) and are aware of themselves as men from moment to moment. Unlike most genetic males, who take their gender for granted, FTMs have to weigh their experience of living in female bodies against their intrapsychic identities as males. They have to reconcile the negative aspects of female conditioning—the torture of PMS, the "wolf whistles" of solicitous men, sexual exploitation, economic disfranchisement—while simultaneously enduring a mistaken identity imposed on them by society. They are not "half-women" or "half-men." I would say they are "supermen," combining the qualities of men with their unique experience of having lived as women.

As a photographer I have made it my life's work to document and honor the *differentness* of persons often thought of as representatives of subcultures, such as gay men in Santa Fe, N.M., and people who have full-body tattoos. I have also utilized photography in my therapeutic work with psychiatric patients.

I first met Dean Kotula when we offered support to Kenny, a mutual friend who had undergone mastectomy surgery as part of his FTM transition. Kenny was just beginning his physical transition; he had already started hormone therapy and had planned his "top surgery," a double mastectomy, to commit to the physical transformation that would affirm his deepest self.

Kenny knew Dean as another FTM and as a passionate photographer living on very limited means in one room in a crack-infested neighborhood. Dean's room had black paper over the windows, there was an enlarger perched at the end of his bed on a plywood board, and he washed his prints in a clawfoot tub in the only bathroom—which roommates stood in line to use on Friday nights. Ken had appealed to me a couple of months before, saying that the best Christmas present for his photographer friend Dean would be a photographic easel and printing paper so he could print some astounding photographs taken while working aboard foreign fishing vessels. I contacted other photographers, and they generously responded by providing the easel and paper. On the eve of Ken's surgery, when I finally met Dean, we pored over each other's photographic work. I became convinced that Dean was the perfect person to pull together an FTM documentary. I encouraged him to create a book examining his and others' experience as FTMs.

It was, and remains, my hope that *The Phallus Palace* will offer many people the opportunity to gain new knowledge about misunderstood individuals and that such knowledge will translate into acceptance and humane love. Dean's accomplishment of creating this

book brings to mind a few fragments of a poem by the photographer Minor White written in 1963:

Who are you
Holding your hands
Toward me?
...
Which of us says:
Out of my love
I give you
Back to yourself?

Introduction

By Dean Kotula

My mother says that as a small child I was always smiling, laughing, giving kisses, and reaching for hugs. She said I would dart out of the house unnoticed, wearing nothing but a floppy hat, and escape down to the river's edge to play in the sand. It astounds me to hear of myself so carefree, so unself-conscious of my body—a time when my body was just there, careening in the wind.

We all experience this to some degree. But while discovering self we interface with society and begin adapting ourselves for inclusion. Consequently, modesty and shame about our bodies is common in American society. For the transsexual, this shame is far more extreme. Its origins aren't strictly cultural; there is a biological premise as well. In the foreword of Mark Rees's *Dear Sir or Madam,* Dr. J.L. Gooren states:

> It has always been assumed that the sexual differentiation (of a foetus) was completed with the formation of the external genitalia but it is *not.* Since the beginning of this century we have known that the brain also undergoes a sexual differentiation. Sex difference only becomes manifest three to four years after birth. Long after you have been born, and your sex has been determined by the criterion of the external genitalia, your brain has still a long way to go to become sexually differentiated.

In the case of female-to-male transsexuals (FTMs), this means that at age 3 or 4 they are receiving signals from the brain that they are male but are being indoctrinated into a society that views them as female. They are told that they are, and are treated as if they are,

female based solely on their female sexual anatomy. Not only are their minds incongruent with their bodies, but their actions are incongruent with societal expectations, so they are told they are "wrong." Imagine having a child who has a penis as an imaginary friend!

It is extremely difficult to explain (to someone outside of the experience) just how someone can know that they are a man, with everyone and their bodies telling them they aren't. FTMs will tell you they identified with boys rather than girls, with men rather than women. Children have an instinctive ability to distinguish between male and female, and they identify themselves with one or the other. This identification is established by age 3 or 4 and cannot be reversed. At the onset of puberty, FTMs are shocked and appalled when they discover their developing breasts and begin menstruating, even though they know this is the natural course of sexual development in females.

I became extremely dysphoric about my body from puberty on. No longer that immodest, free-spirited child, I began to cloak my body with layers of clothing and to disengage with drugs and alcohol. I suffered long bouts of agoraphobia and panic attacks because I couldn't bear to be seen as female. I wasn't, and I didn't know how to play the role. I also had an androgynous appearance, which disturbed people. They insisted on knowing if I was male or female and would literally cross the street with the sole purpose of finding out. I developed self-directed tunnel vision so people would leave me alone. I noticed over time that since I wasn't using my peripheral vision, my approach to photography changed: Images I framed were predominantly vertical; my original preference for horizontality had changed. These behaviors became so ingrained in me that some still exist today. I have to continually remind myself that, at present, I am accepted as male unequivocally and go through life relatively unnoticed.

Learning early on that I couldn't rely on what I saw or heard to reach the truth, I sensitized myself to energy. It is a better gauge of truth: We harness it in polygraph tests, believing it is unaltered by the whims of the tested. I always believed that if I took a Kirlian photograph of myself (in which high-voltage, low-current electricity is used to record the corona discharge, or aura, of an object), it would undoubtedly reveal a phantom penis.

This idea isn't as far-fetched as one might think. A friend, Dana Montgomery, brought the research of Prof. Ronald Melzack to my attention. Professor Melzack, a psychologist at McGill University in Montreal and a leading researcher on phantom limb phenomenon, recently reported that "even children born without arms or legs can feel phantom limbs." Melzack says this suggests that "the body we perceive is in large part built into our brain—it's not entirely learned. In fact, you do not need the body to feel the body."

It was my father who first introduced me to photography when I was 10. He shuffled me off to his workroom in the basement—a place shrouded with mystery, since it was off-limits to us kids. (I had six siblings, one of whom died). He handed me some negatives, put one in the negative carrier, and shut out the lights with the exception of one bare amber bulb.

He then put paper in the easel, exposed it to the light of the enlarger, and dunked it into three consecutive trays, paying close attention to the clock on the wall.

It was another 15 years before I set foot in another darkroom, but I will never forget the rudimentary lesson with the appearance of that first latent image in the tray of fixer.

In my approach to photography, outside of technical considerations it is energy I respond to, not my thoughts. I was always impressed with the way my grandfather could locate a vein of water in the earth with nothing but the simplest divining rod and the sensitivity of his hands. With the camera as my vehicle I attempt to draw out and record the essence of a subject. My grandfather would wait until an intense vibration would pass through his stick and up his arms, and only then did he know he had water. Similarly, it is only when I feel emotions thundering inside of me and all my senses are locked into place that I know the time is right to release the shutter.

I went to college in Kaneohe, Hawaii, and did work-study in the media center. I had cameras, film, paper, and darkroom at my disposal, so I spent countless hours teaching myself the intricacies of the photographic medium. I went on to study at the Art Institute of Boston and to apprentice in 19th-century photographic processes with Robert Steinberg.

My photographs have always been related to what I most responded to in life. They chronicle my life like a personal diary. I photographed a coworker while employed as a chimney sweep and shot an extensive portfolio of commercial fishing while working aboard foreign fishing boats as a fisheries inspector. I photographed shepherds in the Himalayas and a human rights demonstration in Kashmir while visiting India in 1990.

I received acclaim for my work in the forms of grants, exhibits, employment, and awards, so I knew there was an audience for my work. Nevertheless, although I continued to photograph, in recent years the only audience I sought out was family and friends. I gave up hope of developing and sustaining a reputation as a fine artist since I knew I would eventually change my public identity—my name and body—from female to male. I began this transition over nine years ago.

Because this is the most pivotal point in my life and because I am wholly aware of the challenge transsexuals face with a prejudiced public, I was apprehensive about doing the work for this book. In fact, I never considered it until I was strongly urged to do so by Cherie Hiser. Cherie is a talented photographer who has been extensively involved with the medium since the mid '60s. Veteran photographer Lee Friedlander refers to her as a "photo evangelist."

I met Cherie in the winter of '95. She had responded to a friend's personal ad, in which he had disclosed that he is FTM. Her initial reason for contacting my friend was that she was interested in photographing FTMs, since much of her work deals with the disclosure of secrets. Sometime later, when Cherie and I finally met, we were so taken with one another, both personally and professionally, that we talked nonstop for three consecutive days. It

wasn't long before she relinquished the idea of documenting FTMs. Instead, she convinced me that I was the one to do it. She understood that although she was coming from a place of integrity, she couldn't possibly comprehend our issues. In retrospect, I wholeheartedly agree.

I am disturbed by the distorted textual portrayals of transsexuals and the many academic treatises, authored by non-transsexuals, theorizing on the "condition" with preconceived agendas. I also object to the term *transgender* when applied to transsexuals, since we are not changing our gender (I don't know of any FTMs who have ever had a feminine identification) but are instead changing our body's sex. Furthermore, we do not fit the definition of transgender as described in the fourth edition of the book *Sexuality Today* by Gary F. Kelly: "These [transgender] individuals do not exhibit the dissatisfaction with their anatomy of birth that is found in transsexuals, and they generally do not have a strong urge to undergo a sex reassignment process." The vast majority of transsexuals do not regard themselves as transgendered, and to categorize us in this fashion is to ignore and deny the tremendous commitment we make by actualizing ourselves with the aid of hormones and surgery.

Furthermore, it is written in *An American Dialogue*:

> When the content of one culture is left solely to another to express, without any consultation with that culture's community, then the result is usually distorted, unintentionally or by design. This outcome is even more likely—and more threatening—if the two cultures are at odds: have and have-nots, majority and minority, victor and vanquished…In short, no culture can survive intact if its interpretation and transmission are controlled by people outside the culture.

I would add to this that in consulting a community, one needs to recognize the diversity within that culture and that the most obvious person, the most accessible, acting as spokesperson for the group doesn't necessarily represent the community as a whole.

Even as an insider, I don't purport that the experience or ideas I express are common to all transsexuals. However, what is common to all transsexuals and what distinguishes them from other sexual minorities is an aversion toward or awkwardness with one's genitals and a desire for sex-assignment surgery. Aside from this, transsexuals are as varied as any other population; this is why I've asked each man in this book to speak for himself.

W. Eugene Smith, whose photographs I find most passionate and revealing, talked about the personal approach to journalism and the impossibility of remaining objective: "Honest, yes; objective, no." He said, "Let truth be my prejudice." His extraordinary photographs are empathetic, distilled from the heart, and he has truly been an inspiration for me.

The arts have always played a key role in challenging dominant culture and acting as agents of social disruption and change. Robert McCormick Adams, secretary of the

Smithsonian Institute, addressed the issue of controversial art in the August 1990 issue of *Smithsonian* magazine:

> Surely art has always—and perhaps cumulatively—extended the boundaries of insight and perception, providing much of the ambiance of individual liberty and cultural diversity toward which, to our pride and pleasure, the whole world now strives. From this viewpoint, I am even tempted to suggest that some part of art may belong precisely along the shifting boundaries that successive ages assign to the morally abhorrent or legally impermissible. By evoking the extremes, it helps us all find a context for the prism of changing norms through which we view the human condition.

This book is meant to be an overview to supplement current information available on the topic of transsexuality. It is a more personal approach. I have kept the concentration solely on the female-to-male transsexual, since we have often been overlooked and neglected in books dealing with the subject of transsexuality. Hopefully, this book will find a place in the homes of male-to-female transsexuals as well. And perhaps in the homes of society at large as a "prism...through which we view the human condition."

The book has been developed into parts rather than chapters. The first part, "Perspectives and Viewpoints I," opens with essays from two therapists who specialize in gender issues. Katherine Rachlin, Ph.D., addresses stereotypes pertaining to transsexuals, and Diane Ellaborn, LICSW, writes about the recognizable signs of the female adolescent who wishes to be male. These two essays are followed by the transcript of videoconference interview with Dr. Milton Diamond, biophysicist and sexologist, where he talks to me about his involvement in the well-publicized John/Joan case—a prime example of how biology rather than socialization determines our gender identity—and about various research projects pertaining to the biological implications of transsexualism, homosexuality, and intersexuality.

The second part contains photographs of 19 FTMs—snapshots of the men prior to transition (in their female personas) and full-page portraits of the men post-transition. (The length of time on hormones varies widely among the men, as does the amount of surgical intervention.) Personal testaments written by the men accompany their photographs.

The next part, "Perspectives and Viewpoints II," examines the development of historical paradigms related to specific FTMs or the general subject of transsexuality. Rachel Pollack, lecturer, writer, and creator of the Shining Woman Tarot, contributes an essay in which we get a fresh and fascinating perspective on the Osiris myth when she compares the experience of Osiris to that of the modern-day FTM. An article by Ken Morris, FTM and Civil War reenactor, provides convincing evidence that two FTMs served in the Civil War. (It is

well-known that women masquerading as men served in the war, but soldiers Cashire and Wakeman, born female, were different—they never saw themselves as women at all.) Margaret Deirdre O'Hartigan, writer and political activist, then writes about members of the gay community mistakenly claiming FTM Dr. Alan Hart to be homosexual. Alan Hart, born Alberta Lucille Hart, physically transformed himself in the 1920s, by all available means, in order to live his life as a man, and O'Hartigan defends the identity many believe he chose for himself—male—and aims to dispel the notion that he was a butch lesbian.

In the fourth part, on surgeries, the reader is taken into the operating rooms and is able to witness, for the very first time (outside of medical textbooks), actual sex-reassignment surgeries for the FTM being performed. These shocking and explicit photographs are evidence of the determination, courage, and commitment behind the FTM's goal to live fully as a man. Interviews with doctors Toby Meltzer and James Reardon convey their heartfelt interest and commitment to helping the FTM succeed in his goal of self-realization.

The fifth part, "Gender Memories," is a collection of diverse, variable-length personal writings by me in the forms of journal entries, short stories, and memory traces that recount my experience of having gender dysphoria from early childhood to the present. Interspersed throughout are self-portraits and photographic memorabilia. Following my writing is a contribution from Sharon Kotula, my sister, who offers her perspective and describes the experience of growing up with a sibling suffering from gender identity disorder.

The sixth and final part begins with an article by Jeff Brody, FTM and art psychotherapist, in which he talks about transition—the physical transformation from one sex to the other—as a creative act. Next is a self-portrait drawing and poem written by L.C., who was then a 10-year-old FTM, reminding us just how pervasive and urgent issues surrounding gender identity are. Following L.C., we hear from his mother, E.C., who recounts her agony around the suffering of her child. In closing, Emily Yoffe, nonfiction writer and journalist, writes about her meeting FTMs for the first time while attending a conference in Portland, Ore., as part of her research for an article on FTMs for *Details* magazine (November 1994).

I believe that I and the great many contributors to this book have an impressive tale to tell and an important message to convey. If we have done our job, the reader will be moved to set aside their prejudices and see the courage, resiliency, and triumphs of the men pictured here.

Transsexuals meet with a variety of responses from employers, family, and friends regarding their transitions. They run the gamut from complete abandonment to total support, including financial backing for surgery. The responses I've gotten fall somewhere in the middle.

In past correspondence from my father, he said, "I find that I am not ready to give up the little girl that I loved so much. She is special to me—I love her and don't want her to go, even though I know I must. In a way, this is like a death and a birth in the family at the same

time. Allow me to mourn the loss of my daughter and, I assure you, I will rejoice the birth of my new son."

During the course of preparing this manuscript, my father contracted Lou Gehrig's disease (amyotrophic lateral sclerosis). He died within six months of his diagnosis. Knowing he was dying, he took it upon himself to write a eulogy to be read at his funeral. I had no doubts about attending his funeral, but aside from feeling shocked by his death, I had feelings of great trepidation about coming in contact with relatives I hadn't seen for years—relatives who knew little or nothing about my transition to "Dean." I feared the worst—an onslaught of negative judgments toward me in the course of my grieving. I kept my distance as relatives gathered. Even though I had the urge to run up and embrace my favorite aunts and cousins, I couldn't bear, in my already vulnerable state, to risk rejection. As it was, the few people I did approach didn't know who I was. Their blank stares stilled my heart.

During the church service, my father's final words were read: "I leave behind my wife, four daughters, and two sons—John and Dean." All of a sudden there was a stir in the room, as if one suddenly heard a mouse scurrying in the belfry or the scuffle of a skeleton being dragged from a closet—or was it my imagination and only the stir in me, the flood of emotion I felt having learned of my father's acceptance?

After the service, relatives milled around and in hushed whispers began to ask questions. Again, I roamed the edges of the room and spoke with only the immediate members of my family. To my surprise and great relief, relatives approached me with open arms and loving smiles as though nothing had changed. They made it overtly clear that I was and would remain a valued member of the family. The day my father died, he gave me back my extended family and was, in part, responsible for my birth a second time.

Part One
Perspectives and Viewpoints I

FTM 101:
Dispelling Myths About the Invisible and the Impossible

By Katherine Rachlin, Ph.D.

Katherine Rachlin is a clinical psychologist and gender specialist with a private practice in New York City.

There was a time when I did not believe that a man could be born in a woman's body. This was an impossibility with so many inherent contradictions that I dismissed it without hesitation. That was before I knew anyone who was transsexual. It took knowing not just one transsexual person, but hundreds, to create my evolving understanding of gender. And the experience was transformative. I was brought into the transsexual community by a friend and participated in this community for eight years before becoming a psychotherapist in private practice. By then I knew many men who had been born in female bodies. Some of these men were among the healthiest people I have ever known. They knew exactly who they were and what they wanted from life. They fit no stereotypes and were nothing like the scientific literature said they should be.

Because most of us have a gender, we consider ourselves experts on the subject and assume that our understanding and experience of gender is all there is. Transsexual individuals have been told that their experience is false, that they are impossible, that they are not real. Once I came to understand the reality of the transsexual phenomenon, I shared in the experience of being told that my experience was not real, that what I knew to be true was not true and that my experience of others was flawed.

After more than a decade of working with female-to-male transsexuals and their significant others, friends, families, and allies (SOFFAs) I have found that there are a few questions that almost everyone asks. I hope that this chapter will answer some of them. As a psychologist, I have become extremely aware of the lack of resources for FTMs and of their invisibility compared to male-to-female transsexuals. As a researcher, I have been deeply distressed by the absence of research data and information that would be useful to FTMs and their SOFFAs. This chapter contains an exploration into the causes and implications of the invisibility of FTMs. It also looks at the many myths surrounding them.

People who are reading this book are engaged in a process of revelation. The reader should be aware that there are many divergent points of view about the origin of transsexuality and options for living with it—each individual's experience is his own. There is probably as much variation within the transsexual population as there is in any other group. There is no substitute for participating in the community and for learning from FTMs and their significant others. That experience is essential for understanding that some men are born female, that people make physical and social changes because their transsexuality leaves them no choice, and that a man may appear more masculine by altering his body, but this appearance does not determine his masculinity. This book focuses on FTMs who define themselves exclusively as male and as transsexual rather than transgendered, so I have limited this chapter to reflect their experience.

FTMs: THE LESSER-KNOWN OF A LITTLE-KNOWN POPULATION

Historically, FTMs have not been as visible as MTFs. Indeed, to most people looking at a group of men, the FTMs in the group would not be visually detectable as such; they blend into the general male population with ease. While the ability to appear to be a non-transsexual male is an asset, it also creates a dilemma for many FTMs: How can one obtain information and find community when the members of that community are invisible? In order to make contact, one must become visible and find others who are visible and accessible.

One reason fewer FTMs have surfaced to request professional or peer support services is that the quality of the support services available has been severely lacking. FTMs were less visible to the medical establishment because they had less incentive to come forward than MTFs. By comparison, more services and better medical technology have been available to MTFs. That has changed in recent years. FTMs are truly transformed through the use of the currently available hormones. The effects of testosterone—deepening of voice, growth of facial and body hair, changes in skin texture, clitoral enlargement, increase in libido, reduction in subcutaneous fat, redistribution of fat, and male pattern baldness—usually result in a distinctly male appearance. Though FTMs are, as a group, physically

smaller than other men in any given ethnic group, the cultural norms for men are flexible enough to include men of their size. FTMs are not generally perceived as being different from other men.

In addition to taking hormones, some FTMs elect to have some combination of liposuction, mastectomy, and/or chest reconstruction/contouring. This surgery can create a chest that will allow a man to comfortably remove his shirt at the beach or in the locker room, although there are usually visible scars.

The results of hormones and chest surgery are usually gratifying, but some men feel adamant that they are not complete without gender-congruent genitals. Some FTMs will not make any transition unless they know that genital surgery is a realistic part of that transition. FTM surgical options involve a variety of compromises and sacrifices that will be discussed later in this chapter.

MTFs outnumber FTMs in most mental health facilities. This may reflect a greater reluctance to come forward or less of a need for psychiatric or psychological services. Because a much smaller number of FTMs than MTFs request surgery, a smaller number undergo the psychotherapy or psychological evaluation suggested in the sixth version of Harry Benjamin Standards of Care. People also engage in psychotherapy when they are depressed, anxious, or experience problems in their relationships or career. Difficulties associated with "passing" are a tremendous source of stress for both MTFs and pre-transition FTMs. But once an FTM is on masculinizing hormones for a while, passing is rarely a concern. And some FTMs don't need *any* medical intervention to pass as male. FTMs may also experience less stress due to differences in cultural response as compared to MTFs. Because men are socially privileged, MTFs are perceived as requesting a reduction in status. Some cultures may regard it as humiliating for a man to take on the qualities and dress of a woman, while those cultures think a woman would be reaching above her status to become a man. These factors subtly affect people's attitudes toward MTFs and FTMs.

Many professionals (medical and mental health providers) who work with transsexuals have seen only, or primarily, MTFs. This makes it more difficult for FTMs to find knowledgeable professionals. Not long ago I spoke on a panel about providing support for partners of FTMs. Also on the panel was someone who was regarded as an expert in sexuality and an expert in working with transsexuals and cross-dressers and their significant others. In discussing our prospective panel I referred to female partners of FTMs who don't identify themselves as lesbian. The other professional said, "What do you mean? What *would* they identify as?" From that comment I realized that he had very limited contact with FTMs individually or in couples (which he later admitted). By taking on the role of expert in this setting he was assuming that his experience with MTFs would carry over and that he could apply the same general paradigm to FTMs. With experience counseling FTMs, though, he would have learned that their partners may embrace any sexual orientation.

BECOMING VISIBLE

Invisibility has both advantages and disadvantages for men who are FTM and for those who support and work with them. The ability to be invisible has given FTMs the option of complete anonymity: One does not have to make being FTM a central focus of one's life or relationships. Indeed, there are many people who identify simply as men and will not in any way embrace their early history. I sometimes meet FTMs who claim to dislike "transsexuals" for one reason or another and maintain that they have nothing in common with them. There are more FTMs than we will ever know who are leading their lives as men without any contact with gender professionals or the FTM community. Most people value their anonymity highly and would like to make their own decisions about when to disclose information about their personal history. Thankfully, an increasing number of FTMs are outspoken about their experience. FTMs who would otherwise be isolated can now find peer support and information networks. There is a major movement to build community, increase visibility, and educate people on FTM issues. As a united lobby they can campaign for human rights, medical coverage, and family rights (such as marriage and parenting). Jamison Green has described the evolution of FTM community in his 1998 paper "FTM— An Emerging Voice" and in his 1999 paper "Look! No, Don't! The Visibility Dilemma for Transsexual Men." In these essays he reviewed the important issues facing FTMs and the individuals and events that have formed FTM-related politics, thought, and visibility.

Educating the public is not without its costs. One reason that FTMs were not identified was because people did not know that they existed. When the concept of an FTM did not exist, being "read" was very unlikely. As more people learn about FTMs and realize that they know FTMs, it is likely that more FTMs *will* be "read"—particularly, early in their transition. As more people become educated they will *know* what the scars of a radial forearm flap phalloplasty look like, or the scars of bilateral mastectomy and male chest reconstruction. Easy identification of these clues will make it more difficult for FTMs to control personal information about their history and their bodies. While many people see a more educated public as a sign of progress, it is clear that there is a trade-off, and we lose something valuable: choice. We must respect both a man's cherished anonymity and his right to be out and proud.

LACK OF DOCUMENTED INFORMATION

Research data is used to inform legal, social, and medical policy decisions. The lack of FTM visibility has led to little understanding and poor representation in the scientific liter-

ature. FTMs are indeed the lesser-known members of a little-known population. A psychopathology textbook used in a clinical psychology doctoral training program in 1993 stated that there were no FTMs who were attracted to men; that same book stated that all transsexuals wanted the currently available surgery (Willerman and Cohen 1990). These statements are typical of the misinformation to be found in the scientific literature.

Where can people learn about FTMs? There is a growing body of work, composed largely of personal testimony, published from within the transsexual community. This material is extremely valuable, but it does not take the place of the kind of data obtained about other groups of people. There is so little research and literature about FTMs that it is nearly impossible to get educated through the professional literature. So limited is the amount of data that most people rely on their own experience and personal research.

There is an enormous peer-support movement that includes exchange of information over the Internet. Unfortunately, much of the information is not being archived in places where policy makers have access to it. Things may be common knowledge to people in peer support groups or on Internet news groups, but this common knowledge is not documented anywhere in an accessible body of literature. There is no substitute for research data.

What is in the scientific literature about FTMs? What researchers find frequently depends on the questions they ask. To date, most research questions revolve around mental health, relationships, and satisfaction before and after surgery (Boltzer and Vehrs 1993). When there is a mixed sample, the number of FTMs in a study is usually far fewer than the number of MTFs. The information is often based on FTMs who ask for surgery at one of the major gender clinics or university-affiliated centers. It does not include the great number of people who put together their own treatment teams, transitioning without any clinic or official gender program.

The first few decades of documented research are characterized by a great deal of misinformation, ignorance, and prejudice. Much of the research does not reflect the experiences of transsexual individuals who are physically and mentally healthy and professionally successful. Research concerning transsexuals has traditionally reflected anti-transsexual attitudes. Researchers have begun with the premise that all transsexuals are "disordered" and that transsexuality is a condition to be cured. This lack of acceptance is demonstrated when professionals refer to FTMs as females or seek to confirm hypotheses that pathologize the transsexual experience. In light of such prejudice, it is not surprising that many people distrust researchers and fear that research will be used to further perpetuate these negative attitudes. However, the solution is not to stop participating in research. The FTM community must make a commitment to actively initiate and support research and create a new body of literature that accurately reflects the FTM experience. Two works that I regard as belonging to this new body of research are *Transmen & FTMs: Identities, Bodies, Genders, & Sexualities* by Jason Cromwell (1999), who is an anthropologist, and *FTM: Female to Male*

Transsexuals in Society by Holly Devor (1997), who is a sociologist. It is no accident that these pieces of research come from arenas outside of medicine or psychiatry.

I hope these works can set a tone that medical and psychiatric researchers can follow. There are so many medical questions we need answered (like the long-term health effects of testosterone and how to build a better penis). To be most valuable, research must answer the questions that FTMs ask themselves. It must provide information useful to helping them make decisions about transition, healthcare, and other personal concerns. In that way the new generation of FTMs, scholars, and the professionals who work with them can reshape the knowledge base and make major contributions toward changing attitudes and policies.

MYTHS

There are many myths and stereotypes concerning FTMs that continue to plague the professional and nonprofessional communities. The readers of this book may be well-educated and aware of FTM issues. The myths to which I refer may seem strange to people active in the community. But I assure you that these myths are alive and well in consultation rooms, on talk shows, in university classrooms, in textbooks, in living rooms, and even in Internet chat rooms. These are not misconceptions held only by people who have never heard of female-to-male transsexuality. These are ideas also held by people who know a little—but not enough.

Myth: FTMs Were Women Before They Became Men

In most cases it is erroneous to say that FTMs make the transition from female to male. The FTM experience of being a female is not the same as that of a non-transsexual female. The essential experience of being transsexual is that of being a male in a female body. Most FTMs report this awareness as far back as they can remember. They report that they were *always* male. Family members may confirm that even as a child the FTM appeared to be more like a boy than like a girl. He may have resisted the traditional female role, refused to wear female attire, and voiced a desire to be, or a certainty that he was, male. Transition later in life is a way of creating a physical and social reality that reflects an enduring inner reality. Because many FTMs resisted being female, they may have deliberately avoided many of the aspects of female socialization. While some FTMs have great insight into women because of their socialization, others never experienced life as a woman and have no special insight into the female psyche. FTMs' attitudes toward women are no different from those of other men. I know some FTMs who dislike women and some who adore them. Many FTMs miss the intimacy of the female friendships they had when they were perceived as female.

Males are socialized differently from females. There is a great variability between families and cultures as to what those differences entail—the magnitude and type of initiation rituals, expectations, and roles. The anticipated differences between men and women generally create different child rearing practices, which build different skills (ice hockey versus ballet, building versus baking). Having been socialized as female can be an asset but may also be a liability. An FTM may arrive at manhood without the usual childhood and adolescent experiences to prepare him. Some of the stress of transition from female to male is a lack of training for the role. At this time there are few places an FTM can go to get this training. The need for big brothers is being partially answered by peer support groups and networks. There have been a number of organized rites of passage developed by and for FTMs to fill the gap. During transition it is important to be aware that some difficulties arise simply because of a lack of skill, which can be developed through experience.

Lack of experience in having non-transsexual men's bodies can lead to unrealistic perceptions and expectations. Many men evaluate their bodies and research surgical options without knowing what an average male body is really like. Heterosexual FTMs may not have had contact with men's genitals. They may not have seen other men, have no history of locker room comparison, no peers who are male, and no lovers who are male. Even if they have been exposed to photographs of genitalia through pornography or medical texts, they may know very little about the appearance or functioning of an average healthy male and his sexual organs.

Part of the transition process involves finding a comfortable style of masculinity. Early in transition most FTMs make a deliberate effort to appear masculine and will usually experiment with style. FTMs in early transition, especially prior to hormonal or surgical interventions, may rely on other external indicators to pass as male. The challenge of appearing male during the early stages of transition may necessitate wearing clothing that is unambiguously masculine and using deliberately masculine body language. Almost inevitably these individuals become less rigid as they become more physically advanced in transition (e.g., as a man grows a beard, he no longer needs to wear a tie to signal that he is male. After a man has chest surgery, he no longer has to bind his chest and can wear an androgynous T-shirt rather than a tailored men's shirt and vest.)

Some FTMs are told that they are not "butch" enough. This is a peculiar fact that draws attention to the reality that not all men are butch or macho and that FTMs reflect the variety of men in the world. When making judgments regarding an individual's gender presentation, we must take into account age and cultural context. What is age-appropriate behavior for a 30- or 40-year-old man undergoing puberty? An FTM in early transition (at any age) may, in some respects, be more like an adolescent male than a male his own age. He is going through the process of finding personal style and defining himself in relation to other people as well as experiencing and exploring his emerging sexuality. Most people continue to

develop these aspects across a life span, but in adolescence they flare up with a certain drama. Young boys often rely heavily on peer approval and have a great need to prove themselves. FTMs may have the same sexual preoccupations as other men, but they don't have a lifetime of experience learning to channel and act on those impulses and preoccupations in a culturally appropriate manner. That ability usually comes with time. Research has shown that pre-transition individuals often display more stereotypically masculine behaviors and attitudes than those who have gone through some transition. (Barrett 1997; Hunt, Carr, and Hampson 1981; Pfafflin 1993). This may occur for all of the reasons mentioned above. Through the process of transition they come to a physical and social identity in which masculinity is effortless.

Myth: All FTMs Want the Currently Available Sex-Reassignment Surgery and Are Willing to Sacrifice Anything to Obtain It

What about this assumption that all transsexuals, and specifically FTMs, want surgery? Almost any FTM will report that he has a strong desire to have a body like other men. FTMs, for a variety of reasons, may not request surgery. Most FTMs describe a lifetime of experiencing themselves as male. But most do not become *actively* interested in changing their body and living in their chosen role until they learn that it is possible. Most report that the wish was always there, but without the belief that it was possible, they did not attempt to actualize their potential. Because MTFs have been more visible, FTMs often report that they believed that "it was not possible" and were surprised to learn that one could "go the other way." With limited information available, FTMs sometimes begin a process of transition with the mistaken belief that the medical technology exists to give them their fantasy of a male body. After a little education such men usually realize that the state of technology leaves much to be desired.

Because the technology available to transform from female to male falls short of what most FTM men want and/or can afford, many do not begin transition at all. Some take hormones; some will have chest surgery without genital surgery. People choose the options they need most and the level to which they are willing to compromise. Some FTMs will choose not to have genital surgery, *not* because they do not want a penis but because they feel that there is no satisfactory or affordable penis available. Others are prevented from obtaining the available surgery by lack of funding, prohibitive health problems, or professional or family obligations. It is unrealistic to limit the definition of an FTM to include only those who decided to have this risky, costly, often technologically inadequate surgery. Metoidioplasty (creation of male genitals using the clitoris) is a more common option than phalloplasty (creation of a full-size phallus). However, there will always be FTMs who desperately want phalloplasty. Some men who are well-informed from a number of sources as to the risks and benefits will choose that procedure rather than live without a phallus. It is also a fact that very few peo-

ple in the United States can afford this surgery unless it is subsidized by some form of medical coverage. In a recent study in the United States, 80% of the respondents reported that lack of money was an obstacle to having surgery, and 40% said that it had contributed to their decision not to have surgery at that time. In this study, 40% of the people were considering phalloplasty or had undergone it already, while 60% of the people rejected phalloplasty as an option. (Rachlin 1997, 2000). Did surgical choices reflect differences in their gender identity or in their financial resources? What would the protocol be if these were non-transsexual men? I speculate that if a group of non-transsexual men had lost their penises, some would opt for metoidioplasty (if it were available), some would demand phalloplasty, and some would wait until technology advanced to give them back what they had lost.

Myth: There Are Not As Many FTMs As MTFs in the World

Most people have never heard the phrase "female-to-male." Even people who have some awareness of the existence of transsexuality are often surprised to find out that there are FTMs as well as MTFs. This is changing as FTMs organize, hold conferences, issue newsletters, and appear in the media. The Internet is also a large agent of change, as more individuals have more information at their fingertips through the World Wide Web. However, there are still many people who are not connected and would not think to search the Net for that information.

A common comment from someone hearing about the FTM phenomenon is, "You mean women become men? I didn't know they did that." Many of my clients report that their early-life decisions have been dictated by lack of information. Without knowledge of the existence of other FTMs, they thought their only option was to try to fit into the world as a woman—either by entering the lesbian community, living a heterosexual lifestyle, or, because neither of those options was viable for them, isolating themselves and abstaining altogether from relationships.

How many FTMs are there? In order to look into that question, we must first define what we mean by *FTM*. I am using the phrase to refer to someone who is male-identified (experiences himself as male) and was born in a female body and socialized as female. Though there are some FTM-identified people who do not claim a traditional male identity, this book is focused on those who do identify unambiguously as men; this chapter is about them. Such an FTM is a man. An FTM can choose to create a physical appearance and social life congruent with his male identity. To some men *FTM* is a label a man earns when he is committed and willing to make the sacrifices necessary for gender transition. There is no rule saying that a person becomes FTM at a certain point or after a particular surgical procedure. If you define an FTM as someone who has undergone phalloplasty, the numbers are very small. If you define an FTM as someone who has undergone metoidioplasty, the numbers are not quite as small. If you define FTM as people who have chest sur-

gery, the number gets larger. If you define FTM as people who take masculinizing hormones to live as men, the number gets larger still. And if you define FTM as female-bodied men (including those who want male bodies but who don't view transition as a viable option), there is no way of counting them, because only a small portion of such people have come forward to be counted. Most people who want to make the transition never will; many will not be able to afford it or to access information to get on the road toward transition.

In the United States, we do not have any centralized method for keeping track of the number of people that come forward with requests to change their gender. We do have information from countries such as Germany, Russia, Poland, and the Netherlands where larger and/or longer-term studies have been conducted (Kestern et al. 1995; Krug 1995; Vasilenko, Belkin, and Kinrik 1995). Weitze and Osburg (1996) reported that between 1981 and 1990, 1,422 judicial decisions were rendered in Germany for name changes and legal changes of sex status: "The sex ratio was 2.3:1 in favor of male-to-female transsexuals." Does the difference in numbers mean there are fewer FTMs than MTFs? Not necessarily. Landen, Walinder, and Lundstrom (1996) reviewed data on the sex ratio of transsexualism in Sweden from the 1960s until 1992. They found that the incidence of primary transsexualism was equally as common for MTFs and FTMs. In fact, several European facilities report a higher number of FTM than MTF patients (Govorun and Vornyk 1997).

Myth: FTMs Are the Same As MTFs—Only in Reverse

In discussions of transsexuality we sometimes lump together MTFs and FTMs, as if they were two sides of the same coin. You *cannot* simply apply the same principles in reverse. They are different populations. When we fail to understand this, we miss the essence of the FTM experience.

FTMs and MTFs are really two distinct populations. The differences are important in trying to understand and support men who are FTM. Cultural norms and medical technology are two contributing factors to the vastly different life experiences of the FTM. I have heard many comparisons concerning who has an easier time: FTMs pass better, but MTFs have more satisfying surgical options; FTMs may experience an elevation in social status and an increased sense of respect and safety, while MTFs may take a pay cut, a demotion in status, and become more socially vulnerable. These situations do occur but not to all individuals. MTFs and FTMs are as different from each other as men are from women. The more closely you look at their worlds, the more you will know this to be true.

The available research has borne out a number of differences between FTMs and MTFs. Studies using both groups usually compare the results for each separately, side by side. Ross and Need (1989) found that "factors which make it difficult for postoperative transsexuals to 'pass,' or which continue to remind them of their gender reassignment status, are associated with adjustment difficulties." Boltzer and Vehrs (1993) found that FTMs often pass

very well, and such reminders may be comparatively few. It follows then that FTMs would have fewer of these "adjustment difficulties" and therefore may not come for assistance in psychotherapy or peer support groups. Kockott and Fahrner (1988) found that the FTMs "more often had close ties to their parents and siblings, established stable partnerships, and were more satisfied sexually." Similar findings were reported by Verschoor and Poortinga (1988). But should MTFs be the group to which FTMs are compared? Or is it more appropriate to look at FTM lives as compared to those of other men, because FTMs are men who have had a particular biological/social experience?

Myth: FTMs Share a Sexual Orientation

Questions about sex (and which bathroom to use) are among the first questions asked by people who are learning about transsexuality. Let us address a few basics. People are generally sexually attracted to, and can be aroused by, their partner before physical contact takes place. Sexual orientation ordinarily depends on this kind of attraction and arousal. Depending upon the FTM's comfort with his body, he may or may not remove his clothing during a sexual encounter. Some people are comfortable enough to participate in sex nude with their partner and experience pleasure when their partner touches them. The FTM, and his partner, may accept his given genitals as male because they are his. But there are many FTMs who are very uncomfortable with aspects of their bodies and may remain partially clothed (such as in shorts and an undershirt). FTMs who have not undergone genital reconstruction surgery may use prosthetic phalluses (dildos) during sex and use them exactly like non-transsexual men use their penises. The prosthetic phallus, though not literally a part of his body, may be experienced by both partners as being part of him. Partners of FTMs are often extremely satisfied with the sexual aspect of their relationship. Rather than as a man without a penis, the FTM may function sexually as a man with a penis that is hard whenever and for as long as he wants, and can be whatever size he desires.

Some people find it difficult to separate the concept of gender identity from that of sexual orientation. Gender identity is one's sense of self as gendered (usually male or female); sexual orientation refers to who or what a person finds sexually stimulating. These two characteristics are related but independent. Most men are attracted to women, but not all men are attracted to women. FTMs are no different from other men in this respect. They represent a variety of sexual orientations. For most people the object of attraction is not the only important aspect of sex. How a partner makes us feel about ourselves, how they see us, and who we are when we are with them are also part of the sexual chemistry. It is crucial that the partner, whatever gender, respects and views their FTM partner as male. The prevalence of FTMs in relationship with women may in part be due to the greater ease with which women are able and willing to accept their FTM partners as men.

Certain questions inevitably arise: "If you want to have sex with women, why not be a

lesbian?" And "If you want to have sex with men, why don't you just stay a woman?" These questions have made many FTMs cringe. First of all, an FTM undertakes transition because he cannot just "stay a woman." That is not an option, because most FTMs never experience themselves as women. Heterosexual men rarely aspire to be lesbians. A gay non-transsexual man does not want to be a woman, and neither does the gay FTM. FTMs are *men* first. Whether an FTM has sex with a man or a woman, he can only do so comfortably if his partner accepts him for the man that he is. One must understand the primacy of gender identity over sexual orientation before one can begin to understand the nature of sexual relationships.

A sexual relationship between an FTM and a heterosexual or bisexual woman is usually experienced by the couple and those around them as a heterosexual relationship. A relationship between a lesbian woman and an FTM is usually experienced as a heterosexual relationship by the FTM. The same relationship may be perceived as either heterosexual or lesbian by the woman (see partner section below). A relationship between two men who are FTM is generally experienced as a male homosexual relationship, as is a relationship between an FTM and a non-transsexual man. These are generalities and do not necessarily reflect the wide variety of FTM relationships and sexualities. The best rule of thumb is that one should not make assumptions about gender identity or sexual orientation.

Is the variety in sexual orientation among FTMs different from a comparable non-transsexual male population? What effect might the experience of being socialized as a female have on a man's sexuality? One can only imagine what the incidence of bisexuality and homosexuality would be if all men were encouraged from earliest life to mate with other men. It is probable that because of this social pressure some percentage of FTMs will have had sexual interactions with men, even if they are primarily attracted to women.

Many FTMs spend time as members of the lesbian community before their transition. It is not unusual to hear an FTM say, "I was attracted to women, so I thought I *had* to be a lesbian. But I never did fit in." Their connection to the lesbian community may be strained when friends or lovers cannot understand, or are repelled by, the FTM's male gender identity. When an FTM makes the decision to undergo a physical transition and/or to live socially as a man, he might be compelled to break away from the lesbian community. Leaving the lesbian community can be a serious loss for the FTM in transition. This community may have been a major source of friendship and support.

Our knowledge about the sexual orientation of FTMs has been distorted by a number of factors. It is probable that the majority of FTMs are attracted to women and desire heterosexual relationships. However, the misconception that *all* FTMs are attracted to women was partly fostered by a tradition in which FTMs were considered poor candidates for sex reassignment if they admitted to being attracted to men. FTMs presenting with "gender dysphoria" have been denied hormones and surgery based on their sexual attraction to men

(Sullivan 1990). This resulted in an underreporting of the number of FTMs who were attracted to men. FTMs usually do research before seeking treatment; they knew of the biases and did not report their gay male preference even when it existed. FTMs who were attracted to men or who identified as gay men were forced to lie about their orientation in order to receive professional services. Homosexual FTMs, though, are beginning to be a presence in the literature, although they remain terribly underrepresented (Blanchard 1988; Blanchard et al. 1987; Blanchard and Steiner 1990; Coleman and Bockting 1988; Coleman et al. 1993; Devor 1993; Lothstein 1983; Randell 1959).

Homosexual FTMs were also less visible because of prejudice within the gay and bisexual men's communities. Increasing acceptance from those communities means increasing FTM visibility there. From the very first FTM Conference of the Americas in 1995, homosexual and bisexual FTMs have come out in numbers, making diversity in sexual orientation an undeniable reality.

Myth: SOFFAs of FTMs Undergo the Same Experiences As SOFFAs of MTFs

Virtually everyone who has a relationship with a man who is transsexual is affected by the FTM phenomenon. Even the most remote acquaintances experience a shift in the way they regard gender. A brief section about relationships is inevitably superficial, but I will attempt to highlight some common experiences.

The people that the FTM meets as a man will have a very different experience from people who have known him before transition. This is in part because the first impression and experience of meeting a man will never be "undone." The acquaintance will likely still experience the FTM as a man, and disclosure makes minimal demands on the acquaintance. S/he does not have to do anything different such as use a different name or pronoun. But it will be different for the people who have known the FTM before this change; these people virtually transition with him. They must redefine the status of their friend or relative, calling him by a new name and using new pronouns. Some SOFFAs are very supportive from the beginning because they have already realized that being a woman was unnatural for the man who is FTM. But SOFFAs may also feel helpless, angry, and confused. They may feel that they are losing a daughter, a wife, a mother, a sister, a lesbian partner, or a girlfriend. At the same time, the SOFFA's concept of gender is challenged, and they may experience philosophical, religious, or political objections.

There are some notable differences among the experiences of the significant others of MTFs and FTMs. SOs of MTFs and FTMs may both suffer shame as the result of their SO being perceived as different or deviant. However, the family of an FTM gains a male, while the family of an MTF loses a male. The reaction may differ depending on the cultural value placed on maleness and femaleness. When an MTF in a traditional marriage transitions, her family no longer has a man as the head of the household. While it is not unusual for house-

holds to be headed by two women, family members may feel change in statuses when they no longer have a visible husband or father. Because men are regarded as generally stronger and more able to support and protect themselves and their loved ones, the SOs of MTFs may feel vulnerable and weakened. Parents of an MTF child (of any age) may view their child as potentially more vulnerable than they would a child who is FTM. This vulnerability is one reason that parents bring in MTF children for psychiatric help in greater numbers than FTMs. Parents of transsexual children most often think (or fear) that their child is homosexual. Attitudes toward homosexuality have greatly affected attitudes toward transsexuals because most people do not understand the distinction between gender identity and sexual orientation. To the extent that people view sexual relationships between women as more acceptable than sexual relationships between men, there may be greater tolerance for FTMs. In most cases there is greater tolerance for a female who is attracted to the male role (generally a "superior" position and thus understandable), which makes the transition slightly easier for the family of the FTM.

Gender transition of a family member will be stressful for most families. In one case, if the FTM has a family with a female partner, that partner may be perceived by others to be lesbian before transition and as heterosexual after transition. In another family, an FTM prior to transition may be the wife of a non-transsexual man. In order for this family to remain intact once the transition has taken place, the original husband must be willing to be perceived as homosexual, because there will now be two men raising the children together. How do the children fare when a parent undergoes a gender transition? In my experience with a number of families who have small children (from ages 2 to 9), the children appeared to accept the transition very well—they asked questions and were given honest answers. Without exception the children at these ages maintained strong loving connections with their transsexual parent. On the other hand, I have known several adolescent and adult sons who have virtually disowned their MTF parents. These relationships are often healed later in life. Research has consistently supported the observation that children "do not experience any gender disturbance, but must go through an adaptation period following their parent's SRS." (R. Green 1978, 1998)

There are predictable issues that might be anticipated in lesbian, bisexual, heterosexual, and other FTM partnerships. Partners of FTMs encounter a variety of challenges to their self-definition and their cultural affiliation, in addition to sexual issues. A common example is the dilemma of a lesbian who unexpectedly learns her partner identifies as a man. Being in a relationship with a man may pose a fundamental threat to her identity as a lesbian and to her relationship with the lesbian community. Many lesbians have intense fears around what it will be like to be in a relationship with a man. Will the partner change as he becomes more masculine? Will he take on characteristics that she has sought to avoid?

A relationship with an FTM may be confusing for heterosexual women as well. The part-

ner may question her sexuality, especially during pre- or early transition, when the people around them will view the couple as lesbian. The heterosexual woman will usually experience her FTM partner as a man and respond to him socially and sexually as she would to other men. This experience happens in spite of her partner's body, which contains contradictions for them both.

The variety of FTM experience and relationships makes any brief chapter seem incomplete. Each person's experience is precious and compelling. The first few contacts I had, the first few stories I heard, had tremendous impact on my perception of gender. As I spend time with more and more people who have been affected in some way by the FTM experience, my understanding continues to grow. Trends and subcultures as well as common and uncommon experiences become apparent.

In the past decade there has been a renaissance in the FTM community, and FTMs are more visible than ever before. As FTMs organize in varied communities, hold support groups and conferences, and express their true selves to the world, more FTMs may become visible; more people, FTM and non-FTM, will learn from FTM role models, heroes, friends, coworkers, and family members. As medical technology advances, as hormonal and surgical options are more appropriately available, there will be more FTMs being counted in the scientific literature. As transsexuals' existence is acknowledged and human rights legislation is written to include them, there will be more accurate information and fewer myths.

References

Assalian, P., Wilchesky, M., and Cote, H. (1997). Phalloplasty in female to male transsexuals: The radial forearm revisited. Paper presented at the XV Harry Benjamin International Gender Dysphoria Association Symposium: The State of Our Art and the State of Our Science, Vancouver, Canada.

Barrett, J. (1997). Psychological and social function before and after phalloplasty. Paper presented at the XV Harry Benjamin International Gender Dysphoria Association Symposium: The State of Our Art and the State of Our Science, Vancouver, Canada.

Bettochi, C., Ralph, D., and Pryor, J. (1997). Pubic phalloplasty in female to male transsexuals. Paper presented at the XV Harry Benjamin International Gender Dysphoria Association Symposium: The State of Our Art and the State of Our Science, Vancouver, Canada.

Blanchard, R. (1988). Nonhomosexual gender dysphoria. *Journal of Sex Research* 24: 188–193.

Blanchard, R., Clemmensen, L., and Steiner, B. (1987). Heterosexual and homosexual gender dysphoria. *Archives of Sexual Behavior* 16(2): 139–152.

Blanchard, R., and Steiner, B., eds. (1990). *Clinical management of gender identity disorders in children and adults.* American Psychiatric Press.

Boltzer, M., and Vehrs, B. (1993). Factors contributing to favorable outcomes of gender reassignment surgery.

Paper presented at the Harry Benjamin International Gender Dysphoria Association's XIII International Symposium on Gender Dysphoria: Advances in Treatment, New York City.

Coleman, E., and Bockting, W. (1988). "Heterosexual" prior to sex reassignment, "homosexual" afterward: A case study of a female to male transsexual. *Journal of Psychology and Human Sexuality* 1(2): 69–82.

Coleman, E., Bockting, W., and Gooren, L. (1993). Homosexual and bisexual identity in sex-reassigned female to male transsexuals. *Archives of Sexual Behavior* 22(1): 37–50.

Cook-Daniels, L. (1998). Trans-Positioned. *Circles Magazine* 1(2): 16–24.

Cromwell, J. (1999). *Transmen and FTMs: Identities, bodies, genders, and sexualities.* University of Illinois Press.

Devor, H. (1993). Sexual orientation identities: Attractions and practices of female to male transsexuals. Paper presented at the Harry Benjamin International Gender Dysphoria Association's XIII International Symposium on Gender Dysphoria: Advances in Treatment, New York City.

Devor, H. (1997). *FTM: Female to male transsexuals in society.* Indiana University Press.

Govorun, T., and Vornyk, B. (1997). The self-concept development of transsexual persons. Paper presented at the XV Harry Benjamin International Gender Dysphoria Association Symposium: The State of Our Art and the State of Our Science, at Vancouver, Canada.

Green, J. (1998). FTM: An emerging voice. In *Current concepts in transgender identity,* edited by D. Denny. Garland Publishing.

Green, J. (1999). Look! No, don't! The visibility dilemma for transsexual men. In *Reclaiming genders: Transsexual grammars at the fin de siecle,* edited by S. Whittle and K. More. Cassell.

Green, R. (1978). Sexual identity of 37 raised by homosexual or transsexual parents. *American Journal of Psychiatry* 135(6): 692–697.

Green, R. (1998). Transsexuals' children. *International Journal of Transgenderism* 2(4): 1–6. Available at http://www.symposion.com/ijt

Hunt, D., Carr, J., and Hampson, J. (1981). Cognitive correlates of biologic sex and gender identity in trans-sexualism. *Archives of Sexual Behavior* 10(1): 65–77.

Levine, S. (chairperson), Brown, G., Coleman, E., Cohen-Kettenis, P., Joris Hage, J., Van Maasdam, J., et al. (1998). *The standards of care for gender identity disorders.* 5th version. Symposium Publishing.

Kesteren, P., Asscheman, H., Megens, J., and Gooren, L. (1995). Side effects of cross-sex hormonal treatment: An update of mortality and morbidity in 1,109 transsexuals. Paper presented at the XIV Harry Benjamin International Gender Dysphoria Symposium, at Kloster Irsee, Bavaria, Germany, September 7–10, 1995.

Kockott, G., and Fahrner, E. (1988). Male to female and female to male transsexuals: A comparison. *Archives of Sexual Behavior* 17(6): 539–546.

Krug, J. (1995). The plan of surgical treatment of transsexuals. Paper presented at the XIV Harry Benjamin International Gender Dysphoria Symposium, at Kloster Irsee, Bavaria, Germany.

Landen, M., Walinder, J., and Lundstrom, B. (1996). Incidence and sex ratio of transsexualism in Sweden. *Acta Psychiatrica Scandinavica* 93: 261–263.

Lief, H. (1993). Orgasm in the postoperative transsexual. *Archives of Sexual Behavior* 22(2): 145–155.

Lothstein, L. (1983). *Female to male transsexualism: Historical, clinical, and theoretical issues.* Routledge and Kegan Paul.

Meyer, W., III (chairperson), Bockting, W., Cohen-Kettenis, P., Coleman, E., DiCeglie, D., Devor, H., et al. (2001). *The standards of care for gender identity disorders.* 6th version. Available at http://www.symposion.com/ijt/.

Monstrey, H., Hoebeke, P., Van Landuyt, K., Blondeel, P., Tonnard, P., and Matton, G. (1997). Phalloplasty in female to male transsexuals: The radial forearm revisited. Paper presented at the XV Harry Benjamin International Gender Dysphoria Association Symposium: The State of Our Art and the State of Our Science, Vancouver, Canada.

Pfafflin, F. (1993). Unexpected findings of psychological testing of pre- and postoperative transsexuals. Paper presented at the Harry Benjamin International Gender Dysphoria Association's XIII International Symposium on Gender Dysphoria: Advances in Treatment, New York City.

Rachlin, K. (1999). Factors which influence individual's decisions when considering FTM genital surgery. *International Journal of Transgenderism* 3(3). Available at http://www.symposion.com/ijt

Rachlin, K. (2000). Research into surgical decision-making. (Condensed version of above article, available at http://www.ftm-intl.org/Resources/Surgery/rachlin.pdf.)

Randell, J. (1959). Transvestism and trans-sexualism: a study of 50 cases. *British Medical Journal,* Issue 2, 1448–1452.

Ross, M., and Need, J. (1989). Effects of adequacy of gender reassignment surgery on psychological adjustment: A follow-up of fourteen male to female patients. *Archives of Sexual Behavior* 18(2): 145–153.

Sanders, G. (1995). When the mirror is wrong: An interview with Gary Sanders. *In the Family* 1(2): 8–13.

Sullivan, L. (1990). *From female to male: The life of Jack Bee Garland.* Alyson Publications.

Vasilenko, L., Belkin, A., and Kinrik, N. (1995). Experience of organization of a complex medico-social help of persons with transsexualism. Paper presented at the XIV Harry Benjamin International Gender Dysphoria Symposium, at Kloster Irsee, Bavaria, Germany.

Verschoor, A., and Poortinga, J. (1988). Psychosocial differences between Dutch male and female transsexuals. *Archives of Sexual Behavior* 17(2): 173–178.

Weitze, C., and Osburg, S. (1996). Transsexualism in Germany: Empirical data on epidemiology and application of the German Transsexuals' Act during its first ten years. *Archives of Sexual Behavior* 25(4): 409–425.

Willerman, L., and Cohen. D. (1990). *Psychopathology.* McGraw-Hill.

Seeking Manhood:
An Introductory Guide to Assessment of the Female-to-Male Adolescent

By Diane Ellaborn, LICSW

Diane Ellaborn is a psychotherapist and gender specialist with a private practice in Framingham, Mass.

INTRODUCTION

As I began assessing and treating adolescent FTMs as a clinician, I couldn't help but think about the first FTM teenager I met—long before I ever contemplated becoming a psychotherapist or gender specialist. As a 9-year-old girl in the 1960s I met Jay. Jay was 19 years old at the time, the first female-bodied person I knew who had the courage to live as a man. I remember being fascinated by his face shaving ritual, the way he composed his hair into a masculine style, bound his chest, and dressed completely in male attire. Choosing to call himself by a gender-neutral name, he was most often perceived as a male but mistaken to be much younger than he was. At other times, he was seen as a lesbian or masculine female. I remember my discomfort when adults would ask me if Jay was male or female, thinking the adults were foolish for asking.

The times were against Jay. He did not have role models or the means for gender transition. He was destined to live in limbo. As a result, he never completed high school and his

career ambitions were thwarted. He never had a legal name change, so he constantly feared the embarrassment of handing over documents that would reveal his female identity. And since he never had medical interventions, he struggled with hating his body. Over time I observed with sadness his frustration and pain. He also turned to illegal activities as a means of support, which led to a series of incarcerations. I'll never forget Jay's agony and awkwardness when he needed to don a skirt and stockings to appear before the male judge and be sentenced to a female jail.

By the time I was in full-blown adolescence, my family lost its connection to Jay due to his numerous incarcerations. As I grew to adulthood, I wondered, and still do, if he ever took steps to allow his true manhood to emerge. Without taking those steps his life appeared doomed to failure—alcoholism, unbearable frustration, and unhappiness.

Most of us vividly remember our adolescent years, whether we consider them the best times of our lives or an awkward, embarrassing age we wish we could forget. As today's adolescents know too well, the preteen and teen years present enormous challenges. But for the adolescent transsexual (TS)—specifically, the female-to-male transsexual—those years are inevitably experienced negatively. Having felt from early childhood that their birth sex and their sense of internal self as a male were in opposition, their adolescence is a period when their body betrays their mind. As female bodily attributes develop, the psychological impact on the adolescent is often devastating. The anguish that is experienced demands concerned attention and care.

Unfortunately, many teen FTMs do not receive any professional counseling, and the few who do seldom benefit because their therapists do not know how to treat these youngsters and typically depend on inappropriate psychotherapeutic models in their counseling efforts. A psychotherapist's failure to address a TS's need to explore his or her inner gender identity and the resulting concerns all too often turn off an adolescent to therapy. In some extreme cases, FTM youths who enter the psychotherapy system are misdiagnosed as highly disturbed emotionally, schizophrenic, or manic-depressive; they are subjected to psychotropic medication, aversion therapy, and often are inappropriately sent to psychiatric hospitals.

Although few therapists have experience in counseling that requires addressing both adolescent and gender issues, the situation is slowly improving. A growing number of innovative therapists are developing skills in this specialized area, cultivating more effective strategies for assessing adolescent TSs and supporting their gender transitions earlier in life. They are also helping families to constructively accept the diagnosis of transsexualism and to support the child's need for gender mind-body congruency. Recent research concludes that transitioning during the traumatic years of adolescence benefits the TS later in life (Cohen-Kettenis and van Goozen 1997). When these FTMs finish adolescence and become adults, they are less likely to have feelings of "lost years" that many TSs experience.

In the discussion that follows, we will explore theories of the origins of transsexualism,

risk factors, and the assessment of the female-to-male TS. To avoid confusion, FTMs will be referred to by their preferred gender pronouns (he, him, his).

THEORIES OF TRANSSEXUALISM

Hormones affect the structure and operation of the brain over the course of our entire lives but have the greatest effect on us while in the womb, throughout the infancy-toddler ages, and at adolescence. In the womb, hormones regulate the layout of the neural network of the developing brain. By toddler age, these areas of the brain have matured. At puberty, testosterone (in genetic males) and estrogen/progesterone (in genetic females) stimulate this neural network into activity. Many experts now believe that the seeds of transsexualism are present even before birth. Beginning in early childhood, many TSs feel strongly identified with the gender opposite their own sex. For many reasons, s/he senses that the "choice" to transition to the opposite gender was predetermined. In adolescence, the influx of what the youth typically considers the "wrong" hormones causes internal and external psychophysical conflicts. S/he wants to express the innate cross-gender identity in some way but is almost never allowed to follow personal desire to the extent that s/he feels is necessary due to restraints defined by family, friends, institutions, and society at large.

The origins of transsexualism remain unclear. Some have labeled it a psychopathology, while others have looked for a genetic basis. Other researchers theorize some combination of genetics and environment might account for the condition. An early hypothesis postulated that an influx of cross-sex hormones (a hormonal wash) in the womb established gender variance in the brain cells. According to "brain sex" theory, transsexualism may have a biological origin. The unborn child's brain cells have the seeds of gender identity, nearly always corresponding to anatomical male or female development. The area of the brain possibly linked to gender identity and sexual behavior, the hypothalamus, is fully developed at about age 3 or 4. A genetic basis for human brain sex theory remains theoretical. The embryonic brain continues to form in the womb, and although physicians can easily determine the physical sex of a fetus a few months into the mother's pregnancy, science has not developed any way to test for "brain-determined" transsexualism in living children or adults, let alone in a fetus. Defined relative to deceased subjects, recent research at the Netherlands Institute for Brain Research in Amsterdam showed that "the volume of the central subdivision of the bed nucleus of the stria terminalis (BSTc), a brain area that is essential for sexual behavior, is larger in men than in women," that "a female-sized BSTc was found in male to female transsexuals," and further, that the "size of the BSTc was not influenced by sex hormones in adulthood and was independent of sexual orientation" (Zhou et al. 1995). This study is the "first to show a female brain structure in genetically male transsexuals and supports the hypothesis that gen-

der identity develops as a result of an interaction between the developing brain and sex hormones." A study on the brains of deceased FTMs has yet to be conducted.

KEY ADOLESCENT ISSUES

Key issues common to adolescence are the "Three I's": independence, identity, and intimacy. Independence has emotional, economic, and intellectual components. Identity involves accepting (or rejecting) one's body, a masculine or feminine role, and the values and belief systems of society. Intimacy includes forming new relationships with companions of both sexes and preparing for possible committed relationships, marriage, possibly family, and coping with sexual desires. During adolescence, teens acquire skill, knowledge, and attitudes that help them master higher-level tasks. Youths who successfully master the challenges of adolescence consolidate independence, identity, and intimacy. Failure in one or more of these areas during adolescence can have dire consequences, including an inability to adjust to changes, increased anxiety, the disapproval of society, and stunted developmental progress.

Independence

Achieving a sense of independence is difficult for all teens. For the FTM youth, cross-gender desires further complicate the situation. The unverbalized need for a female to live as a male detracts from the teen's burgeoning need for independence. Unlike non-transsexual peers, who typically attend college, form intimate committed relationships, and directly enter the work world, FTM teens often see no viable future goals. They may have trouble asserting emotional and intellectual independence because they can't directly realize the gender identity they feel to be innately authentic. This restricts present and future educational and career opportunities. For example, FTMs often state that they cannot imagine themselves studying for a professional career where they would be required to dress in standard women's clothing; thus they tend to gravitate toward lower-paying jobs where dress code requirements are not restrictively specified. The majority of FTMs as teenagers and young adults lack the autonomy and funds to get the treatment they need. Even if they are able to begin transition, very few insurers will cover the medical costs. The expense of uninsured mental health, medical, cosmetic, and surgical treatments such as sex-reassignment surgery often drain limited finances of the young TS. This can leave the TS inordinately dependent upon the income of parents.

Identity

Internal stress arises within the FTM over the widening gap between society's gender role expectations and gender identity. Developing a consolidated gender identity is a diffi-

cult process that may take many years to establish. Some teens confuse the difference between gender identity and sexual orientation. TS teens or questioning youth may join teen gay-lesbian-bisexual-transsexual/transgender support groups in an effort to find the support of a safe peer group. The developmental needs of TS youth parallel those of gay, lesbian, and bisexual peers: "coming out" to one's self and others about their gender condition; establishing a support system if they have a strong inner drive to transition; developing a social group and intimate relationships, sometimes with same-sex peers; and dealing with the oppression of being different. Yet FTM adolescents face much more complex and multifaceted challenges. The biggest differences between FTMs and their gay-lesbian-bisexual (GLB) peers derive from acts of bodily transformation and the physical and social implications of gender change. While body dysphoria prompts many young TSs to search for medical and nonmedical options for changing their bodies, they also struggle to figure out their sexual orientation as straight or as gay, lesbian, or bisexual. For example, young FTMs who are attracted to females may initially identify as lesbians. Family members and other adults, including therapists, may label them as such. Such identification and labeling often proves erroneous, particularly when an FTM discovers that it is possible to change their sex, that the term *male* better describes them, and they transition with the aid of surgery and hormones to their rightful sex and live out their lives as heterosexual men.

A 1979 study compared behavioral patterns during childhood and adolescence in FTMs and a matched group of lesbians. Both groups were relatively young, with a mean age of 21 years, 10 months. The groups did not differ in respect to the frequency of tomboyish behavior or lack of interest in doll play and other aspects of maternal rehearsal. The FTM group recalled preferring the company of male peers more often. The groups differed significantly in regard to childhood cross-dressing: 80% of the transsexuals cross-dressed, as compared to 0% of lesbians. The lesbians in this study reported no gender identity confusion in adolescence, and only 10% reacted negatively to breast development and onset of menses, in contrast to 70% of the FTMs. The similarities and differences between the two groups in childhood and adolescent development are relevant for clinical management and the differential diagnosis of transsexualism versus lesbianism (Ehrhardt, Grisanti, and McCauley 1979).

Intimacy

The FTM teen often is socially isolated and may have few friends. Cross-gender identification directly impacts the beginning of intimate and sexual relations with potential partners. As TSs reach their teen years, dating, educational, and personal development are partly suspended (O'Keefe and Fox 1996). While junior high and high school peers begin dating, the TS feels excluded. Many FTMs go through these years without a teenage boyfriend or girlfriend. Their gender dysphoria makes dating seem impossible and unfulfilling. The young FTM often struggles with expressing intimacy toward his first love and confiding with

a potential partner about his gender identity. Heterosexual FTMs will find themselves attracted to girls and young women, but society will perceive them as lesbian. On the other hand, gay FTMs may fall in love with boys or men who may not fully grasp how the FTM wants to be perceived and may misinterpret and/or thwart romantic advances.

RISK FACTORS

There are considerable internal and external risks for FTM youth. For the adolescent TS, this part of life holds formidable obstacles: confusion, body betrayal, hopelessness, social withdrawal/isolation, medical risks, and school/career choices.

Confusion

While many teens express confusion about aspects of their lives, for the teen FTM, confusion stems from their cross-gender feelings. Some will seek counseling to resolve uncertainty about these complex issues. Therapy is becoming more common and accepted among teenagers, though some have little motivation for it. On the other hand, gender-questioning teens are generally more willing to see therapists who are knowledgeable about gender issues. Adolescents trying to find ways to cope with the implications of transsexualism feel reassured when they locate gender specialists who can help them clarify their gender identity, explore options for living with a gender condition, and assess their eligibility and readiness to start transition. If the FTM teen fails to come to terms with his inner gender, he may remain in a perpetual state of confusion well into adulthood, which would delay identity consolidation and transition.

Body Betrayal

Often, preteen FTMs experience some degree of freedom to express their inner male identity to the outside world. Before puberty, the FTM—often labeled a tomboy—feels boyish and may be allowed to build forts and play sports alongside young male peers and siblings. However, the physical changes that mark the FTM's entry into adolescence set him apart from genetic boys on the threshold of puberty. Society increases pressure on the cross-gender youngster to conform to the gender role of young women. Male peers who had previously accepted or tolerated this prepubescent gender expression now treat the FTM as a teenage girl and exclude him from their cliques. The young FTM has great difficulty in early adolescent puberty because it feels so much different to him than to his female peers or siblings. He experiences body changes like breast growth and the first menses as body betrayals—which lead to negative body image and diminished self-esteem, or, as some clinicians have suggested, no self-esteem. Although puberty makes him realize that his body will not

become male to match his inner gender, he continues to secretly desire that his "inner boy" mature into a young man instead.

Hopelessness

The FTM may lose hope that his body and brain sex will ever correspond. He may suppress his intense awareness of cross-gender feelings for fear his parents might condemn any expression of inner gender. Hopelessness makes it difficult for the FTM teen to see a future and plan for it. He may experience sad, angry, or irritable moods. Depression is a common mental health concern with these adolescents. It is always immobilizing and sometimes fatal (Schaefer et al. 1995). Depressed TS teens lose interest in friends, school, and themselves, have dramatic mood swings, and frequently develop irregular sleeping or eating patterns. The suicide risk is very high; suicide attempts or accomplished acts definitely occur. Although there are no official statistics for TS youth, many experts believe the suicide rate is similar to that of GLB youth. The Hetrick Martin Institute estimates that suicides in GLB youth account for 30% of total completed teen suicides. Between 50% and 88% of TS youth have seriously considered or have attempted suicide (Israel and Tarver 1997).

Social Withdrawal/Isolation

In general, many adolescents experience forms of social withdrawal and isolation, some of which might go unnoticed by adults. For the FTM teen, fitting into their peer group is very difficult. Many say that they feel like an outsider—isolated and detached from others. They have no one to confide in about their gender identity. They may rarely socialize with teen peers or date, if at all. They are often excluded from social events and school activities with peers, which can inhibit their healthy functioning in society. Young FTMs may spend a lot of time alone and may draw further into themselves. There are very few TS peer support groups for them to attend in person, although the popularity of the Internet has improved opportunities to meet others with similar gender issues.

Medical Risks

Both teen and adult FTMs tend to avoid medical services, especially gynecological care, due to discomfort and embarrassment over their bodies. Thus, medical risks for FTMs are very high. Of all age groups, teenagers are at greatest risk for experimentation with tobacco, alcohol, and drugs. A troubled young TS may abuse alcohol and drugs as a way to meet others, as a means of escape, or as self-medication for their gender dysphoria and related depression and anxiety. To overcome peer pressure and their own insecurity, they may experiment with addictive substances. Over the long term, severe substance abuse could damage the liver, which in turn affects future hormone treatments. The lack of sex education applicable to TSs poses another medical danger. Some teen FTMs participate in unsafe sexual

practices, putting themselves at risk of contracting HIV or other sexually transmitted ill-nesses. Certainly the risk of gay FTMs becoming HIV-positive is much higher than genetic females of any orientation (Clements et al. 1998).

School/Career Choices

The pressure to conform makes school difficult for FTM teens. Adolescent TSs risk rejection, harassment, and sometimes violence. Few teachers and school counselors are sensitive to TS issues, and most are not capable of helping the TS's peers to be accepting. FTM teens are at risk for school refusal, and homeschooling is sometimes an appropriate alternative. Deciding on an occupation and holding down a steady job may be challenging for FTM youth, who often appear as very masculine women. Before hormonal or surgical assists to transition, they face job discrimination: Few employers will accept an FTM employee in the initial stages of transition; both blue-collar and white-collar employers may discriminate against a TS employee, who has no protection under the law; TS employees are also extremely vulnerable to layoffs or being passed over for promotions or raises. Transitioning before entering the workforce can help the young FTM avoid discrimination.

ASSESSMENT

Despite the many challenges they face, FTMs can minimize, overcome, and even avoid difficulties through early assessment and treatment by a gender specialist. The first step is to identify the nature of the condition as transsexualism. Although therapists may diagnose adolescents as TS, it is unfortunate that many hold the misconception that transsexualism is either a noncorrective psychiatric disorder or evidence of underlying psychopathology. Furthermore, the unique needs of FTM adolescents in particular must be noted. The Harry Benjamin International Gender Dysphoria Association's Standards of Care for Gender Identity Disorders, fifth version, states, "Two Primary Populations with GID Exist—Biological Males and Biological Females. The sex of a patient always is a significant factor in the management of GID. Clinicians need to separately consider the biological, social, psychological, and economic dilemmas of each sex. For example, when first requesting professional assistance, the typical biological female seems to be further along in consolidating a male gender identity than the typical biological male in her quest for a comfortable female gender identity. This often enables the sequences of therapy to process more rapidly for male-identified persons." (Levine et al. 1998).

Increasingly, teenage FTMs are seeking help from knowledgeable professionals who comprise a gender team. The gender team usually includes a therapist specializing in gender issues (a clinical social worker, psychologist, and/or psychiatrist) and physicians (a pedi-

atric endocrinologist, primary care doctor, and, if so required, a surgeon). This team may confirm a diagnosis of gender identity disorder (GID), which, according to the American Psychiatric Association's Diagnostic and Statistical Manual of Mental Disorders (DSM-IV), is identified as:

A) Strong and persistent cross-gender identification (not merely a desire for any perceived cultural advantages of being the other sex).

In children, the disturbance is manifested by four (or more) of the following: (1) repeatedly stated desire to be, or insistence that he or she is, the other sex; (2) in boys, preference for cross-dressing or simulating female attire; in girls, insistence on wearing only stereotypical masculine clothing; (3) strong and persistent preferences for cross-sex roles in make-believe play or persistent fantasies of being the other sex; (4) intense desire to participate in the stereotypical games and pastimes of the other sex; and (5) strong preference for playmates of the other sex.

In adolescents and adults, the disturbance is manifested by symptoms such as a stated desire to be the other sex, frequent passing as the other sex, desire to live or be treated as the other sex, or the conviction that he or she has the typical feelings and reactions of the other sex.

B) Persistent discomfort with his or her sex or sense of inappropriateness in the gender role of that sex.

In children, the disturbance is manifested by any of the following: In boys, assertion that his penis or testes is disgusting or will disappear, or assertion that it would be better not to have a penis, or aversion toward rough-and-tumble play and rejection of male stereotypical toys, games, and activities; in girls, rejection of urinating in a sitting position, assertion that she has or will grow a penis, or assertion that she does not want to grow breasts or menstruate, or marked aversion toward normative feminine clothing.

In adolescents and adults, the disturbance is manifested by symptoms such as preoccupation with getting rid of primary and secondary sex characteristics (e.g., request for hormones, surgery, or other procedures to physically alter sexual characteristics to simulate the other sex), or belief that he or she was born the wrong sex.

C) The disturbance is not concurrent with a physical intersex condition.

D) The disturbance causes clinically significant distress or impairment in social, occupational, or other important areas of functioning.

Early in the assessment process, the gender specialist should take a detailed client history that covers psychosocial, developmental, medical, and gender issues. The counselor must obtain history and information from the youth individually and also from the parents. It is important that the therapist not just obtain history from the parents' point of view—the young FTM should be able to express thoughts to the counselor that he might feel uncomfortable sharing in the company of his parents. Therefore, history-taking with the adolescent alone is crucial. As the therapist and adolescent develop a rapport, the gender specialist gains a better understanding of how the adolescent views himself. The therapist should also note the extended family's background and their reaction to their child's gender-variant behavior. Two keys to success at this stage are self-education for the adolescent client and his parents, and contact with support groups in the area, if available. Access to the Internet is an excellent way for young FTMs to learn from and communicate with peers.

The diagnostic assessment continues with a semi-structured interview with the adolescent. The counselor discusses a list of topics, including identification figures, relationship with same-sex and opposite-sex parent, first conscious cross-gender feelings, and the youth's emotional reaction to their maturing body. The discussion addresses many aspects of sexuality—sexual fantasies, sexual behavior, sexual orientation, anxieties, and the meaning of cross-dressing and transsexualism. The interview also covers current issues such as school/career choice and school problems, relationship problems at home or with peers, and romantic involvements, attractions, and sexual fantasies. The gender specialist observes several aspects of the child's functioning, problem-solving abilities, interpersonal functioning, reality testing, consistency of the sex-reassignment surgery wish, and gender role behavior. The adolescent may undergo intelligence and personality testing and, if necessary, neuropsychological testing. A standard battery may contain other specific instruments, such as a Lindgren/Pauly body image scale and a gender dysphoria scale (Cohen-Kettenis and van Goozen 1997). In many cases these youngsters have undergone previous psychological testing that a gender specialist can review and reinterpret, rather than retesting the adolescent. The therapist must also diagnose co-morbid psychiatric conditions, such as depression and anxiety, and recommend appropriate treatment.

There are a number of diagnostic considerations in assessing whether a client is a true FTM. In terms of differential diagnosis, one must also consider other psychiatric conditions, lesbianism, and whether this client is a masculine female or tomboy who may turn out to be a heterosexual female. As a clinician who has seen a high percentage of FTMs in my private practice, I have developed a list of characteristics that may reflect whether the client is an FTM rather than a lesbian or tomboy.

The first list of characteristics concerns rejecting or denying female thoughts and behaviors. These may include: refusal to wear or shop for female clothing, especially skirts, dresses, stockings, undergarments, bathing suit tops; refusal to engage in maternal rehearsal in

play (e.g., doll playing or playing female roles in imaginative play); refusal to sit for urination; disinterest in or refusal to buy and/or wear first bra; desire to wear a sports bra after development to flatten the chest; denial that menses have occurred; depression; often-suicidal depression at times of menses; refusal and/or avoidance of calculating menstrual cycle; refusal to use typical menstrual products (e.g., using rolled-up toilet paper instead of a menstrual pad); refusal to buy menstrual products; refusal to shave legs and/or underarms; avoidance of female locker rooms and avoidance of joining all female sports teams; and denial of lesbian identity, if attracted to females (for heterosexual FTMs).

Second, male-affirming thoughts and behaviors are evident. They may include: identification figures and emulation of key male role models, such as fathers, grandfathers, and uncles; cross-gender play, such as rough-and-tumble play; male peer preference; wearing hair in a male style; adopting a male name; standing to urinate; "packing" (wearing something in underwear, either prosthesis and/or homemade material to look like a bulge in the pants); identifying with male role in imaginative play (e.g., as a superhero); cross-dressing, including ties or male underwear; desiring to go shirtless; mock shaving; smoking or mock smoking; muscle flexing in the mirror; presenting self as male; use of male products like deodorant or cologne; indirect methods of masturbation; and fantasizing about having a penis, performing intercourse, and/or receiving fellatio.

The length of the evaluation period will vary. The first phase of the assessment may take months or even years (Cohen-Kettenis and van Goozen 1997). At the very least, the therapist should be aware of the Harry Benjamin International Gender Dysphoria Association's Standards of Care for Gender Identity Disorder, which suggests a minimum of six months of evaluation before beginning hormone therapy and/or the "real-life experience." In diagnosing adolescent TSs, gender specialists must be very careful, using much stricter criteria than with adult clients before referring youths for hormone treatment. It is recommended by this therapist, since I work independently in private practice, that a TS youth seek a second opinion to verify the first gender specialist's assessment of GID and receive recommendations for treatment. Ideally, the parents and adolescent will come to the same conclusion about what options to explore. If not, the adolescent can ultimately pursue options without parental support when he reaches the legal age of adulthood.

Once the gender-specialist team confirms the diagnosis of GID, the adolescent and parents should explore the options available to them. Nonmedical options include steps such as cross-dressing and changing the adolescent's name, and possibly changing schools so the FTM can present as male. Medical options include hormone treatment and eventual SRS. A technique called advantage-disadvantage analysis helps the young TS more fully comprehend and refine their decision-making (Israel and Tarver 1997). This decision-making technique helps the patient weigh the pros and cons of each step of the process. When the FTM, his parents, and the gender team can assess the issues, they can address and thor-

oughly review the options and answer hard questions about disclosing TS status, changing names, using hormones, and undergoing SRS. The therapist must emphasize that the one option that parents do not have is doing nothing. This attitude can only have disastrous consequences (Schaefer et al. 1995).

Forging a solid alliance among the adolescent, parent, and professional is a tricky balancing act but an important one. The agendas of the parents and the FTM are often very different. The adolescent usually comes into the assessment as a self-defined TS or as questioning gender identity. The parent may deny the gender identity problem completely. Some acknowledge there is a problem but will not initially accept a diagnosis of transsexualism. Other parents cling to false hopes that their transsexual child can be "cured." The intention of the therapist should be on reaching a state of harmony between parents and the adolescent. A gender specialist has a unique set of skills to help clarify the adolescent's condition and address the parents' confusion, worries, and understandable concerns about their child's welfare.

However long it may take, most parents eventually accept the diagnosis when the gender specialist presents evidence of their child's lifelong cross-gender behavior, dress, and play. This behavior, for which they previously had no explanation, now has a definition— *transsexual*.

Grieving the loss of their daughter is part of the parents' acceptance process. They must give up whatever hopes and dreams they had of their daughter becoming an adult woman. Group therapy with other parents of transsexuals is quite effective in building parents' understanding and eventual acceptance of their child's gender condition. Support groups such as the Transgender Network of Parents, Families, and Friends of Lesbians and Gays are also helpful. After a few meetings some parents start to "come around," and their resistance to the child's treatment decreases. Educating siblings and the extended family is an important component to family sessions. Of course, there are always some holdouts within the family who refuse to acknowledge either the FTM's sincere pleas for understanding and acceptance about his gender conviction, or the conclusion of a trained specialist.

SUMMARY

A greater number of female-to-male transsexuals are seeking help in their teen years. The mental health professionals most likely to help these individuals achieve more fulfilling lives are clinicians with experience both in gender assessment and adolescent development. Research indicates that accurate assessment in adolescence can facilitate FTMs transitioning earlier and with less psychological damage. Because of their young age, the support of parents and extended family is crucial to their transitioning; therefore, including parents in this

process is a fundamental part of working with a teen FTM. It is also important for clinicians to gain greater sensitivity with the unique life experiences and needs of adolescent FTMs.

References

American Psychiatric Association Diagnostic and Statistical Manual of Mental Disorders. (1994). 4th ed.

Clements, K., Rani, M., Guzman, R., Ikeda, S., and Katz, M. (1998). Prevalence of HIV Infection in Transgendered Individuals in San Francisco. Abstract presented at the 12th World AIDS Conference, Geneva, Switzerland.

Cohen, L., deRuiter, C., Ringelberg, H., and Cohen-Kettenis, P. (1997). Psychological functioning of adolescent transsexuals: Personality and psychopathology. *Journal of Clinical Psychology* 53(2): 187–196.

Cohen-Kettenis, P., and van Goozen, S. (1997). Sex reassignment of adolescent transsexuals: A follow-up study. *Journal of American Academy of Child and Adolescent Psychiatry* 36(2): 141–146.

Ehrhardt, A., Grisanti, G., and McCauley, E. (1979). Female-to-male transsexuals compared to lesbians: Behavioral patterns of childhood and adolescent development. *Archives of Sexual Behavior* 8(6): 481–490.

Fernald, D., and Fernald, P. (1985). *Basic Psychology.* 5th ed. William C. Brown Publishers.

Gooren, L., and Delemarre-van de Wall, H. (1996). The feasibility of endocrine interventions in juvenile transsexuals. *Journal of Psychology and Human Psychology* 8(4): 69–74.

Hetrick Martin Institute. "Factfile: Lesbian, Gay, and Bisexual Youth" pamphlet.

Israel, G., and Tarver, D. (1997). *Transgender care.* Temple University Press.

J2CP Information Services. "Transsexualism: Information for the Family" pamphlet. 3rd printing. San Juan Capistrano, CA.

Kirk, S. (1996). *Masculinizing hormonal therapy for the transgendered.* Together Lifeworks.

Levine, S. (chairperson), Brown, G., Coleman, E., Cohen-Kettenis, P., Joris Hage, J., Van Maasdam, J., et al. (1998). *The standards of care for gender identity disorders.* 5th version. Symposium Publishing.

Levy-Warren, M. (1996). *The Adolescent Journey.* Jason Aronson Publishers.

Meyer, W., III (chairperson), Bockting, W., Cohen-Kettenis, P., Coleman, E., DiCeglie, D., Devor, H., et al. (2001). *The standards of care for gender identity disorders.* 6th version. Symposium Publishing.

Moir, A., and Jessel, D. (1992). *Brain Sex.* Dell Publishing.

O'Keefe, T., and Fox, K. (1996). *Trans-x-u-all: The naked difference.* Extraordinary People Press.

Schaefer, L., Wheeler, C., and Futterweit, W. (1995). *Gender identity disorders* (transsexualism). In Treatment of Psychiatric Disorders series, 2nd ed. Vol. 2: 2015–2079. American Psychiatric Press.

Transgender Special Outreach Network of Parents, Families, and Friends of Lesbian and Gays (PFLAG). (1998). "Our Trans Children" pamphlet.

Van Kesteren, P., Asscheman, H., Megens, J., and Gooren, L. (1997). Mortality and morbidity in transsexual subjects treated with cross-sex hormones. *Clinical Endocrinology* 47(3): 337–342 (paper 260).

Van Kesteren, P., Gooren, L., and Megens, J. (1996). An epidemiological demographic study of transsexuals in the Netherlands. *Archives of Sexual Behavior* 25(6): 589–600.

Zhou, J., Hofman, M., Gooren, L., and Swaab, D. (1995, November 2). A sex difference in the human brain and its relation to transsexuality. *Nature*: 68–70.

A Conversation With Milton Diamond, Ph.D.

By Dean Kotula

Milton Diamond, Ph.D., is a professor at the John A. Burns School of Medicine at the University of Hawaii at Manoa and director of the Pacific Center for Sex and Society. He is a past president of the International Academy for Sex Research and current president of the Society for the Scientific Study of Sexuality.

Among his accomplishments, Dr. Diamond presented, on PBS, the first full series of 30 television productions on human sexuality; has published or edited eight books; and written more than 125 articles on sexual topics covering species from fish and mice to monkeys and humans. He serves on the editorial board of different journals and consults frequently for various legal firms on sex-related issues. Among the awards he recently received are the Lady Davis Fellowship, the British GIRES (Gender Identity Research and Education Society) Research Prize for gender concerns, and the Magnus Hirschfeld Medal for contributions to sex research from the German Society for Social Scientific Sex Research (DGSS).

DK: When you were a graduate student at the University of Kansas, did something occur which motivated you to have questions about the primacy of nature over nurture?
MD: I don't think there was any single thing. As a graduate student I was studying behavior from both biological and psychological perspectives and was repeatedly considering the factors that influenced behavior. But since I was working in a laboratory that specialized in research on sexual behavior, it was questions within that realm that took most of my attention. Within that lab [of Dr. William C. "Bill" Young] were many researchers working on questions of sexual development, so as a graduate student it was easy for me to slip into sim-

ilar research. I was fortunate that my mentors at the time were, in addition to Bill Young, Bob Goy and Charles Phoenix. The most salient question being studied at the time was "What factors were most crucial in determining adult sexual behaviors, and how did they develop?" In the laboratory the work was mainly with guinea pigs and rats. I was also curious as to those factors in humans that structured sexual behavior. The zeitgeist at the time held that it was rearing that most determined basic sexual behaviors, such as whether individuals would act as males or females and toward which others they would be sexually attracted. It is within that framework that we asked if the factors that determined behavior were more in the upbringing or in the biology with which the individual was born.

DK: I'd like you to talk about intersexuality as it relates to transsexuality and to elaborate on the concept of "brain sex," if you would.

MD: To best answer that question, I think it worthwhile to first define some terms. To put it as simply as possible, a *transsexual* is a male or female individual who thinks he or she is more suited or meant to live as a member of the opposite sex. Thus, a male might believe, *I should really be a woman* or even *I am…trapped in a male body and I should be in a female body.* On the opposite side of the coin, a female would think analogously. These are individuals that see the world as having two basic "flavors," male and female, man or woman. These convictions are strong enough that the individual goes to great efforts to change sex. An *intersexual,* in distinction, has recognized combinations of male and female biological characteristics. Often the person with an intersex condition has genitalia that are ambiguously male or female. An intersexed individual might have the sex chromosomes of a male and the body characteristics of a female or vice versa. Or an intersexed person can have male and female gonads, both a testis and an ovary. Recognizing both male and female features in body, they may also manifest it in their behavioral preferences. Such persons typically don't see male and female as opposites. They can accept with, more or less, ease that they are male and female combinations in body and mind. However, the social situation in which they find themselves will determine how they react to their condition. Some will live and identify socially as men, others as women, and yet others as intersexed individuals. The term, years ago, for an intersexed person would have been a *hermaphrodite.* Some accept this condition with relative ease, while others meet it only with difficulty.

Since the brain is the organ determining or scripting male or female behaviors, the term *brain sex* is shorthand to reflect on how an individual thinks and organizes the world—whether in stereotypical male or female ways. It is certainly true that the brain is the most sexual organ of the body, and the term *brain sex* reflects its male or female disposition. It directs the individual to think and act more like a stereotypic male or more like a female. For transsexuals, since there is little evidence that they have been brought up in anything but typical circumstances and there is no obvious ambiguity in their biology, the question arises: *How do the feelings of being of the opposite sex develop?* The simple answer is: *In the*

brain. Transsexuals have the mind-set of a person of the opposite sex. Since individuals with different intersex conditions must also come to terms with their situations and live in our society as men or women, the analogous question arises: *How do they decide how it is best to live?* Again, the simplistic answer given is: *It is determined by their brain sex.* And of course, this may all be done at an unconscious level. I must add here that this is not without awareness of the person's position in and reaction to society. The brain is integrating the individual's personal history with his or her social, familial, and religious milieu.

Transsexuals make this major change in their lives, often at great sacrifice socially, financially, and otherwise, and without apparent provocation. Transsexuals have no apparent anatomical traits that are of the opposite sex; they have typical genitalia appropriate for their natal sex, but, I think, their brain is somehow predisposed to code for the opposite sex and they are thus by our previous definition, intersexed.

Currently there are only a few pieces of evidence of actual structural differences between male and female brains, and fewer (pieces of evidence) of differences between the brains of transsexuals and intersexuals and others. But this may be because we don't yet know where to look for such differences. The differences are unlikely to be of major size and might even be found in the way that different thought patterns are generated or organized. We might have to look for differences in physiological or biochemical brain processes rather than differences in anatomical structure. For instance, we know that females use both sides of their brains in language processing, while males typically only use the left hemisphere.

The bottom line is that any behavioral differences in how one sees self and others, and how one interprets ways of living in society, must lie within the nervous system. And the organ most involved with such analyses is the brain. Even if it is something about gender that we learn from a figurative blue-room upbringing or a pink-room upbringing, it's got to be encoded differently in the brain somewhere. And we don't as yet know how to recognize such differences. Let me use an analogy: All people are born with a disposition to speak, to communicate with voice. When one learns to speak, there must be a change in their nervous system. If a person learns to speak English rather than Chinese, that too must be encoded in the nervous system. Now, English and Chinese may be encoded in the same place, but each would have a unique code. We could, by extension, say there is a Chinese and an English brain. With the learning of a language there generally is no or little thought given to why we learn Chinese or English. We learn the language of our parents and those around us. The learning of gender is more complicated but is similar in that we learn the gender differences of our parents and those around us. For the transsexual, I think their brain sex tells them the gender they are learning doesn't fit.

DK: Could you elaborate on how one's brain sex factors into the developmental process and the formation of identity?

MD: Sex and gender, and all the things that we learn associated with them, are encoded in our nervous system. This is manifest by a person's predisposition to learn and do certain things and avoid doing other things. Some kids like to play with frilly dolls and other kids avoid them. And with this predisposition comes a somewhat innate feeling of belonging to a social group of either boys or girls. What I think happens is that as kids grow they are keenly aware of differences and similarities. I don't think there is a brain template that simply says *male* or *female, boy* or *girl,* but I do think we have a template that basically says *same* or *different,* and built-in predispositions which encourage and discourage certain behaviors over others. When these predispositions are sex- or gender-related, we could say they are tied to brain sex.

With growth, I believe, the child categorizes his or her interests and proclivities as *same* or *different* in comparison with those around. When the great majority of those with whom the child feels similar in interests and behaviors are boys, that is how he or she comes to identify. When the great majority of those with whom the child feels similar are girls, that is how he or she identifies.

As every child develops, whether he or she will eventually end up as a typical male or female, a transsexual, an intersexual, or whatever, he or she looks around and unconsciously sees "I'm like my playmates" or "I'm different from others that are called by my category." If the person is a male and called and treated as a boy, and he feels he's like the other boys around town or in his family or neighborhood, everything seems fine and he doesn't question his gender situation. But problems develop when he feels he is not like the others or when he feels a greater affinity to those called girls or thinks he is one of them. How strongly and clearly the child feels these differences will determine how he or she reacts. If the boy strongly enough sees himself more as a girl, he can envision himself becoming a girl and woman. If a girl strongly enough sees herself more as a boy, she can envision herself becoming a boy and man. These self-revelations are not necessarily clear-cut or rapid in appearance, nor do they always occur very early in life or in the same way for all transsexuals.

Often there is a period of confusion. The boy might say to himself something like, *Mommy and Daddy call me a boy, and yet I am not at all like any of the others that I know who are called "boy."* While the only other category the child knows is *girl,* the thought runs through his mind that he might be one of those. But that thought can be too great a conceptual leap to be easily accepted. There often is a period of doubt as to how to reconcile these awkward feelings. The boy might imagine he is, if not a boy, than possibly an *it,* an alien, or some sort of a freak. Eventually he might say, since he knows of no other options, that he is a girl or should be a girl. With a child's way of believing in the Tooth Fairy or Santa Claus he might even come to expect he will grow up to be a woman. When the realization develops that such won't happen, the child then begins to seek ways to effect the desired change. Of course, the same sort of situation might hold for a girl. Mary might say to her-

self, *They're calling me "girl," but judging from what I prefer to do and how I prefer to act, I think I'm more like those kids across the street that they're calling "boys." I'm different from all the girls I know.* But Mary doesn't necessarily go running to Mommy with these thoughts. She might even think, *Mommy, I'm not a little girl, I'm really a little boy.* It isn't necessarily put in those words but might be expressed behaviorally.

These gender doubts can last for years, and the individual might live with the discomfort. Eventually, however, they may be resolved by the person saying something like, *Despite my male body, I am a girl and want to live as such.* Or he will live as some sort of in-between person accommodating as best he can. This is not an easy decision or change, but neither is the uncomfortable feeling of not fitting in as "assigned" and reared. With maturity and understanding and awareness of the implications of the terms and recognition of medical-anatomical realities, the male or female might say, *I must effect a transition so that my body matches my mind.* For many persons, while the feeling and desire to switch occurs early in life, they don't effect the change until a major life event comes to pass. A parent might die that they didn't want to offend or disappoint while alive; a marriage and children might have become part of their life in an attempt to adjust to a typical existence; and they didn't want to jeopardize these relationships. A traumatic divorce might trigger the long sought-after change. There are many life conditions that are considered in making such a life-altering change. The individuals that switch gender without any apparent medical basis for their decision are called *transsexuals.* Intersexuals too might switch from the gender in which they were raised, but they do so with more obvious medical conditions associated with their decisions.

DK: It fits. I like the way you're talking about this, because it's not like I was always cognizant of the male/female thing. It took time to really figure it out. I was distressed because I couldn't identify with girls and felt alienated because of that.

MD: I don't know your background, but my guess is that your parents were calling you "girl" and calling you by a girl name, and you were looking around and saying to yourself, *Somehow this doesn't fit.* If you have a brother, you might say, *Hey, I'm more like my brother than I am like my sister.*

DK: Right, I grew up having both sisters and a brother and felt I had much more in common with my brother. I was thought of as a tomboy, and with reservation I accepted that identification because it separated me out from my sisters and gave me more freedom. I felt that I could operate under different parameters. Even so, being called a tomboy gave me a queasy feeling; it didn't really fit, and I learned to resent it. It meant I was acting inappropriate somehow, and I didn't believe I was. Later I took on the label *lesbian,* but that didn't fit either, since I never felt myself to be female. I had to try on all these different things to see what did fit.

MD: That follows. If you're different, you also want to find out if there are any others like you. You wonder, *Who am I the same as?* It's a great revelation when you first find out there

is somebody else who has similar feelings and that you're not the only one in the world like you. That is usually a great day. This also points to the importance of positive role models.

DK: Yes. I first met another FTM 25 years ago, and believe me, it was my moment of truth! Mickey, in your intriguing article "Self-Testing Among Transsexuals: A Check on Sexual Identity" that appeared in the *Journal of Psychology and Human Sexuality* in 1996, you make clear distinctions between the terms *sexual identity* and *gender identity*—whereby gender identity refers to how people see themselves relative to societal expectations and sexual identity is the private, internal feeling of self that says *I am a male* or *I am a female*. These are the definitions and terms I am most familiar with, but I am becoming increasingly aware that these terms are sometimes being used interchangeably, possibly incorrectly, and that the term *gender* is used not only in referring to one's masculinity or femininity but also in referring to morphology, whether someone is male or female. The use of the term *sex* as a noun also seems to be outmoded outside of scientific circles, and the word *gender* appears to have come into favor just as the term *transgender* has been popularized and applied to transsexuals. These inconsistencies further complicate an already complicated issue. Could you help to shed some light on this?

MD: What you are referring to really is a commentary on the fluidity of language and the different ways scientists and laypersons use terms. Several of us in the sexology field have tried to standardize the use of many terms, but others prefer their own usage. I place myself with those that prefer to standardize terms. Basically, I consider *gender* to refer to social and societal contexts and *sex* to refer to medical and biological contexts. For instance, *male* and *female* are biological (sex) terms, while *boy* and *girl* or *man* and *woman* refer to social (gender) terms. It is thus obvious that a male can act like a girl or woman and a female can act like a boy or man. Following from that, as I see things, the distinctions I make between sexual identity and gender identity as concepts are crucial in the understanding of many aspects of transsexuality and intersexuality.

For the typical individual, sexual identity and gender identity are concordant. He or she is viewed in society as a boy or girl, man or woman. That is their gender identity. They also see themselves as biological males or females, respectively. That is their sexual identity. To the typical person there is no conflict between sexual and gender identity, although the terms involved refer to different things. Now consider the transsexual. The transsexual sees how he or she is viewed in society, either as a man or woman, and recognizes that as his or her gender identity. It conforms to the individual's sex as male or female. But the female individual who thinks she should live as a man recognizes *male* as her sexual identity. For her, gender identity and sexual identity are in conflict. To reconcile the differences the transsexual says, *Change my body, not my mind.* Knowing that society interacts with her as a woman because that is the way she looks, and she prefers it to interact with her as a man,

she chooses to have surgery to make the body conform to the mind. A male body type will comfort her feeling of being the male she desires to be and assist the world in treating her as a man, the gender identity she prefers. Her gender identity, how she is viewed by society, will then match her sexual identity.

Some people, it should be clear, use the term *gender* to replace the term *sex* because they are sex phobics. To such persons gender seems "clean" while sex is viewed as "dirty." The term *transgender* was popularized by Virginia Prince in the 1970s to describe people like herself who prefer to live as the opposite gender without undergoing surgery. Typically, the only thing the transgenderist wants to change are features of their gender, not their sex. However, the term has become popular particularly to describe individuals that manifest social and behavioral characteristics and preferences typically associated with both males and females and has become more inclusive. The transgender category now might be used as an inclusive term to describe transsexuals, transvestites, drag queens, so-called gender benders, and others.

It might be useful here to introduce the term *sexual orientation*. This refers to the type of person with whom one wants to have erotic and love relations. Most males are oriented toward females, and most females are oriented toward males. When discussing transsexual and intersexed persons I prefer to use the terms *androphilic* (male-loving) and *gynecophilic* (female-loving) to describe the preferred erotic or love interest. This gets away from the confusion and social taboos when terms like *heterosexual* and *homosexual* are used. For instance, what would be homosexual or heterosexual for an intersexed person who has both male and female biology? And whose view of things should prevail, the transsexual's or the onlooker's, when considering the individual's partner before and after sex-reassignment surgery? *Ambiphilic* (both-loving) would replace the term *bisexual*.

DK: The term *transgender* is often used as an umbrella term meant to include all sexual minorities, but I think there are important distinctions between the various groups that are being glossed over. Transsexuals are attempting to undergo sex reassignment or have done so and want to be medically and legally recognized as their "chosen" sex. Without a medical diagnosis these surgeries would not be performed. The medical term *gender identity disorder* strikes me as a misnomer since one can have a gender identity disorder or some level of gender dysphoria without being transsexual. As you pointed out, there are different elements to one's identity, and if there is nonconformity in any of these aspects, one could be considered to have a gender identity disorder. The term or "condition" could address all sexual minorities. For example: In my case, I consider myself male, always had a masculine identification, and I consider myself heterosexual in that I prefer to have sex with women. I fit the male norm on all accounts except for the fact that my morphology at birth was female. In using the transvestite Virginia Prince as an example, this is someone who would likely be con-

sidered to have a gender identity disorder along with being a transvestite. My point is that there is no longer a medical diagnosis ascribed solely to the transsexual.

MD: Your comment relates to several issues. One issue is how a gender identity disorder, small letters, is viewed as a general term in popular language. Another issue is how Gender Identity Disorder, capital letters, is seen as a medical condition. GID is a constellation of thoughts and behaviors that is still used by the scientific and medical communities to identify and label transsexuals only. One major component of the diagnosis that separates this GID and transsexuals from all the other groups subsumed under the term *transgender* is that only the transsexual feels he or she is rightly a member of the opposite sex and persistently wants surgery and hormones to effect a sex reassignment. And while drag queens, transvestites, and others might have some aspects of gender confusion or dis-ease or dis-order, they don't fit the medical definition of GID. One problem you may be reacting to is that the word *disorder* has negative connotations. In the medical definition the term reflects the psychological distress which the transsexual usually shows.

Certainly transvestites and others can have some gender conflicts and disputes with society's strictures, but their condition usually doesn't reach the level of intensity seen among transsexuals. They also don't need the medical community's assistance in affecting their life roles and behaviors.

Lastly, we must admit that the general public and many persons from different disciplines interchange the terms *sex* and *gender* without any concern for a precise definition of each term.

DK: Could you please discuss the issue of passing? I think that in some instances it is cruel to expect someone to live as the opposite sex for one year prior to going on hormones. This is particularly true if the person can't easily pass when cross-dressed. I understand the need for safeguards, but there are many individuals who aren't fortunate enough to start out with the physical features of their self-proclaimed sex or even have an androgynous presentation. Such persons are subjected to endless ridicule. By the time a person approaches a professional, he or she has done years of soul searching to finally come to the decision to transition. Waiting yet another year is still no guarantee that the decision will be the right one. I can better understand that there be a rigid criteria set up for surgeries. I believe that as transsexualism is better understood, more accepted, and as more professionals are trained and qualified to evaluate whether or not someone is truly transsexual and are able to separate them out from persons who are either psychotic or delusional, we will find that some of the current obstacles to transitioning will be removed.

MD: Your concerns are well-understood and a frequent topic of discussion among professionals that try to adhere to the standards of care proposed by the Harry Benjamin

International Gender Dysphoria Association (HBIGDA). As you know, this professional society, named for the physician who first extensively studied transsexuality, recommends a standard of care for transsexuals which includes a "real-life test." This test requires living for up to two years in the gender to which the individual wishes to transition. The problem is how to protect the individual and the professional in this interaction and decision-making process. First off, these recommendations are not written in stone, so different therapists interpret them differently, and some are more permissive than others. Thus, in actuality, a therapist might be more liberal with one who can not pass easily and might consider hormones early on. Also, as you well know, there is a great difference between a male wishing he were living as a woman, or a female wishing she were living as a man, than actually living the life. The real-life test allows the individual to try the life out before too many irreversible changes occur. The administration of hormones can induce changes which would be difficult to reverse, so they are frequently given after the individual has at least some real-life experience and feels comfortable in the chosen gender. There are also instances where hormones are given early on or even before the switch just to ease the transition and passing.

But I do think caution is warranted and would not feel comfortable if all the safeguards of the standards of care were removed. Yes, doing away with them would make it easier to transition, but that is not always a good thing. I've probably seen several hundred transsexuals who have satisfactorily made the change. And they are no doubt happier and more satisfied with their lives now than they were before the sex reassignment. However, I've also seen two that were very unhappy. And they couldn't easily go back to living as they had been. These two both had money enough to be able to bypass all the rigmarole of evaluation, counseling, and the real-life test. One went to Casablanca and the other to Mexico. They paid their money, got the hormones and surgeries they wanted, and too late found out that their lives hadn't changed as they had hoped. They are two very unhappy campers. I have to admit, these are only two out of several hundred, but I think it offers a warning not to bypass the test and evaluation.

DK: That is certainly a low percentage. They may have forgone an evaluation knowing they wouldn't fit the criteria set in place. Their regret may also have been due to poor surgical results. At any rate, with such an important life decision I think it is extremely important to confer with professional counsel. Numerous studies have been conducted to determine who are the best candidates for sex-reassignment surgery. Those that were least satisfied were typically those who transitioned late in life. The reasons for delaying the process, as you mentioned earlier, are varied. Some people simply didn't know how to proceed, the information wasn't available to them, or they couldn't locate professionals in their area who were familiar with the condition. Others had doubts, yet their lives weren't interrupted by debilitating feelings of unease about their bodies until they were well into adulthood. Their choices were affected by their feelings of unease,

yet they went on to establish careers, raise families, and so on, as opposed to the transsexual whose early survival hinged on transition.

In your article "Self-Testing Among Transsexuals: A Check on Sexual Identity," you offer some keen observations that begin to explain behaviors that are atypical to the transsexual population as a whole. Your paper documents "a phenomenon which more than a few transsexuals undergo in trying to reconcile their disparity of sexual and gender identities. These are the behaviors of persons who, for an extended duration, overindulge in rather than shun behaviors typical of their birth sex. I label this a process of *self-testing.*" You go on to describe transsexuals who are self-tested and those who are not: "With *convinced transsexuals,* repeated normal encounters with living, from early on, seem an affirmation that they are of the other sex. Failure in gender-stereotypic behaviors, being accepted or rejected without fanfare or concern by non-transsexuals, is cause for internal reification by *convinced transsexuals* that they are 'in the body of the wrong sex.' They do not need nor seek any *self-test;* their *living-test* convinces them early on. *Unconvinced transsexuals,* while also harboring doubts from early on, nevertheless continue to question this disparity between inner and outer sex and eventually only decide they are transsexuals after a period of direct and usually prolonged arduous self-examination. This process is often quite deliberate. It may, however, become apparent only in retrospect. Individuals of this second group of transsexuals are *self-tested transsexuals.*" Later in the article you cite specific case examples of self-tested transsexuals: a female-to-male transsexual who, by all outward appearances, was living successfully as a woman. You say, "Although eminently successful and reinforced as a professional stripper and domestic wife and mother, B.B. felt, nevertheless, she had to live her life as a man. Her inner voice was stronger than any external reinforcement. Her self-test convinced her that although she could easily pass any test of female (social) gender identity, she could not pass her own self-test of internal sexual identity." B.B. first felt herself strongly to be male at age 7, but it wasn't until much later that "she" transitioned to male. I was particularly struck by this example, since I myself never lived any part of my life in the female role, nor do I personally know of any FTMs with the experience you describe, although I do know of FTMs who married and bore children. In effect, you are pointing out examples of transsexuals who have compensated in a very dramatic way for the feelings they had early on with hyper-feminine or hypermasculine (in the case of male-to-female transsexuals) behavior. I have seen this phenomenon in practice, on more than one occasion, in the case of male-to-female transsexuals. These categorical differences between transsexuals were recognized early on, and transsexuals were either classed as *primary* or *secondary* transsexuals. Your paper is the first I have read addressing this issue and not only do you

address it, you explain how it works and offer explanations. I am curious about the two transsexuals you mentioned earlier who came to regret having had sex-reassignment surgery. Were either of these individuals self-tested transsexuals?

MD: It is not clear. It might have been so with the first one. She had been in the Marines, came out of the military service with a satisfactory record, and decided that while he could make their standards for masculinity, he felt he would be happier as a she. He had the money and family connections to get the surgery and went and did it. She is now quite unhappy about it. The second individual also had money and apparently just went and had it done. I have to be somewhat vague about these two, since I saw them when they came to me after all was said and done and wanted to know how to go back. They wanted from me a simple solution as they had sought for their original gender conflicts. When I couldn't offer them one, they left.

But there are people who make every type of decision—there are female-to-males who only have a hysterectomy and their breasts removed and don't have penile construction, for example, and they are happy. Others want the penis constructed. Some male-to-females have their penis and testicles removed, most all have extensive depilation, and some go on to have their Adam's apple shaved or jaw reconstructed. Each one makes a decision for him or herself as to how much surgery he or she wants or can afford. Virginia Prince, the well-known transvestite, is convinced that many—I don't believe this, by the way—transsexuals would be happy if they were simply allowed to live in their chosen sex without changing their genitals. She believes this because she's done it herself. On the other hand, I've heard some surgeons say that some of their TS patients never seem to be satisfied and always want more surgery.

DK: So, Virginia Prince is basically projecting her own experience onto everyone else.

MD: Exactly. It's like, "Hey, I did it, why can't you do it?" By the way, I think that many homosexuals have some similar thoughts. They think of transsexuals: *If you want to sleep with someone of the same sex, just do it. You don't have to be a transsexual to achieve your goal.* Of course, not all transsexuals are oriented toward those of their original sex.

DK: While I accept that there are varying levels of discomfort one may have with their body's sex, I think it is also important to look at why many individuals who define themselves as FTM choose not to have surgery. If pushed for an explanation, a vast majority of FTMs say they would have genital surgery performed if they could be guaranteed a positive outcome, an aesthetically pleasing and sensate penis from which they could urinate and perform sexual intercourse. Aside from the enormous costs and risks involved, the likelihood of having all of these objectives met is extremely rare.

MD: Yes, all these aspects need to be looked at, and there is a lot of variety among the pop-

ulation of transsexuals. But, in comparison, it should be said that most MTFs want a vagina constructed even if it doesn't work well.

DK: In recognizing this range of diversity, would you suggest that the criteria set for sex-reassignment surgery be restated or reconsidered to include a broader range of people requesting surgery whose experience may not fit the current requirements?

MD: I'm not sure of your question. I think that people ought to be allowed to live however they want. If they want to live with chickens, I think they ought to live with chickens. If someone wants to wear green hair, I think that is OK too. So, that's one thing. Now the law is generally not that liberal, nor is society. The law wants most things to go in very neat lines. For example, in Hawaii the legislature is discussing the issue of whether we should allow individuals of the same sex to marry. They don't even want to think about what considering transsexuals might mean in this because then they might have to consider people that are same-sex married already. In regard to new looser criteria for allowing sex-reassignment surgery, all I can say is that the standards or requirements for such are always under review. And there are post-op transsexuals on the HBIGDA review committee. Until we have more information and know better, I think it is appropriate to follow their guidelines.

DK: Of course. I know a number of transsexuals who, once their appearance changed solely from the use of hormones, managed to get the sex designation on their driver's license changed simply by saying a mistake was made. As I see it, the true deception was the original designation, the assigned sex at birth. What would your perception be about these rigid legal distinctions and the motivation behind it?

MD: I think some of the gender distinctions have value and others not. Most of the motivation behind the legal distinctions goes back to our religious and cultural values. In Judaism, Christianity, Islam, and in other religions and in secular culture as well, people are very concerned with male/female difference. This background sets the stage for seeing the male have very different functions in the religious world and in society than does the female. With these beliefs come certain privileges and certain restrictions and responsibilities associated with the different genders. The distinctions also facilitate matters of expectation; stereotypes are sometimes helpful but, admittedly, they can be detrimental. I see many benefits where our gender and sexual expectations are much less rigid.

DK: I can certainly believe that. That brings something interesting to mind. In my experience and in the experience of others advocating for transsexual rights, I've learned that some of our strongest supporters, ironically, are right-wing fundamentalist Christians. They seem to be more sympathetic with our goals than a lot of leftist politicians. I believe this is because they find homosexuality so abhorrent and they see transsexuality as the perfect solution to eradicating the behavior. If gays and lesbians would just have sex changes, there would be no more same-sex relationships. You know [*laughter*], when it works for us, why not, but...

MD: You're just telling me your political agenda, that's all. But I wouldn't put too much stock in right-wing religious support for transsexuals.

DK: [*Laughter*] Yeah. Right. Obviously, I would never support antigay legislation or anything of the sort. I do find it laughable that the conservatives believe they've found a purpose for us. The thing they don't seem to realize is that not all transsexuals are heterosexual.

MD: Right. You know, another interesting thing that comes to mind when I think of religious fundamentalists is that many early artists depicted Adam and Eve as hermaphroditic. In some early paintings both Adam and Eve were depicted with both a vaginal cleft and a penis. This comes from the Bible. In Genesis it speaks of God creating the first human with words something like "male and female created he them."

DK: That's very true. Mickey, I'd like to introduce the reader to the John/Joan case because of its significance to the topic of transsexuality and because of your involvement in bringing to bear the true findings in this aspect of John Money's research. This case serves as an excellent example to confirm the hypothesis of nature over nurture; that we know what sex we are at an early age, and any amount of social conditioning won't deter us from our innate conviction. Would you please describe and elaborate on this case?

MD: The John/Joan case was the unfortunate story of a set of normal identical male twins. They developed a penile condition called phimosis, which is a closing of the foreskin, so it becomes difficult to project the head of the penis. It can make it difficult to urinate, and the closed foreskin can accumulate dirt and gunk. To correct this condition the boys were sent for circumcision. Instead of the circumcision being done with a knife and bell clamp as is typically done, it was done with a cautery, a device that basically uses a hot wire to cut. Surgeons often like to use such an instrument in surgery because the heat also closes off any cut blood vessels. In any case, there was an accident and the penis of the first twin was burnt off. For privacy's sake, in our publication we called him John when living as a boy and Joan when living as a girl. The parents anguished about the decision of "What to do now with John?" What could be done for a boy without a penis? The local physicians they consulted recommended he later have cosmetic surgery to fashion a penis. However, they saw Dr. John Money on television telling how a male (transsexual) can have surgery to live as a contented female. He was then consulted. His solution—with the basic idea that males and females were psychosexually neutral at birth, and any male without a penis would be better off living as a girl and then as a woman—led him to recommend that the child be given appropriate sex-reassignment surgery and raised as a girl.

The parents followed Dr. Money's advice. This sex reassignment included removal of the child's testicles and scrotum, and preparing him to have a vagina. The parents did the best they could to raise the child as a girl we called Joan. As the child grew up, however, Joan

began to look around and say, "Well, they're calling me 'girl,' yet I'm more like my brother than I am like the girls around here. My parents are calling me 'girl' and I have a girl's name, but I'm not like any girl I know. I think more like a boy and prefer to do boy things." But there was a long transition stage before Joan would come to refuse to live any longer as a girl. First off, not only did Joan realize something was amiss, so did her schoolmates. They teased her for the incongruities between her male-like behaviors and her female dress and appearance. They called her Gorilla, since they saw the male in her behavior and demeanor. Finally, despite the absence of typical male genitalia and the administration of female hormones to induce breast growth and feminine hips and fat deposits, Joan decided she could no longer live as a girl. She had to live as a boy. After the switch she was called John instead of Joan. After the switch, Joan was eventually received better as John than as the girl she had been led to believe she was.

With psychiatric help and hormone therapy in addition to the surgical removal of his breasts and the construction of a penis, John developed into a mature man, married in his 20s, and adopted his wife's children. He now lives as a self-respecting husband and father.

DK: Was John Money following up on these twins the entire time?

MD: As far as I know, he was aware of how the twins were developing.

DK: OK, and during this time he was writing all these reports saying that his theories were correct and the outcome was what he expected?

MD: That appears to be so.

DK: So you're the one that's responsible for following up on the reports and finding out what actually happened to John; you along with Dr. Sigmundson?

MD: Correct.

DK: You're quoted in this article from the *Journal of Sex and Marital Therapy*: "Zucker and I agree that the significance of the original twin reports has been overplayed. This is certainly true for the credit the twins' story of female conversion received as supposed proof of the power of a gender conditioning. The actual failure of this sex reassignment has not been as widely recognized. Possibly, since it was not a surprise, nor as noteworthy or as newsworthy or not a 'politically correct' finding." I understand that there is a lot of resistance against this type of research given current politics. Certainly feminists are opposed to the idea of identifying biological determinants that rule behavior and illuminate the differences between men and women since they attribute social conditioning as the cause of sexism and use the concept of nurturing as their platform to discuss it. There are also a lot of sex-reassignment surgeries still being performed on intersexed infants without their consent. Could you address how politics affect or enter into research?

MD: I think you are addressing several separate things. Intersexed infants with ambiguous genitalia are often given cosmetic surgery because the physicians and or their parents think

this is better for them. If you think this is in response to the politics of gender that every-one has to be clearly male or female, I guess your comment fits. I think, however, this treat-ment is wrong on ethical grounds and because there is to date no published evidence that it is either necessary or warranted.

But you are certainly correct in referring to the politics of gender when it comes to many feminists. It definitely helps the feminist cause politically to argue that the only difference between men and women is how they were raised, and if only child rearing practices were equal, the differences between the sexes would disappear. Certainly we want a level play-ing field to offer equal opportunities to both men and women. But we have to recognize that often men and women come to the field with different abilities that are linked to their sex or gender. And sometimes recognizing these differences is actually helpful. If it is a disad-vantage to be short, society can offer a ladder or stool. By the way, I consider myself a fem-inist, if we use that term to mean somebody who wants equal opportunities for men and women.

A last thought is that getting funding for sex or gender research is often handicapped by political considerations.

DK: I certainly ascribe to general feminist principles as well. At the same time, when I'm looked at as a traitor to the female sex, or when feminists attempt to subvert research that might better explain the existence of transsexuals—why I feel the way I do—I've got to object. Transsexuals simply don't suit feminist objectives; they see our existence strictly as a social phenomenon.

MD: Yes. They're saying as transvestites or some lesbians might say: "Hey, look, I solved my problem my way, you ought to solve your problem the same way I solved it." Some feminists would think by transitioning you are joining the enemy rather than fighting for your right to be a masculine female.

DK: Absolutely.

MD: You may know that several years ago there was a feminist music festival in Michigan that some transsexuals wanted to attend. Many feminists got up in arms. They said, "Hey, these are cheats, they're phonies, we don't want 'em." That, to me, is crazy.

DK: You know, I was at that music festival as a lesbian when the first male-to-female transsexual showed up. I think I was in agreement with the lesbians. It just goes to show how I resisted being transsexual! I hope I'm making amends for it now.
[Laughter]

MD: You ought to write a piece on how your views of the world changed from when you considered yourself a lesbian to now, when you consider yourself a transsexual.

DK: I intend to; reflecting how one's perspective changes in accord with various stages of personal realization is not only interesting to think about but an area I always find interesting to read about. When I first read about the John/Joan case in John

Colapinto's [1997] *Rolling Stone* article, I was stunned and moved to tears. At the same time, the story was full of hope at the conclusion when John reclaimed his true identity. The story reads like a major event when you finally came in contact with Doctor Sigmundson and intervened in the situation. It's a very dramatic example of what ignorance or even innocence can do in relation to the alteration of an anomalous or unexpected identity. It also points out to me the importance of a case study like that.

I have to ask, notwithstanding your own research, what would you consider the most significant dimensions of related research today?

MD: Many different people are looking at different things. But I have to mention that there is little money for sex identity research, so all such work is often difficult and from funds allotted for other things or financed out-of-pocket, as much of mine is. Nevertheless, there has begun to be a good deal of research into different intersex conditions both here and overseas. For instance, I think work at Johns Hopkins University by Dr. William Reiner and in London at the Great Ormond Street Hospital by Mr. Philip Ransley on children born with a condition called cloacal exstrophy will be very informative. Here are male children born essentially without any genitals, but they do have testes. They are typically castrated and raised as girls and given female hormones to induce a female-like puberty. The question is, "How will they identify as they get older?" Several of these children already have expressed themselves to be boys. Work is progressing by following up cases of intersexed individuals that have had surgery to find out how they have adapted. Did they remain in the gender to which they had been assigned, or did they switch to another gender? These studies should shed light on identity development.

Among transsexuals, research is developing from large populations, and we should soon have good data on the long-term satisfaction and functioning of postoperative FTMs and MTFs. Much of this comes from Charing Cross Hospital in London and the work of Dr. Richard Green.

Work, particularly among Dutch investigators Drs. D. F. Swaab and Louis Gooren and collaborators Frank Kruijver and Jiang-ning Zhou, is looking at the brains of transsexuals in an attempt to document additional clues as to which areas of the brain might be associated with sexual identity development. Dr. Peggy Cohen-Kettenis, also from the Netherlands, is doing some interesting work with very young and adolescent transsexuals, which I think will be revealing. And the work at the Clarke Institute of Psychiatry in Canada with Drs. Ken Zucker and Ray Blanchard is also exciting. I myself am trying to finish a long-term study of people with a condition called the androgen insensitivity syndrome. These are individuals who have XY chromosomes and have varying degrees of refractoriness to testosterone. Most appear as females, are reared as females, and live as females. Others are reared as males and live accordingly. Surprisingly, many of these persons switch from their gender of rearing to

the opposite gender. We are trying to understand how and why those that remain do so, and we are trying to understand how and why those that change do so. How do they reconcile their gender and sexual identities?

DK: An important aspect of research is that the methodologies recognize differences appropriate to the particular question asked. And that the results might vary according to the research techniques used.

MD: Exactly. And here too, the law sometimes comes into play. We certainly must ensure that studies are done with the welfare of the subjects in mind, and we are sometimes limited in what we can ask or require of the research subjects.

DK: Right. Does research show any major differences between MTFs and FTMs?

MD: Well, the most obvious finding is that the large majority of transsexuals seem to be male-to-female types. And among them, about half are androphilic and half gynecophilic. Among the female-to-male transsexuals, most seem to be gynecophilic. That's just two basic group differences. There are also often other differences in what each group expects from the transformation.

DK: Yes, there is still a lot to be understood. In your self-testing paper you offer a lot of promise when you say, "The details of this process of sexual identity formation are still to be elucidated. Nevertheless, it seems fairly certain that this inner voice can develop without external reinforcement and social approval for the desired sex and with ample reinforcement in the non-desired sex. And it can occur in the face of a socially adverse future, yet provide an inner personal calm more important than any external rewards." This statement and the concluding statements in the article seem to suggest that, particularly in reference to the intersexed person but also as it applies to the transsexual, there needs to be a period of time and other ameliorative efforts made that might well determine whether surgical intervention is necessary. You offer hope that there will be an audience to listen to these inner voices. The opportunity to publish this book with people making very strong personal testaments about their identity, about their travails, and even selectivity, speaking from a multiplicity of perspectives, also lends hope that someone may listen to this—as an individual problem and not just something that's legalistic or [concerns] whether an HMO or insurance company is going to approve an operation.

MD: I fully agree with that. People have to realize that these changes are not done easily or without a great deal of thought and, often, anguish. When people talk about a religious conversion—going, say, from Catholicism to Judaism or whatever—they think of the mental workings that occur. I think going from female to male, or male to female, is a much bigger conversion and requires much more psychic effort.

DK: True, probably the most manifest imaginable. Let me ask this: You mentioned research dollars; if someone wanted to donate money for sex research, what institu-

tions would you suggest they contact, and how can they designate that money go specifically into a particular area of interest?

MD: If they want it to go to gender research or sexual identity research, there are a few specific organizations to which one can donate. The Harry Benjamin International Gender Dysphoria Association, for instance, is interested specifically in supporting research on transsexualism. In the United Kingdom there is the GIRES (Gender Information, Research, and Education Society), which sponsors research on transsexualism and intersex conditions. Some organizations are slanted more toward political activity and education rather than research. The Intersex Society of North America is one such organization. There is also an organization that I head at the University of Hawaii called the Pacific Center for Sex and Society (PCSS). People can send money to the University of Hawaii Research Foundation for use by PCSS and I'd be happy to put it toward identity and gender research. All contributions are tax-deductible, by the way. Another way is for individuals to select researchers they admire and support their research via their host institutions. That way the money is accounted for and everyone gets a tax break.

DK: Great. Why do you suppose the National Institutes of Health has done so little to address these issues?

MD: Candidly, I really don't know how much they have or have not addressed. But often sex-related issues are a problem for government agencies to deal with. They're going to say, "Look, we need money for AIDS research, or breast cancer and prostate cancer research, and identity research has a lower priority." Or, on the other hand, they can say, "We are supporting research in sex. Just look at our efforts in AIDS, breast and prostate cancer, and so forth." When you talk to NIH about something like sexual identity, they think they're dealing with a much smaller need and the issue is less politically viable.

DK: I'd like to switch gears and talk about the article in the November 1995 issue of *Nature*, titled "Sex Difference in the Human Brain and its Relation to Transsexuality." The article talks about an area of the brain known as the bed nucleus in the stria terminalis (BSTc). Referring to an illustration in the article, it says, "Here we show that the volume of the central subdivision of the bed nucleus in the stria terminalis, the BSTc, a brain area that is essential for sexual behavior, is larger in men than in women. A female size BSTc was found in male-to-female transsexuals." It says, "This supports the hypothesis that gender identity develops as a result of an interaction between the developing brain and sex hormones." Afterward, the article goes on to say, "This led to the hypothesis that sexual differentiation of the brain might not have followed the line of sexual differentiation of the body as a whole." Sexual orientation was ruled out as a factor affecting the size of the BSTc with further studies on both heterosexual and homosexual men, and "in addition, there is no difference in BSTc size between early-

onset and late-onset transsexuals, indicating that the decreased size is related to the gender identity alteration per se rather than to the age at which it becomes apparent. The use of feminizing hormones was also ruled out as the cause." So, what they are saying here is that the size of the BSTc in male-to-female transsexuals, an area of the brain responsible for sexual behaviors, corresponds with that of biological females. As these postmortem studies were done only on male-to-female transsexuals, would it be supposition to suggest that the BSTc size of female-to-male transsexuals resembles that of biological males?

MD: Yes, that would be the supposition. Research data on FTMs would be needed to substantiate the thesis.

DK: Your own research seems to follow along the lines of what is contained in the article.

MD: In many ways, yes. We know, for example, in many of the intersex people with whom we have worked, that what happens to their genitals is different than what seems to have happened in their brains. Keep in mind, we have not done any actual anatomical studies of the brain. But we attempt to evaluate brain differences by people's thinking processes and behavior patterns. Some years ago, in monkeys, Drs. Robert Goy, Fred Bercovitch, and Mary McBrair showed that they could induce changes in the genitals that were not followed by brain (behavioral) changes, and vice versa—they could induce behavioral changes in the brain that were not followed by changes in the genitals. The brain and the genitals can be differentiated and develop independently.

DK: That sounds quite conclusive, with some very interesting ramifications.

MD: Well, it's conclusive for monkeys. And I happen to think, with this matter, that we can extrapolate from monkeys to humans. There are others that still have to be convinced.

DK: So, there are still to come a few surprises in brain and identity development research.

MD: Absolutely. I'm sure there are interesting results yet to be gotten. As we started this discussion, I said that people like to find anatomical differences between male and female brains—they're easier to see and understand than thinking differences. The biggest differences may not be in big structures, like an interstitial nucleus, or a BSTc. It may be in the dendrites, or the connections the nerves make. It may be in brain biochemistry. I'm reminded of a joke. A guy sees his friend looking under a lamppost, and the conversation goes something like this:

"What are you doing?"
"I'm looking for the watch I lost."
"Where'd you lose it?"

"I lost it down the street."
"Well, why are you looking here?"
"There's better light here."
[*Laughter*]

MD: That's what happens—we look for big things where the light is better. But the crucial answers we are looking for may require techniques not yet available or understood. We may have to look at some different hormone combinations, we may have to look at some bio-chemical reactions, some genetic thing that we don't know yet. We're just beginning to peel back the layers of the onion, as it were. And each time we come to a mole on the onion we say, "Hey, look at this mole." Well, it may just be a mole; we still have to get down to the core of the onion and understand the contribution of all its layers. I do believe there are dif-ferences yet to be discovered in the hypothalamus and in the stria terminalis, and in basal ganglia, in the amygdala in the forebrain and the cortex. Unfortunately, we don't yet know how to measure them. When we first came up with X-rays or holograms, people began to use those as images and analogies for how the brain works; now people make analogies between the brain and the computer. We might even have to find new ways to conceptual-ize these complicated workings of the brain. We're still learning…. We know a lot about the brain, but we're also ignorant of many things about it.

DK: Again, I'd like to ask: Do you know of any research currently being conducted around the issue of sexual identity?

MD: Well, I mentioned several studies before. Other studies that come to mind are those of Dr. Dean Hamer, who is studying the gene structure, trying to map out areas of the genes that may be associated with sexual orientation, heterosexuality and homosexuality. This is a question associated with transsexuality as it is with non-transsexuals. Other studies that should probably be mentioned are the works of Drs. Simon LeVay, Roger Gorski, Mark Breedlove, and others. Much of the crucial work is also coming from the studies of inter-sexed individuals. Here we have people that, due to endocrine or genetic or other develop-mental situations, allow a peek into how behavior patterns, sexual orientation, and sexual identity might come together. In addition to those I've mentioned before, the work of Drs. Julianne Imperato-McGinley, Ariel Rosler, Ronny Schtarkshall, Melvin Grumbach, Justine Schober, and Heino Meyer-Bahlburg is important. I think that there are many projects going on. Most of this work doesn't have a direct commercial value and so doesn't get as strong a measure of support as does something like Viagra. The ethical, scientific, and social issues, however, are very important.

DK: Right. I'd like to think lives are viable enough and valuable enough without an economic inducement.

Let me ask you to respond to a question that I imagine one of our readers might

ask. We've been discussing the biological implications of transsexuality: Do you think there are individuals—transsexuals, if you will—who have simply chosen to change their sex for social reasons or any reason not linked to biology?

MD: That's not an unusual question, and it's a good one. I guess anything is possible, but, no, I don't think an individual would go through sex-reassignment surgery and switch gender just for social reasons unless the stakes were extremely high. And offhand I can not imagine how high that might have to be. Certainly, a male might think, if he were homosexually oriented, that it could be easier to attract a male if he were attired or built like a woman, but he would have to be willing to accept all the other things that go with being a woman and that go with transitioning—he must accept the surgery, the stigma, and other social and medical features of transsexualism. And the real-life test should convince him that the anticipated benefits did not come about. Also, the typical male homosexual or lesbian appreciates his or her genitals and doesn't want to give them up. I don't think anyone wakes up in the morning and decides they're going to be a transsexual just to attract a certain type partner or live a certain lifestyle. Individuals, I believe, change their gender to have it conform to their brain sex. Making the decision to live the life of a transsexual is not a flippant decision.

DK: Mickey, in a recent series of programs called "Brain Sex," aired on the *Discovery Channel*, they talked about the research you mentioned with monkeys and the parallel with humans. It is very intriguing that this is getting into the mainstream. It doesn't mean that the general population is suddenly turning on the *Discovery Channel*, but I think it's an important indicator that some of these issues will become more conscious among the larger populace. I am also impressed with a book by Gary Kelly called *Sexuality Today: The Human Perspective*, which is being used as a college textbook. These contributions are obviously dependent on the serious efforts of researchers, and I would like to personally thank you for the brilliant work you've done and are continuing to do. As a transsexual, I wish to extend my gratitude, as I believe we are in your debt.

MD: Thank you for those kind words.

REFERENCES

Colapinto, J. (2000). *As nature made him: The boy who was raised as a girl.* HarperCollins.

Diamond, M. (1982). Sexual identity, monozygotic twins reared in discordant sex roles and a BBC follow-up. *Archives of Sexual Behavior* 11(2): 181–185.

Diamond, M. (1995). Biological aspects of sexual orientation and identity. In *The Psychology of Sexual Orientation, Behavior, and Identity: A Handbook,* edited by L. Diamant and R. McAnulty, pp. 45–80. Greenwood Press.

Diamond, M. (1996). Response: Considerations for sex assignment. *Journal of Sex and Marital Therapy* 22(3): 161–174.

Diamond, M. (1996). Self-testing among transsexuals: A check on sexual identity. *Journal of Psychology and Human Sexuality* 8(3): 61–82.

Diamond, M., Binstock, T., and Kohl, J. (1996). From fertilization to adult sexual behavior. *Hormones and Behavior* 30(4): 333–353.

Diamond, M. (1997). Self-testing: A check on sexual identity and other levels of sexuality. In *Gender Blending*, edited by B. Bullough, V. L. Bullough, and J. Elias, 103–125. Prometheus Press.

Diamond, M., and Sigmundson, H. (1997). Sex reassignment at birth: Long-term review and clinical implications. *Archives of Pediatrics and Adolescent Medicine* 151: 298–304.

Kelly, G. Chap. 12 in *Sexuality today: The human perspective.* 4th ed. The Dushkin Publishing Group.

Zhou, J., Hofman, M., Gooren, L., and Swaab, D. A sex difference in the human brain and its relation to transsexuality. *Nature* (November 2, 1995): 68–70.

For support of Dr. Diamond's research, thanks are due to the Eugene Garfield Foundation of Philadelphia, Pennsylvania and the Sabra Stiehl Foundation of Atlanta, Georgia.

Part Two
The Men
Post-Transition Photographs by Dean Kotula

Ken

One very simple molecule—three carbon rings with a few oxygen and hydrogen atoms branching off to the side—changed how I feel about myself and how the world relates to me. The power of testosterone continually astounds me.

A year before this photograph was taken, the world saw me as female, no matter how I dressed or acted. I realize that this is not true for all female-to-male transsexuals prior to transition. Some are blessed with more male-appearing bodies to begin with and higher testosterone levels than is typical for females. Some have deep voices or can grow facial hair long before their first injection. I was not so lucky. Although my mind felt male, my body and voice were stereotypically feminine. It was painfully obvious to me that my appearance alone caused people to ignore or disregard most of the masculine tendencies I possessed.

I have come to the conclusion that this was not through malice or institutionalized sexism. People are animals like any other, and they respond instinctively to certain visual, auditory, and olfactory cues. What brought this point home to me was the reaction of my horse, and other animals, to me once I had started taking testosterone. Male dogs would no longer hump my leg, while female cats began to solicit my attention in an unmistakably seductive fashion.

My horse had known me for over a year as female. It had been a difficult relationship. Gelded late in life, he had retained a "studdy" attitude and considered himself dominant over every other horse at the stable. Although he was pleasant and friendly when I wasn't asking him to work, he had trouble accepting my authority. In retrospect, I think he was con-

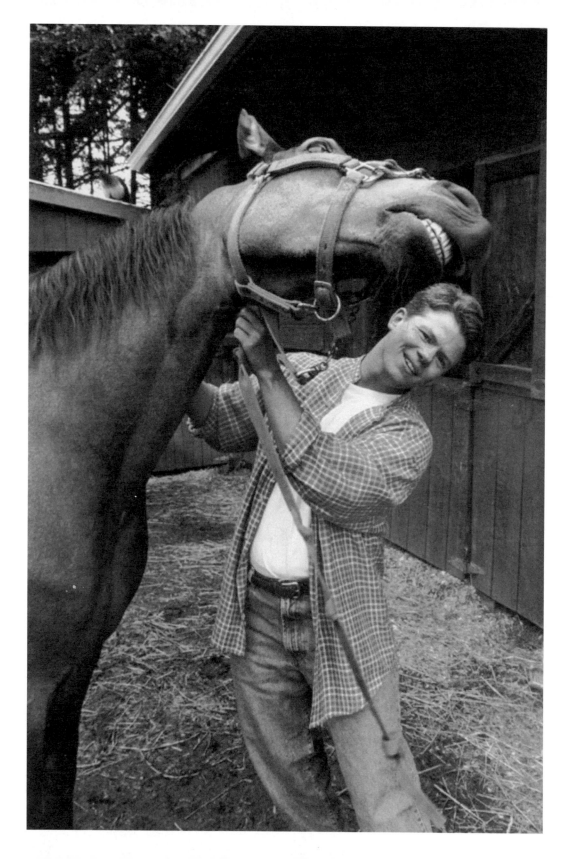

fused by someone that smelled like a "mare" acting like a male. The conflicting signals made him uncomfortable.

About two weeks after I started on "T," the horse noticed that something had changed. He sniffed me intently, with the same abstracted look that horses have when inspecting a stranger's dung pile. "As if he were trying to solve the problems of the world," one friend joked. After a few days the intense scrutiny stopped, but I sensed a gradual change in his attitude. He seemed to relax. Over time, he came to view me as a "buddy" that was one small rung above him on the social ladder. For such a dominant animal, this was saying something.

I think these anecdotes have direct relevance to the question of why transsexuals choose to take hormones, to alter their bodies. Humans, whether they be heterosexual or homosexual, instinctively respond to "male" and "female" bodies and odors differently—just as other mammals do. I believe those who argue that gender is merely a social construct, and that in a more enlightened society people would not care what sex their partners were, are ignoring biological reality. And those who attempt to discourage transsexuals from hormones and surgery do us a terrible disservice. Transsexuals cannot reasonably expect others to accept us as male or female simply because that's what we say we are.

Nature has devised a relatively simple set of cues by which humans distinguish male and female, and a simple mechanism by which those distinguishing traits develop from the same basic pattern. By introducing one simple chemical into my body, I developed all the traits necessary for humans—and other animals—to see me as male (specifically, a deeper voice, facial hair, and a distinctively male aroma). Without hormone injections, and without enough natural testosterone to induce these crucial traits, my efforts to be perceived as male were doomed to failure.

Before I began taking testosterone, I always wanted to be accepted as "one of the guys." As a child, this wasn't too difficult. Despite being forced to wear a dress to school, my brother and other boys accepted me as a playmate and equal (the girls, however, teased me mercilessly). But after puberty I had difficulty integrating socially and invariably felt set apart, outcast. Now, although my behavior has changed little, people are far more accepting of me. The same behavior that people once labeled "brusque," "distant," or "superior" is now interpreted as "direct" and "assertive." More often, and perhaps most tellingly, my behavior now goes unnoticed entirely. I often wonder: If my conflicting signals made my horse uncomfortable, who is to say that humans were not reacting the same way?

I am not talking here about whether I preferred cooking to cars or other culturally determined aspects of gender roles. I am referring to nuances far more subtle and subconscious. For instance, I often participated in that quintessential male game of one-upmanship (the one where you try to top the other guy's story). I didn't plan to do this; at the time I assumed that everybody played this game. I didn't understand why this didn't seem to go over well with the guys. In the dance of human behavior, I liken this to a robin chick growing up in

the forest surrounded by the songs of other birds. Yet somehow it instinctively recognizes "robin" and learns to sing that song. I think this instinctive identification with a role model is at the core of gender identity.

Taking hormones didn't just change my body to match my internal self-image—a feat miraculous enough in itself. It has made me able to interact with other creatures—both human and nonhuman—far more harmoniously than I ever had in my life. Though the solution I chose may seem bizarre and technological to some, it came out of the realization that humans too are guided by instinct. We are unique, but not separate from the rest of animal creation.

Jericho

Sometimes being me hurts; sometimes I thank the powers that be for my life. I flounder between apathy and wanting to save the world. While staring at the clippings on my wall, I 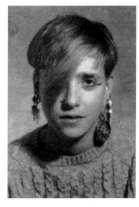 was suddenly hit with the source of my writer's block on this essay. Shall I write about my life? Or *the* transsexual experience? How little my life differs from any other man who spent his teenage years on the streets, got involved with drugs, and at 26 is in search of self (yawn). I didn't lose any sleep about being a man. The most repetitive question of late is: "How do I know I'm a man?" I decided to mirror that back, quizzing my "genetic" friends. Again and again I heard the same answer that I would give, barring the obvious (what one sees when the trousers are dropped): It is inherent, a given. I had no contact with my family for seven years. Without going into details, it truly just happened that way, with no intentional cruelty on my part or theirs. I left with the name Kristen, a daughter and a sister (as far as the obvious signs went), and came back with a beard and a deep voice. My mother's first response when she saw me says everything: "Of course."

I am that I am
Repeated 100 times
I can be nothing other than what I am.
Times 62 and ½.
So much changes, ages, grows, and dies in life,
But in every instance I have been a man.
OK, not exactly; I wasn't a man when I was a boy.

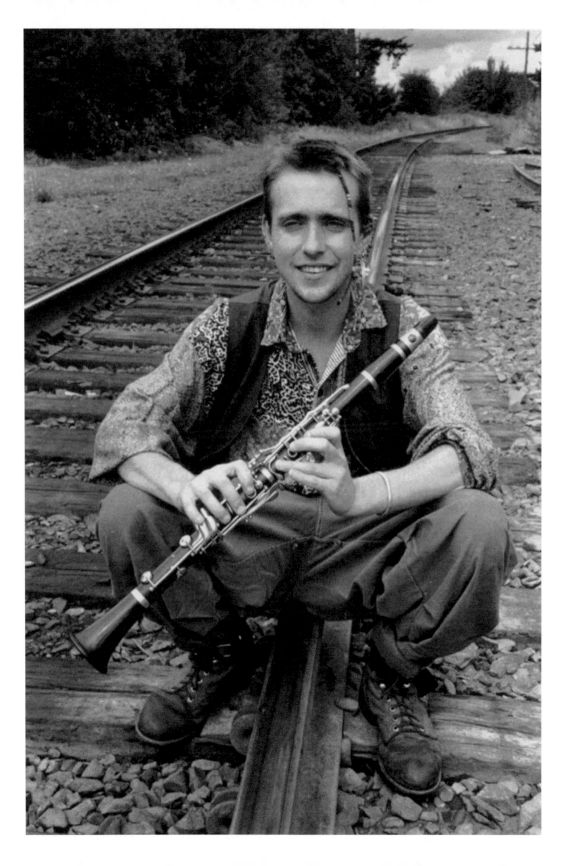

I sing, I cry, I laugh.
I've loved and I've felt such hate I thought it would burn me in two.
I've begged for an early death and I've prayed to live 120 years.
When I was young I was scared of the dark
like a lot of other boys.
I suppose it took me 18 years to accept the unknown demons lurking in the shadows.
Is this where I mention I'm single?

B.J.

When I was younger (I'm 22 at the time of this writing) and thought about my future, I always saw myself as a father, uncle, and husband. I never made future plans for myself as a woman or matriarch. I didn't have the knowledge of transsexualism as a child, but it always felt natural to portray a male role in my life. My younger siblings think of me as an older brother, based on both childhood memories and my transition. I think I make more sense to them now than when we were younger because now they know where I'm coming from. They claim that they always saw me as a big brother rather than a sister.

I tried to appease my family by dating boys, and my friends by being a sexually active tomboy, but I never felt I was doing myself justice. I tried dating women to make myself comfortable, but I still wasn't happy. I had to find out the hard way that sexual orientation and sexual identity are at completely different ends of the spectrum. Now I knew I had more than a sexual-preference crisis going on, I had a gender identity problem to deal with. I found myself going through many phases to find myself, but nothing was working, no matter what I did. I tried doing everything that everyone else did just to feel in place, but still I was unhappy. All I learned how to do was to fit in everywhere but not belong anywhere.

I started taking testosterone at 18, and it still left me androgynous. Transition is a lonely time for anyone, especially if you're changing gender. You don't know where to go or what to do, so I found myself hiding away as much as possible.

I didn't want to deal with the world if half of the people in it still thought that I was a female. It made it very hard to choose new friends, because I felt everyone was dissecting me. It seems like the straight people felt like I was getting a privilege that I didn't deserve

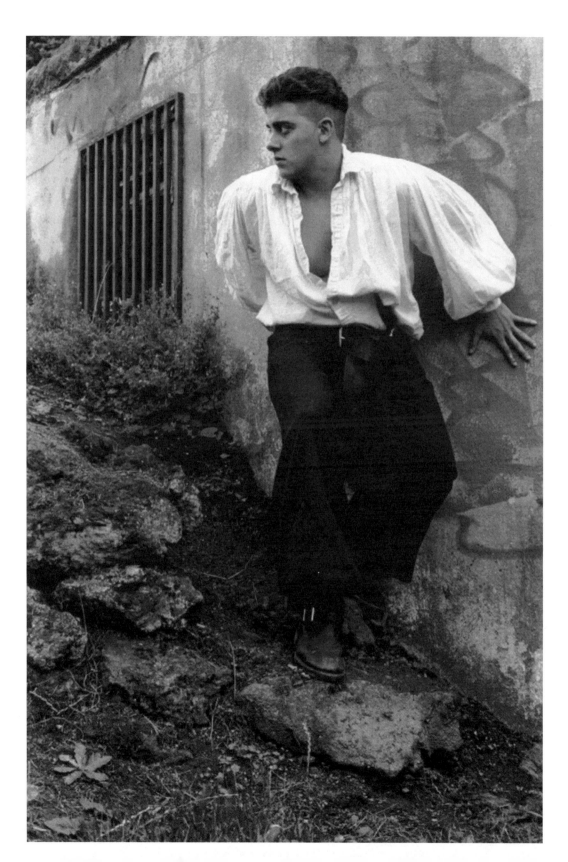

and the gay people felt like I was betraying them. Now I can't rely on people from any community for support, but I feel more like myself every day.

Most of my friends understand my birth defect at an arm's distance; they don't understand my everyday life. I put on a gender costume every day to match my face, and I still feel like everyone is dissecting me. Educating people about transsexualism becomes extremely tiring. I'm tired of people I don't know knowing about me. I now live and pass as a male, but it doesn't change anything. The people who know me or have heard about me will still place bets on what's under my clothing. And no matter who I go home with, at this time I still wake up in the morning with a woman's body; and their opinion of me, I can only guess. All I can do is plan and save money for surgery with a good surgeon and hope people accept me as a person and not a gender.

Chris

It's hard to define what it means or what it feels like to be FTM when the feelings of before and after transition are completely different to me. Before transition there was a desperate need to identify and feel like a part of something. Later, realizing, to much despair, that there was really no place in this world for transsexuals, it became evident that I needed to make my own. The fair-weather friends trickled away and were replaced by chosen and extended family. And even though there was a good support system readily available to use, it wasn't until I started hormone therapy that I began to accept myself. It took what seemed a lifetime for the reflection in the mirror to say something nice; then I finally saw a person, not a specified gender. That was the first time I felt OK with myself. It'll still be a long time until I feel completely OK, but I think that I'll always have to live with not feeling normal. As for now? I'm still evolving.

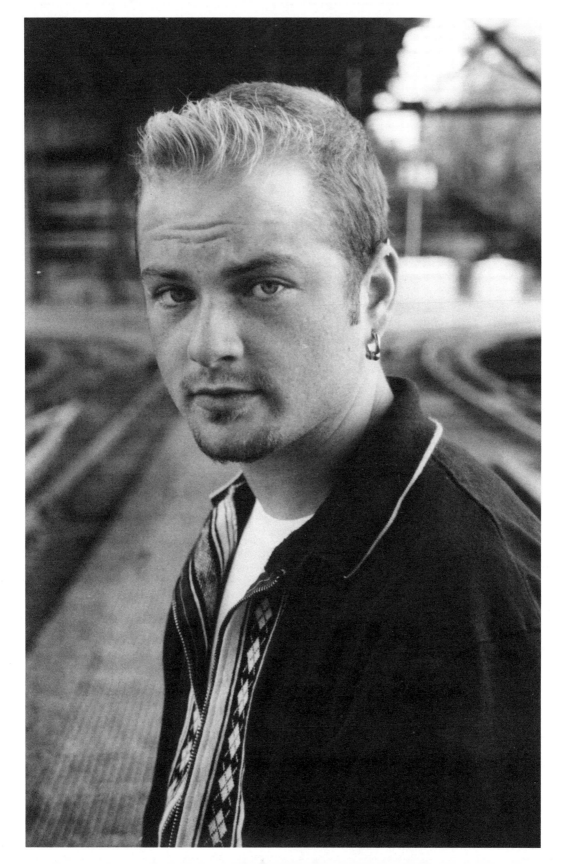

Adam

Now, I am so comfortable in my body that I often forget that I have transitioned. At first, I felt so odd. I felt I had to search out "others like me." But now as time goes by, I find "others like me" in the people I meet every day. Most people I meet are trying to make sense of their lives the same as I am. They are concerned about who they are, where they fit, what their purpose is. These are the same things that concern me. I don't feel different from other people.

I think it's interesting to see how attached people are to the categories we have created with language. Nature creates an infinite number of varieties—this is what propels evolution—and arguing over whether a person such as myself is male or female is like arguing whether a tomato is a fruit or a vegetable. That is, it doesn't really matter. We can eat and enjoy tomatoes equally, fruit or vegetable. We like a tomato because of its specific properties (taste, juiciness, etc.) and not because it belongs to one category or another. Similarly, people should enjoy people for themselves and not because they are male or female, black or white, gay or straight, or any other category.

It's funny—when people look at my partner, Stephanie, they see a woman who is dating two men at once and both men used to be women and those men used to date each other as women and they think, *Wow, they must be wild.* Like they think we have some crazy, wild sex life out of a porn flick—which isn't true at all. We lead a pretty mundane life. We hardly ever go out and mostly stay at home watching movies, reading, or walking the dogs. But people think that because we live outside the norm, we must be amoral and reckless. It's the same as people thinking that homosexuals must be ultra promiscuous.

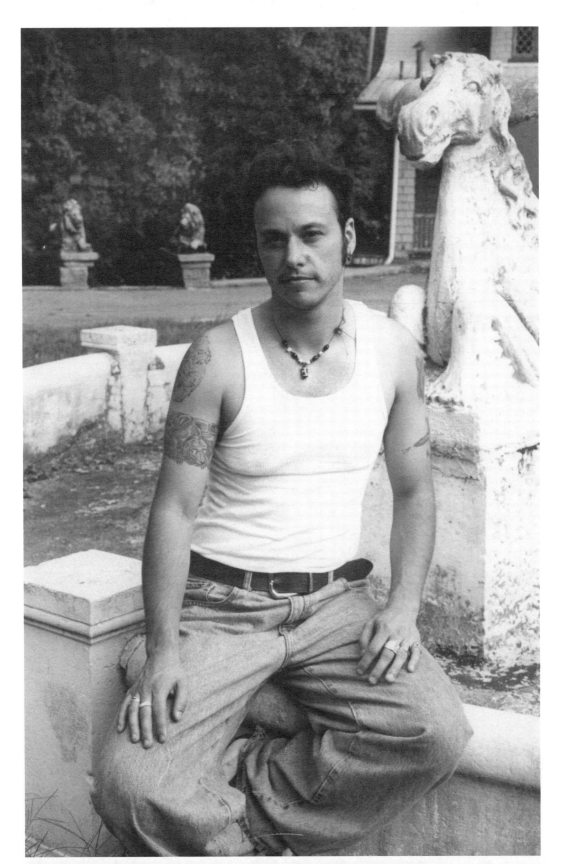

Usually people don't have a clue about who transsexuals are. They don't realize that we are living right under their noses because they expect some ultra flamboyant person whom they could spot a mile away. A good example is when I went to the motor vehicle administration to get the sex identification changed on my driver's license, I decided not to use the letter I had from my endocrinologist and instead went to the desk and told them that for some reason they had put "female" on my license. I didn't tell them that this was an error, but they immediately began apologizing and sent me to several people, all of whom apologized. One of them even joked, "Was the surgery painful?" None of these people thought for an instant that I might be a transsexual. This made it very easy for me to get my license changed, and it was free because it was "their error." But it also demonstrated to me how misinformed people are. The man who joked to me about my "surgery" obviously felt comfortable in his belief that if I actually were transsexual, he would be able to spot it. Because of this, I sometimes feel like an undercover secret agent in the world of the "straight and normal."

I guess that for me, my transition is just another twist in my life's path. I have simply followed where my life led, and this was one of the surprises in store for me. And when I think about it, I realize it is those surprises I live for. I want a life that is going to challenge the way I think about things and not one that lets me sink into the status quo. I feel the world would be much smaller and uglier if I had not had my eyes opened to the rich variety and beauty produced by nature in its entirety.

Drew

When people ask me when I began my transition, I always hesitate before I come up with an answer. I've always been male-identified—I've always known on some level that I was male, and I've lived my life as such. Many people define the beginning of their transition as when they started hormones or when they started passing as male, but I passed for the majority of my life, and my parents unconsciously raised me like the little boy I was, so as I grew older I entered the world having been socialized as a boy. Once I hit puberty I identified myself as a butch dyke, but I acted like a typical teenage boy. The only real butch thing about me was that I did not look or act like a young woman. It was obvious that there was something more to my identity, but it was not until I was 17 or 18 that I had the concepts and vocabulary to describe what I am. I had always known I was a boy, but I finally had language to express what I am to others. Did my transition begin when I said I was a transsexual? When people used male pronouns to refer to me? When I legally changed my name? When I started hormones? Or did it start when I was a kid and saw that what made someone a boy was what they did and how they acted and I figured that I was a boy too?

At this point in my journey, I'm learning to deal with life as a black man in a very white city. I've lived all my life in Eugene, Ore., and there seems to be a misconception that Eugene is a liberal place. I will admit, it's not a bad place for older, conservative white lesbians, but I just don't fall into that category. There are hardly any black people in Eugene, let alone black gay men.

One of the hardest things for me to adjust to is being treated like a black man. Racism

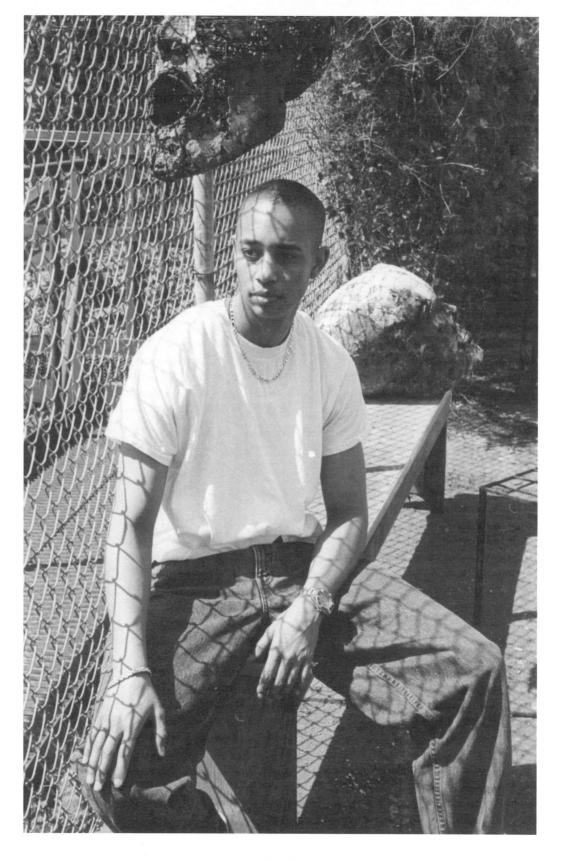

in the Pacific Northwest is subtle at times, in the urban areas, and frighteningly blatant in the rural areas. I never really feared violence as a black "boy," but since coming into my manhood, I've realized how much more harassment black men receive. It's hard being treated like I'm an evil black man who's just waiting to commit a crime. White people will never truly understand what it's like being black, and I can't find any comfort in a black community that does not accept me for being transsexual.

I don't really have a community here, and I doubt I will ever find a community where I feel I really belong. I am a little on the antisocial side, so it does not bother me too much. I've wondered if my dislike for being social has been a product of society's nonacceptance of differently gendered people, a defense mechanism, or just a personality trait. My friends don't blame me for being antisocial after the way I've been treated trying to do the simplest things like going out for coffee or meeting someone for a drink.

I finally feel settled in my life and I'm happy where I'm headed. I was criticized by some for starting hormones so young, but for me that was the critical element I needed to finally grow up out of my teenage boyhood and become the man I wanted to be. I used to stare at myself in the mirror, trying desperately to see who I really was, and I never could. Since I've been on hormones, I look in the mirror and see who I am. My friends have watched me grow from a troubled and stressed teenage boy into a confident and happy man.

I'm 22 now, and I still don't have a good answer to the question of when I began my transition; I still cringe every time someone asks. I'm a transman and I will always be a transman and my life will be a never-ending journey of learning and adjusting. My transition is lifelong.

Nathan

Thirteen years ago when I took my first shot of testosterone I had never met another FTM. I had no idea what to expect when I began my transition. The meager information I was able to find about FTMs was from an autobiography where the only photograph of the author, a man who had transitioned in the 1970s, was of his back. A family member and a close friend, who knew as little as I did about the process, were more than ready to offer uninformed opinions. I was told I would cause others pain, that I could never really be a man or look like one, that people would stare at me and reject me, and that I would live my life alone.

Sometimes I believed what they said and I saw my future as that of a pathetic and lonely freak. Other times I dared to believe that I could live happily as a man, even a transsexual man, but I always feared that if I chose this path, I would cause my family pain. I fantasized about ways I could stage my death so I could spare my family the knowledge of my transition. The pain of having a daughter, sister, or niece who was deceased seemed less than that I would cause by changing my sex.

At 19 years of age I was living at home and working low-paying, unskilled jobs. In high school all my teachers believed I would go to a good college and major in English or perhaps music, two of my greatest loves. But when I went to interview at colleges I couldn't stand the thought of walking on the campus with my fellow students and enduring the knowledge that they thought of me as a woman. Everything in my mind and soul told me I was a man, and to have daily contact with hundreds of people who would be unable to see the truth was unnerving and unbearable. I knew that before my life could move forward, I had to bring my body into harmony with my self.

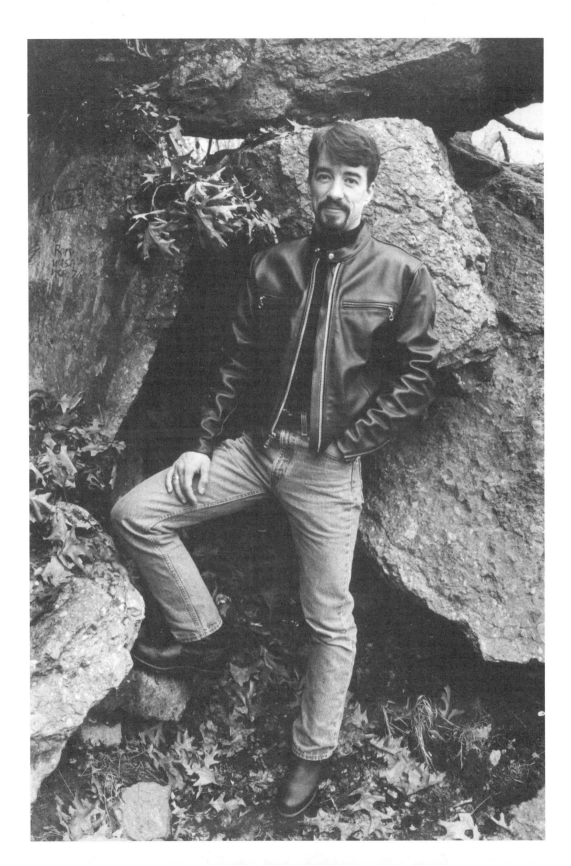

I couldn't say the exact chain of events that led to my ability to begin re-creating my body as male. I tend to think it was a matter of a critical mass of emotional motivation building up and then breaking through the wall of my other concerns. It was almost like I found myself adrift on the ocean after a shipwreck, and although I was uncertain of my ability to swim, I knew if I didn't try, I was certain to drown.

And so I started the long process of seeing doctors, answering their questions, filling out their paperwork, completing IQ and personality tests, recounting my past in intimate detail, so that I might finally be deemed a true transsexual who would benefit from hormones and surgery.

When I began to take testosterone, my concerns about my family were eclipsed by my joy in my body's finally taking on its proper shape. I was ecstatic as my mustache and beard grew in, my muscles thickened, and my voice deepened. The first time the telephone operator called me "sir," I completed my call, hung up the phone, and whirled around the room in a victory dance. Like a 12-year-old boy, I noticed each mustache hair as it grew in, downy and virtually invisible but real and full of the promise of manhood.

I was finally granted the experience that my male friends had years earlier; I was growing up and becoming a man. However, I was painfully aware of a critical difference between my experience and theirs. While they were free to preen and strut their manhood, I could only do so in private. While their families would proudly compliment these boys for their strength or tease them about their razor stubble, I was in agony that my family would notice my beard and muscles and be ashamed of me.

Eventually, of course, my family and friends noticed the changes in my body. My parents struggled to understand my reasons, but nonetheless they accepted me. My sister declared that to her it was a logical step, something she had seen coming for years. And the remainder of my family and friends each said to me that they loved me and would continue to love me regardless of whether I was a woman or a man. The one friend who had been relentlessly negative about my need to be a man has drifted quietly out of my life. He remains the only person whose friendship I have lost due to my decision.

Seven years into my transition, I found a group of FTMs (a support group), when I couldn't say I was really in need of it, and it strikes me how different their experience must be from mine. They have come to their decision and started on this path with a degree of support that I hadn't even dreamed existed. While I believe it was necessary for me to begin my transition alone, without seeking the approval of my family and friends, I paid a price for self-doubt: depression and tears. My isolation proved to myself the necessity of my decision—I know what I was willing to sacrifice in order to be true to myself. But it was a fine edge I had to walk along in order to get to the place I am today.

When I found out about this project, I decided I wanted to be part of it in order to give back to this community. I hope that if there is a young man who is struggling with the deci-

sion of whether or not to transition, he will at least realize, as I never did until years later, that he is not alone in his struggle.

Dana

When I try to think about exactly how I arrived where I am now, which is about a year and a half into transition, there's not really a clear path, only some poignant impressions. As a young kid I lived with my mother and brother in Texas. My mother worked constantly, so we always had baby-sitters and I was allowed a lot of freedom. My best friend Phillip and I used to play King of the Hill or catch crayfish with the neighborhood boys. I don't remember feeling different from them, even being aware that they had penises and I didn't. It didn't seem to matter. At that age I wasn't treated differently from my brother or other boys and did all the things they did. My mother said she tried to get me to wear a dress once to one of my birthday parties, but I threw such a fit that she let it go. I don't remember this incident, but I do remember the Indian-brave outfit she said I wanted to wear instead because I wore it constantly. My childhood revolved around imagining myself as an adventurer of some sort. I kept a raccoon cap for when I was Davy Crockett and often spent the night under the fortress

of my mother's weaving loom. Those were really very contented days for me.

The emergence of breasts caused a coinciding insecurity and self-consciousness I don't recall having had before. I believe it was because I perceived that my body was going to make people respond to me differently from then on. And it did. Feminine gifts that I had no interest in would appear from relatives at Christmas and birthdays. By the seventh grade I became acutely concerned with fitting in and I didn't want anyone to think I was weird, so I began wearing the more feminine clothing that I saw other girls wearing. I felt uncomfortable, but I thought I had to get used to it.

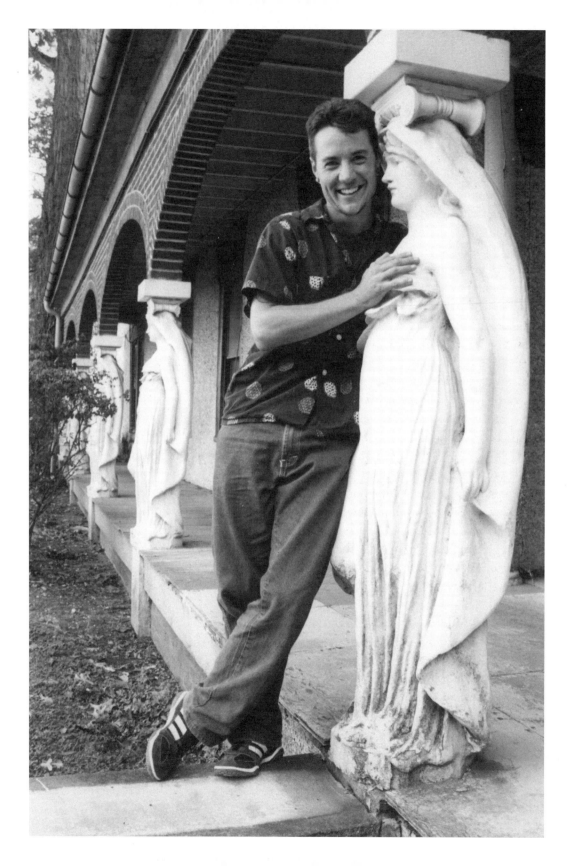

During high school, at age 16, I had an emotional upheaval aggravated by a stint of 13 months in a drug rehabilitation program. Those months were an overwhelming and confusing period, and though I didn't think it helped me figure out who I was, in a strange way, once the experience was over, it made me resolve to do just that: to figure myself out.

By 19 or 20 I had realized my attraction to women and begun living as a lesbian, and in college I found a community where I developed more solid friendships. During this time there were many people around me, male and female, who were open to a wide range of masculine and feminine appearances or identities. I didn't feel compelled to look female anymore. This was an incredible relief to me, and I began sorting out my own male feelings without being completely alone. I think I had to wait until I felt stable in my surroundings before I could do that.

By "male feelings" I mean that I would feel these urges of satisfaction when I was mistaken for a man, and I did things like shaving the downy hair off my face and lifting weights, trying to alter my physique. But the more of these types of things that I did, the more I accentuated the limitations of my body. It still took me a few years to recognize that the difference between me and other women, even extremely "butch" ones, was that I didn't feel connected to being a woman and wanted partners to perceive me as a man. Other women I knew at the time, who were also uncomfortable with their bodies, did not consider having a man's body a solution to the problem as I did.

While I had heard of men changing to women, I was probably 24 or 25 before I knew female-to-male transsexuals even existed and that testosterone injections were used to help in the change. Since I felt my body was already perpetuating an androgynous state, I was afraid that receiving hormones might make me even more physically ambiguous. But when I saw the results of testosterone in photographs of actual FTMs, I was really amazed because…*it worked!* I knew then that I couldn't comfortably identify as a man without taking hormones that would give me male characteristics such as body hair, a voice change, and redistribution of fat—all very important details that couldn't be achieved solely by dress or behavioral changes.

Receiving testosterone has allowed me to feel comfortable with my physical presence and to have confidence that others see me as a man. And the pending surgical removal of my breasts will further enhance my appearance as a male.

Since transitioning is relatively new to me, I'm still seeing the evolution of major physical changes in my body's appearance, caused by the hormones. On some very basic levels, this makes transitioning an external process. It is strange having others watch the process happen, such as at work. It has taken me a while to get used to people I don't know very well having easy viewing access to something so personal. It makes me feel like I am being continuously viewed on one of those little security cameras. For a long time I worried about what everyone was thinking about me and tried to brace myself with every possible defense.

Over time, I realized that these expected conflicts would not likely arise and that most people weren't gawking, certainly not to the degree I anticipated. Pronoun slips are the worst thing that has happened so far.

I am lucky to work in a supportive environment, a tattoo shop. Sometimes I experience some really humorous, even peculiar situations, at least from the standpoint of my transition from female to male. This one guy came up to me after a woman had left the store and said, "Yeah, I didn't want to say this in front of her, but I want a tattoo of a dick on my arm with lettering that says 'Big Mack Daddy.' How much would that be?" Another guy, giving a "wink-wink look," said, "Man, I bet you get to see a lot of breasts in here, huh?" Comments like these make me think that people make assumptions about everything. The first man's statement is ironic for the obvious reason that I lived as a woman for 28 years, while the question of the second man, assuming I was straight, shows how frequently some men think that tattooing is not really a job but a way to get sex thrills with random body parts. I've often been leery of being too open about my history in conjunction with my job because of the possible fetishes it might inspire…I can imagine hearing, "Hmmm, getting tattooed by a real-live transsexual!" Or something worse.

Whenever there is genuine interest and mutually shared respect, I do what I can to remain open to talking about transitioning because I believe communication is important to understanding. I also believe that my presence alone, for those who know about my transition, has made them think about many issues regarding the change; whether they accept it or not, they know the serious commitment it is for me. Every situation of acceptance comes with its own set of circumstances, and sometimes, as is the case with my hope for my family's acceptance, I have been required to have more patience and perseverance. I often wonder if people I know in the future—should I choose to reveal my gender transition—will see me as a "transsexual" instead of "me," the man I am. I think what will be seen and what identification is made will depend on my earned self-identity and focus.

Dana Baird died at home on March 10, 2001, of complications related to Hodgkin's disease. Dana was a skilled artist and, in the last years of his life, became an accomplished tattoo artist. He spent many hours creating original sketches for tattoos and continued drawing until he became too weak to hold a pen. He is survived by his companion and best friend of 17 years, Adam Parascandola, and Stephanie Prete, Adam's wife and Dana's partner of four years. He was surrounded by many friends and acquaintances, and is fondly remembered and deeply missed by all.

David

From my earliest moments, I knew something was *missing*. I didn't even know that there were physiological differences between boys and girls (it would be years before I even knew what a penis looked like). I just knew that I was a boy, and everyone kept treating me like and telling me I was a girl, no matter how many times I tried to correct them.

Of course, strangers would have to be told that I was a girl since, prior to puberty, people around me couldn't really tell that I had been born female. I played with the other boys, acted like the other boys, and I made sure that the other boys didn't treat me any different than each other. But, in the eyes of society, that didn't matter. I was born female, which made me a girl.

As I matured, my body began doing some very strange, very unwanted things. My chest began to hurt, and growths appeared. I began menstruating. I was angry and relieved at the same time. I was happy that I was *normal,* like my sisters, yet I was distraught because of these feelings of maleness I had inside. My body had proven to me that I was female. But that didn't change the way I felt.

As a child, I had been very outgoing and extroverted. I was the leader in the playground and neighborhood. Other kids turned to me for friendship and guidance. When puberty hit, everything changed and I withdrew from society. I became extremely uncomfortable in my own body. I didn't want to deal with the changes or the expectations from society and my family now that I had "matured." I ceased being me and became the person that I thought others wanted me to be.

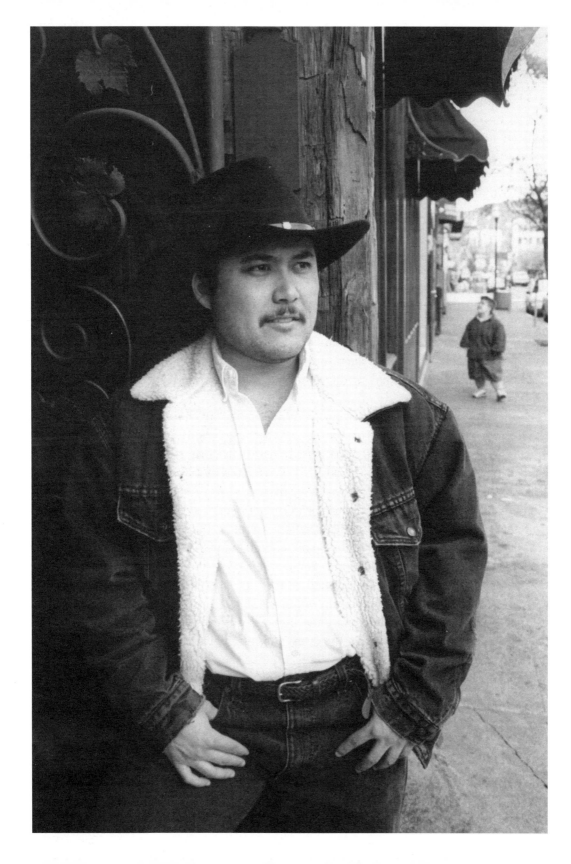

Over time, I grew to accept that I was viewed as a female by society, but I never accepted that I would live my entire life as a female. It didn't take long for me to realize that people were just responding to the physical properties, the secondary sex characteristics; they heard the elevated voice, saw breasts, and assumed *woman*. They had no idea how I felt about my body and the deceiving nature of it: It (my body) presented as female, but I was male. With the assistance of modern medicine, I knew that I could transform my body and that I could be viewed by those around me as the person I envisioned myself to be.

After years of planning, praying, and hoping, I finally began my journey. I contacted the necessary folks and began the process of fixing my life. I was not surprised to learn that there were steps that had to be followed and hoops that had to be jumped through. I sat through the judgments of therapists, doctors, friends, coworkers, and strangers who'd heard about me. I did everything that was expected of me to be allowed to live the life that I wanted to live.

Within six months, I began living my life as David. I began hormone therapy and had surgery to bring my body more into alignment with the body I had always envisioned. I began feeling comfortable in my body again, something I hadn't felt since I was 12 years old. I let go of the facade of being female and began letting the person hidden within shine through. I began to live my life.

Now that I've transitioned, why do I continue to be "out there"? The answer is simple, really. I didn't do this to blend back into society, because I didn't do it for society. I did it for myself. Society just happened to witness it. Transsexuals never stop transitioning. I live the life of a man with the history of a female. My life is different than those of the genetic males around me. At first I was embarrassed by my past, but over time I've come to treasure my unique qualities and believe it's important to share myself with those around me.

Today I do educational panels, and there are two things I want folks to get out of the discussion. First, this is not a choice. We do not choose to have gender dysphoria, we are born with it. Some individuals choose not to pursue transition—to undergo hormone therapy or sex-reassignment surgery and be deemed as transsexuals—but the debilitating effects of gender dysphoria (profound discomfort with one's sexual anatomy and the belief that they were born with the body of the opposite sex) may exist nevertheless. Second, I can't count the times I've had folks tell me that they can "pick a transsexual out" without even knowing that they are talking to "one of them." The hormone therapy works. Transsexuals blend in with the rest of the human race as much as any other individual does.

The sexual-minority community has come a very long way within a very short amount of time. I'm proud to say that I'm part of that.

Jerry

I suppose most transsexuals can tell you they knew at an early age something wasn't quite right. Not to say we could verbalize it in a way most people could understand.

I remember a funny story my mother tells about an Easter dress that gave her a clue that something wasn't quite the same with her 2-year-old as with her others. She went through the trouble to find two identical dresses—one for me and one for my sister. My sister loved hers. I didn't. Mother put the dress on me, I took it off. My mother put it on me again and I took it off. She tried again and again, and I took it off again—only this time I cut it up with scissors.

I remember waking up at the age of 8 and panicking because my penis was gone! Not that I had had one the night before when I went to sleep, but I was totally convinced that something had happened during the night to remove it and I was scared to death of saying anything to either of my parents.

At 10 I had my first menses and thought I was bleeding to death. At 12 my mother made me wear training bras. That lasted about six weeks, and that was the end of that. My mother was very kind in a way and never pushed the issue. My sister wasn't so kind.

At 14, my uncle told me my mother and father called him to say they "had one." He was gay, and they thought I was too. He tried to no avail to get them to send me to live with him for a while so he could expose me to the gay world and "teach me the ropes" so I wouldn't get hurt. My parents wouldn't do it, so I was left to learn on my own.

I knew I preferred the company of boys when I played, but when I became older it was clear to me that I wanted a wife. I said nothing to my family. When I found an issue of *Playboy* sitting out on the dining room table, I asked if I could read it. My mother agreed that

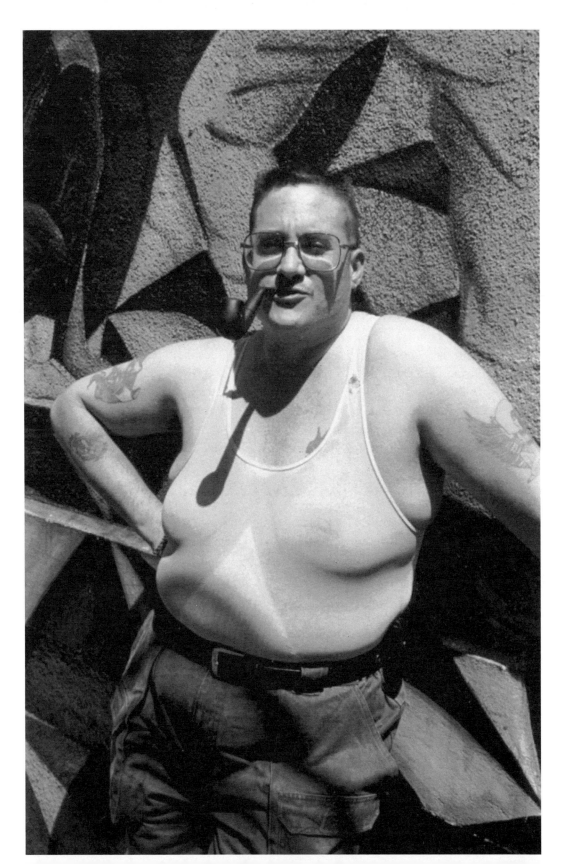

it was OK. This was very unusual. I'm talking about a military officer's family—you didn't come to the breakfast table without being fully dressed or having your bed made.

I read with great joy that my "problem" could be solved! There was an article on a male-to-female transsexual. If they could "fix" it one way, why not the other? I told my mother I was a guy in a girl's body at age 17. My mother was in shock. She just said "OK" with the effect of "That's nice, dear." I don't think she understood.

I went to the local gay center and lucked out. I found a male-to-female transsexual who was also an insurance agent. She set me up with an insurance plan that would pay for all of my surgeries in two years' time. The insurance company was one of the last ones to remove sex-reassignment surgery from their policy. Being young, I didn't understand the implications and let the policy lapse.

I tried my damnedest to live as a butch dyke. I was forever and a day being told by other dykes that I was "too masculine." I didn't understand—I was just being me. I ended up dating "straight" women and would "bring them out" to the lesbian community. My last long-term relationship before I started hormones survived for 12 years. I told her when we got together that I was a guy trapped in a girl's body. She seemed to understand. Eleven years later I had a bad fall from a utility pole and wound up experiencing depression and panic attacks. I also ended up in a psychiatric ward for 40 days. At that time it became very clear to me that if I didn't do something about my "birth defect," I would commit suicide. I had my psychiatrist run blood tests to check my hormone levels. As I had suspected for many years, I had no estrogen cycle but did have a normal male testosterone level for young boys. That was the "frosting," so to speak.

I told my "wife" of 12 years that I could no longer live as a woman, that I needed to transition to become a man. She could not handle the implications and demanded I leave. I left and lived with another dyke for two months until my friend set me up on a blind date. My friend was certain this date and I would hit if off—she was right. Within two months I was living with this woman. She is the woman of every man's dreams—an honest, loving, no-BS, knows-where-she's-going type of woman.

I was honest and straightforward with her from the start. I told her of my birth defect; she didn't bat an eye. She even went out and found other men like me. I started my journey toward manhood.

Six years later we are still together. She has agreed to marry me. I have had a full hysterectomy and am saving money for chest reconstruction. Insurance won't pay for any surgeries because they have all managed to exclude us on the basis of it being "cosmetic" or "experimental."

We still fight on for the right to be recognized as full human beings.

Alec

My name is Alec. I am a 32-year-old FTM. I knew at the age of about 7 that there was something very different about me. I always fought with my mother when she tried to dress me in "girl" outfits. I always related better to boys. I assumed for the longest time, as did my family and friends, that I was a tomboy and merely passing through a phase. However, as I got older I became more masculine. I am half Persian and was quite hairy, having a more than partial yet not quite full beard when I entered my 20s.

There is no history of sexual or physical abuse in my family. I had the benefit of a normal childhood: typical middle-class values, both parents, older brother, younger sister, no alcohol or drugs, no prior sexually or gender-challenged individuals anywhere in the family tree.

I am fortunate to have the complete and unconditional acceptance and support of my family, friends, and employer in my life.

My approach to the situation has always been quite subtle. I never expected or demanded that anyone accept me. All people who meet me assume I am male. When and if they find out I am transsexual, it seems so outlandish that they respond by saying, "Well, I only know you as Alec, and the rest does not matter."

I have been on testosterone for approximately six years. In that time I have progressed in my masculine side very well: For example, I have full chest hair, full beard, complete body hair, male body structure, and a deepened voice. I am very satisfied with the effects of the testosterone and have had no negative side effects, other than increased anger and aggression, but nothing I cannot learn

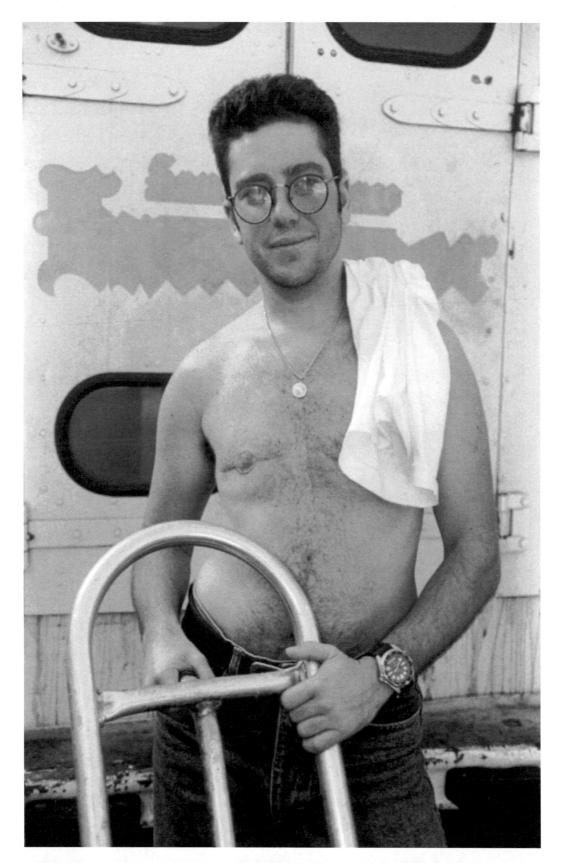

to control as any other man must do.

I have had a complete hysterectomy, oophorectomy, bilateral breast reduction, and a radial forearm phalloplasty operation.

My transition in life has been, for the most part, quite easy and has been met with very little resistance from the community. My only regret through all of this is that I did not get diagnosed with my condition earlier in life.

James

I've been educating the public about the transsexual experience since 1989. I was introduced to the task by two pioneers of the FTM transsexual community: Steve Dain and Louis Sullivan. Steve, who had appeared in the 1984 documentary film *What Sex Am I?*, was growing too busy establishing his new chiropractic practice to maintain his speaking schedule, and Lou, who in 1986 had founded the San Francisco support group FTM (later known as FTM International), had become too ill with HIV-related symptoms to keep up with his regular classroom talks. In addition, ETVC (now called Transgender San Francisco), a local support group for cross-dressers and transsexual women (MTFs), had a speaker's bureau, and at Lou's suggestion I became one of their regular speakers, coached by Ms. Thalia Gravel, who was then the coordinator for that enterprise.

In those days, presentations were predominantly done in groups of three or four people. The usual configuration was an MTF cross-dresser, an MTF transsexual, an FTM cross-dresser (if one was available, since they were—and still are—a rare commodity, even in San Francisco), and myself, the FTM transsexual. We speakers felt safer in groups—this was important then, because often our audiences would shrink away from us in horror, and the questions they would ask indicated their perception of us was as less than human. It was clear that most people regarded us at the time as those who engaged in some sexual perversion that would surely contaminate anyone who met our eyes. No one would risk a handshake with the likes of us.

My appearance in 1989 was still rather androgynous, but as I was masculinized by the prescribed testosterone injections, I found I needed to modify the way I conveyed the information. As audiences perceived me as more naturally male, I realized my message was more effective if they did not know of my transsexual history too soon. By 1991 I was always the last speaker in any group because the effect was very dramatic when I would reveal that I

Dean Kotula in his study watching James Green (on television screen) star in the FTM documentary film You Don't Know Dick.

was born with a female body. Men in the audiences would comment that they thought I was a therapist or that I was going to tell them I was a cross-dresser who had neglected to wear his dress that day. It never crossed anyone's mind that I might have once been female. It was clear that their sudden awareness of this fact about my history was a kind of shock that caused the audience to realize something humanizing about transsexualism. It was almost as though, in their eyes, my masculinity validated the transsexual impulse. Transsexualism was no longer just about men in dresses but became something more universal, almost more natural.

Lou Sullivan died of HIV-related complications in March 1991, and a week before he died he asked me if I would promise to continue publishing the *FTM Newsletter,* the quarterly informational publication that he had started in 1987. He felt this publication, which went out to about 230 people around the world at that time, was crucial to support FTM-identified people who were isolated from others like themselves. Very few people had the benefit of support groups as we did in San Francisco, and there was very little intergroup communication other than through this newsletter. Lou had been the hub of FTM-related information, and when I inherited his correspondence files and his mailing list, I realized just how essential the *FTM Newsletter* was. Virtually everyone in the English-speaking world who was trying to help share reliable, positive information to aid FTM-identified people, to alleviate the isolation many FTM-identified people experienced, had been in contact with Lou Sullivan.

I saw the synergy between educating within the community and educating outside it. The messages were different, but the purpose was the same: to make the world safe for those of us who were different; to increase the self-esteem of transsexual people; to ensure that transsexual people did not have to live in fear and shame because they were transsexual; to ensure that transsexual people would have basic civil rights and the ordinary freedoms that non-transsexual people enjoyed, such as access to reasonable medical care and the expectation of reasonable service from professionals who were aware of their client's transsexual status. I felt that transsexual people deserved no less than equal rights, and I realized that all too often, transsexual people do not receive equal treatment under the law, nor do they receive equal employment opportunities, equal services, equal protection, or benefits equal to those offered or available to non-transsexual people. I felt that living in a condition of fear and shame was not right for anyone, and I decided that it was important to set an example of how to live without that fear or shame. This meant purging myself of that fear and shame, which I indeed possessed.

As I began this quest, I wrote about it in the *FTM Newsletter,* and I received many telephone calls and letters from across the country begging me not to bring attention to the existence of transsexual men. But I felt strongly that the only way we can achieve the freedom of our own existence is by being honest about ourselves. No matter how much surgery we

have, we will never have the bodies we want. We have to find a way to accept the bodies we have as the bodies we should have been born with. This means recognizing our transsexual bodies, these bodies that will always be different somehow, as legitimate bodies. And we cannot do this unless we educate others about our existence. We will never be safe as long as we have to hide ourselves. And until we can openly take our place as respectable citizens, we will always be fearful that we will be "discovered." I don't want to be afraid of growing old and infirm and being "discovered" by medical professionals who cannot treat me with respect because my body is different from other men's bodies. I want to know that there are people who can respect me even if I am a transsexual man. That won't happen without an effort to educate non-trans people.

Since 1993, I've been doing transgender awareness training for medical professionals, attorneys, corporate managers, police officers, and politicians, and I continue to lecture in university classes around the country and to give public lectures and media interviews around the world. Over the years I've seen a tremendous change in audience attitudes. More and more people are interested; more and more people are able to see the connection between transgender or transsexual experience and their own self-awareness and drive toward self-actualization; more and more people are able to see transsexual people as human beings who should be free to do as they will, so long as no one is being hurt in the process. More and more people are able to walk up to me and offer their handshake as they say, "Thank you. You really opened my eyes."

Hap

These poems are from *Guilty by Gender,* by Hap Hanchett:

I AM

I did not ask for the privilege that was given to me
But it came

I did not ask why this fate was mine
But it is

I asked only for a chance to be myself
And I am

WHAT I HAVE LEARNED

As part of the female gender
I was taught and learned
SELF SACRIFICE

As part of the male gender
I was taught and learned
SELF IMPORTANCE

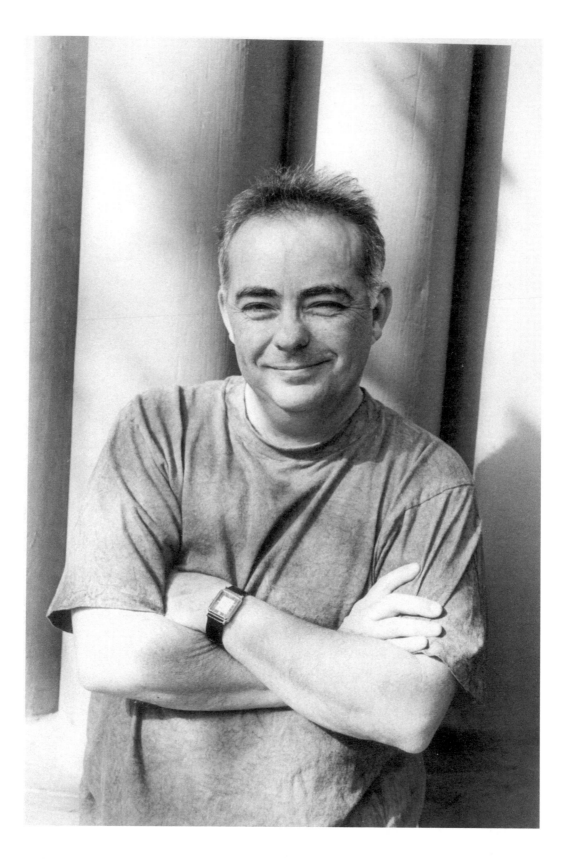

As part of the third gender
I learned the importance
Of sacrificing
Everything I had been taught

PRAYER

Dear God
Let me always remember
what it is to be
as a woman is—
living in the corners of life
relegated to smaller portions
devalued
discounted
dismissed

Dear Lord
Let me never forget
what it is to be
as a man is—
living in the eye of life
inheritor of unlimited possibilities
bestowed
believed
beheld

And Dear Lord God
Let me never forget to remember
what it is to be
the man I am
born the woman I was

SCARS
Men wear them

THE MEN

As a battle
Proud

Women conceal them
as a fault
ashamed

Ashamed to be proud
I fault
my concealed battle

Adrian

I cannot begin to tell you how hard it is to look at pictures of myself. I'm always startled at how strange I look. Is that my face? I always look so awkward and self-conscious in photographs. Well, yeah, I am pretty self-conscious when a camera is pointed at me. A moment in front of the camera opens the door to an eternity of being stared at.

You scrutinize this photograph just as the lens searched and framed and focused and immortalized one blink of my life. Are you looking at my face? At my clothes? Are you trying to "see me as a woman"? Are you measuring the size of my hands, the shape of my jaw, the width of my shoulders? Are you thinking, *He would have been a good-looking dyke,* or *No way, that was never a woman,* or *Which way is that one going?*

I've done that. I am human. When I see transsexuals these things go through my mind. I wonder what's under their clothes, what garments or contraptions are hiding or replacing what body parts. My thoughts can be just as curious and cruel as anyone's.

But as I am the one being looked at, I know how that feels. I know what I want to see in the face that's looking at me and hear, or more importantly, not hear in the conversation. Don't ask me what surgeries I've had or am planning to have. Discussing my surgical status means disclosing what my genitals look like. Is this your normal topic of conversation when you meet someone? No, I didn't think so. You can show your support by simply treating me like any other guy. I will appreciate you for this more than I will be able to express to you.

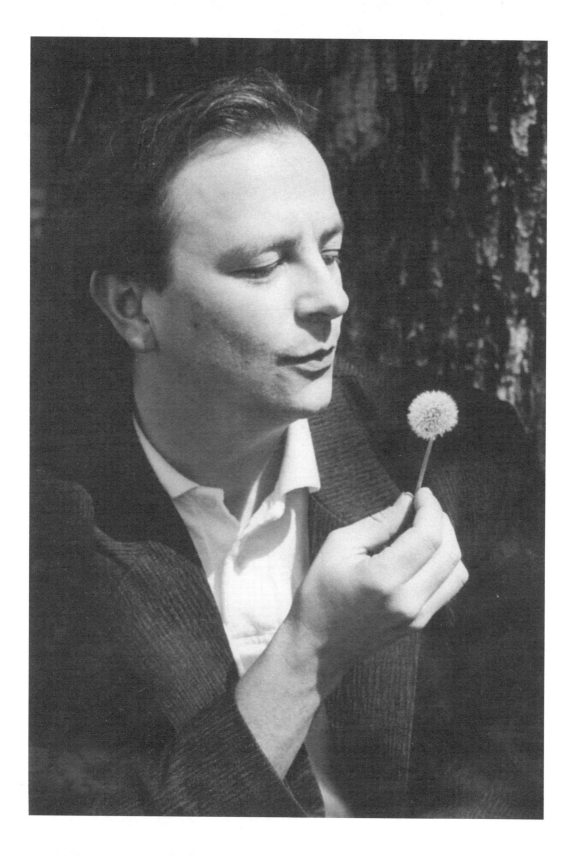

When you've let your human nature have its way and you're done looking at the details, do me the honor of stepping back and looking at the whole person. A photograph doesn't necessarily show you the hopes and dreams, the trials and disappointments, the large and small successes that make up my life. It doesn't tell you my favorite color or what kind of music I like or how I unwind after a long day at work.

But all those things are there. You might get a glimpse if you look with your heart and imagination rather than with your eyes alone. My gender and my sex are merely parts of who I am; they are not the whole of who I am. I'm just a person, just like you, trying to make sense of my life and live it the best I can.

Kim

I was adopted from Hong Kong and grew up in and around New York. Growing up, it was more natural for me to have a crush on a girl than a boy. It wasn't until the fifth grade that I realized this was unacceptable, so, I had to act…like a girl. But I was a hopeless romantic, and one would have to be blind not to see the adoration I held for the girl who had caught my eye. My behavior usually earned me an unhealthy dose of ridicule, but I could not shut off what I felt.

As my teen years faded into adulthood, I had relationships with both men and women. There was a constant battle between wanting to be accepted and wanting to become the man I felt I was. It was the generation of free love, and I went with the flow. Four months after joining the Army I found out I was pregnant. As a kid, I wanted to be a dad and raise a son, like in *The Courtship of Eddie's Father*. My wish for a son would be granted, but I would not get to be a dad.

After the birth of my son I realized that though I loved my son I could no longer deny my unhappiness living in my role as a mother. I felt it was best to leave him and take the time to find a happier me. My son, Josh, was 10 months old when I said goodbye to him. It would be 20 years before we'd meet again.

I moved from the East Coast to the deserts of Arizona. Through inquiries at gay bars I found the name of a physician known to treat transsexuals. It was in 1978 when, after getting psychiatric approval, I received my first testosterone injection. Prior to starting hormones, I had taken to binding my chest, and at the age of 22 I began living life as a man. It had its price.

I met with much resistance from coworkers, which did little for my self-esteem, while my body was going through structural changes, which caused painful charley horses in my

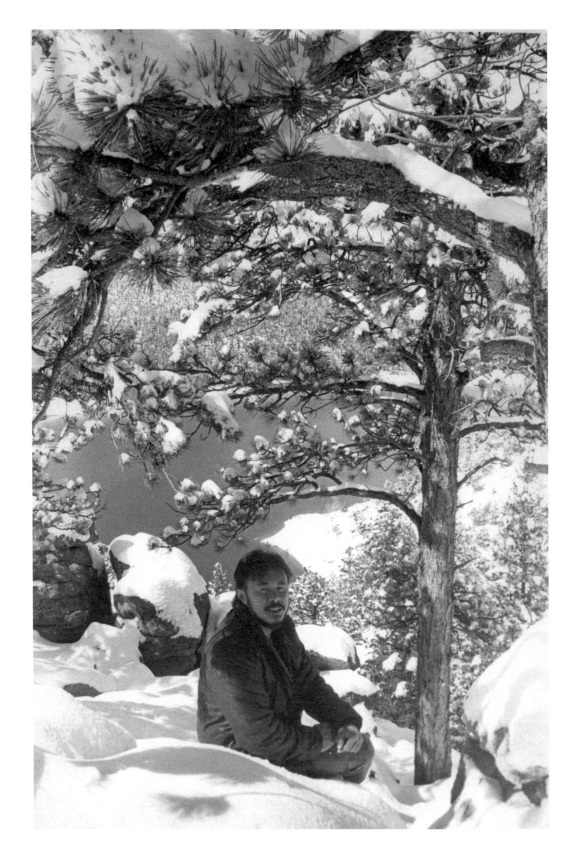

legs and severe acne on my face. I was essentially going through female menopause and male puberty at the same time.

Two years later I had a mastectomy, and the following year I had a total hysterectomy. I worked at the same plant for over 13 years, and as people got to know me through the years they became more open-minded and accepting as they watched me transform from an unhappy, sickly looking person to a confident person full of well-being.

It's been 22 years now that I've lived as a man. I was reunited with my son four years ago. Last year we attended our first family reunion together with my mom's family. It was a great experience for us all.

Fifteen years after starting my life as a man, I received a card from my mom saying how thankful she was to have me as her "son." It was a tremendous turning point in both of our lives! I've been fortunate to have love in my life and to have found lasting and true friendships.

I recently suffered from liver failure and learned that I have been living with hepatitis B for some years. Due to this, I have been unable to continue taking male hormones because they could cause further damage. My hope is that future generations will find the courage to be who they feel like inside and that they can make their dreams come true without drowning their pain with alcohol, as I once did.

My message would be that no matter where you are in your life, be grateful. Life is only teaching us what we came here to learn. And the human spirit? It's far more resilient than we'll ever know!

Max

As a child I wanted to be Superman. To fly through the air, stop bullets with my chest, and rescue women from tall buildings. I longed to bend steel with my bare hands. Later, I progressed to loving Spider-Man, Daredevil, Batman, the Flash, and an obscure superhero, the Black Panther. He had a great outfit, inky black tights, and was as sinewy and graceful as a large cat, with taut, elegant muscles. As I got older, I gave up these childhood fantasies

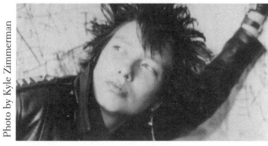

for poetry and rock and roll, a visceral fascination with heresy and art. Besides, I was biologically female, at least as far as anyone could tell, and try as I might, there was no getting around that blind fact. There were a few female superheroes, but I just couldn't get used to the thought of myself in a silk bustier with thigh-high boots and a set of large breasts jutting out like pointy strategic missiles.

However, as I got older I discovered feminism and, for a while, the idea that women are oppressed and forced to emulate male models of empowerment made me believe that perhaps I had just been blind. It took many years and a lot of confusion and pain to remember that I was never comfortable with the idea, the gut-level feeling, of being a woman. I felt a vacancy there that could not be filled with rhetoric or with political resolve. I never fit in to the world of lesbian feminism, although I tried, and now I understand one of the main reasons why. I was actually, in my depths, a heterosexual man. I feel now as though I'm awakening from a long, constricting dream.

Changing my sex has enabled me to begin to know the places where the sexes intersect and where they separate. Being a man has turned the world upside down, and slowly, over

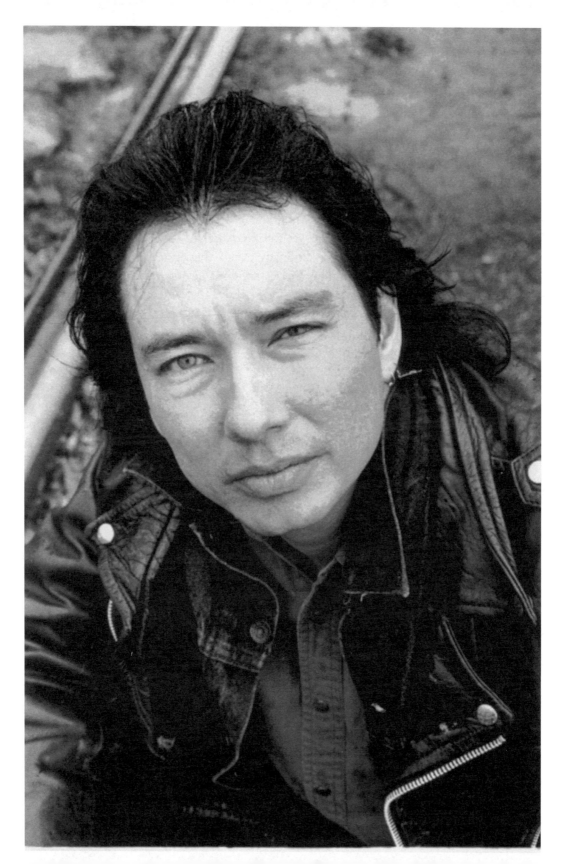

the years, many of my former values have changed. The world opens up for me in meaning. I'm beginning to come back to life after being frozen. I didn't know this would happen, but it has, and I'm beginning to feel relief.

People say that they hate labels and are reluctant to pin themselves down as anything: Making a choice, and believing in that choice, seems to close all other doors. Yet doors have a way of appearing, opening, and then closing in the most disturbing places. There's a dynamic quality to choice that's not easily manipulated. Making the choice to alter my biological sex and become a man was an act of passion, a defiant act of criminal proportion in a culture that can only be ironic about intensity. A talk-therapy culture that prefers "safe space," a controlled and tidy environment, to ecstasy or a punishing engagement with ambiguity and darkness. A culture that treats passion as though it were an addiction, a trite disease that can be negotiated and understood, a culture that attempts to cool passion into a reasonable, quantifiable feeling.

Changing sex is a crime of passion. Passion because it is lived out at nearly any cost to the individual. This transformation requires a leap of faith, a magical belief in the power of the self to know and act. A raw, gut-peeling defiance.

Because our choice to alter our sex is reliant on an interior vision of the self that other people can't completely see or know, transsexuals are easily aligned with divine forces both light and dark. We are considered, variously, to be holy tricksters; subliminal jokers who forge our bodies with alchemical expertise; divine, nimble deceivers; callow imposters; ruthless stealth artists. We seem to have hidden powers to hoax; we know too much; we could be anywhere and anyone; we exist where you least expect us to. We frighten people and inspire them nearly equally. We attract pity and horror. We're the butt of jokes and fascinated, queasy lust.

The truth is, most of us are just folks, and not nearly as exciting or subversive as all that. Like most people, most transsexuals yearn to be perceived as ordinary. Perhaps it's becoming increasingly clear as the media drenches us all with tales of incest, satanic cult abuse, domestic violence, multiple personalities, and Prozac that very few people feel ordinary, although most people actually are.

In changing our sex, transsexual people pry open a door for others, if only for a vulnerable, short moment. There's something deeper in all the curiosity and voyeurism of non-transsexuals toward us, it's more than the impulse to poke fun at the fat lady and the fish boy in the circus. Television talk shows that feature transsexual guests are also a sort of vulgarized spiritual quest. I've found that beyond all the leering, the shock, the titillation, most people want to know. They want to hear us tell them what it is like, what is it like... I believe transsexuals need to go beyond justifying our existence to the rest of the world—we need to talk about what we know and have experienced. Many of us are doing this now, and when we do, with integrity and clarity, with a sense of humor and an unwavering vision of our-

selves as complete and not defective, we have the capacity to inspire a transcendent clarity. We allow non-transsexuals to enter an expansive realm beyond their physical bodies. To endure their dreams; a slanted, explosive glimpse of freedom.

As a writer and a poet, I live for that glimpse, I invoke it as I create. As I'm writing a poem and it's becoming an unknown entity, a force field with its own rules, boundaries, masks, voices, in-jokes. As a prose piece takes off into a sudden, unforeseen arena where I can play and discover an idea or combine an idea with an image, a memory. When I feel that I must tell a truth, no matter how it will be received or understood. Writing ahead of myself, of what I know. Where I can try on a criminal cloak of invisibility and power.

A note on my computer that I've written myself as a reminder for my work, of what is demanded: Absolute courage is required and absolute tenacity. Ferocity of intelligence and expression.

Michael

Manhood for me is the stuff of dreams. I *knew* I was a boy—a male—from my first consciously aware moment. I have *always* been masculine in spirit, and, as such, this has *always* been a spiritual journey for me. It is my spiritual path.

I was *always* masculine in my innermost essence—though I didn't come by my physical manhood until much later, and not easily: It took rigorous preparation, great sacrifice, tremendous risk, high cost, and a singleness of purpose, all of which, as I look back on it, bordered on the heroic. It is the journey that Joseph Campbell refers to as following one's bliss. And this journey, this bliss, is my manhood. I have approached, and breached, what I was made to believe was the impossible: to become a man.

I journeyed with no knowledge of what I would find once I got there—only a great trust/thrust that this was *right*. It all began with feelings that I can only describe as intense anguish. The anguish reached a point of such intensity in me that I could no longer go on *for one more minute* as I was, as female.

At the point where I came face-to-face with the certainty that I was transsexual, I had to confront the truth about myself. Although the details of this intense turning point may vary with each individual, of this I am certain: Every FTM begins with such feelings of anguish that they cannot go on that they must set things right and correct what has been wrong.

The reconciliation of the reality of my manhood with the apparent womanhood of my physique has been a powerful journey. It can only be likened to an initiation/trial by fire. I had to reconcile the opposites within me, the juxtaposition of male and female, and the decision to become what my innermost being is could only be arrived at by passing through

the most arduous of tests.

At times I feel like James T. Kirk, or Jean-Luc Picard, on a heroic mission, or perhaps like one of King Arthur's knights questing for the Holy Grail, but the priceless riches I seek are the lost treasures of my masculinity.

The awesomeness of this moment never ceases to amaze me: The price of this journey is nothing less than everything I was; everything I have been all of life until this moment. And yet, for me, it was worth every sacrifice to finally acknowledge my Self. The adventure began when I finally said, "Yes! This is who I am!"

I undertook this journey with the imperative to distance myself from the hated female within—to disassociate myself with anything female. Now that I've undergone the physical change, there has been a balancing out. I feel more kindly toward some female aspects of myself and can enjoy femininity in women.

My journey now addresses more subtle changes that are no less profound. Now I am appreciating the difference between being a son rather than a daughter, a brother rather than a sister, a nephew instead of a niece. Most profound of all, however, are the ramifications of fatherhood: recognizing and appreciating the differences between being my children's father instead of their mother.

These are the things that no one told me about. The dynamics of fatherhood differ from those of motherhood in both subtle and obvious ways. I find each new discovery opens up whole new expanses of hitherto unknown territory within myself, and, not so surprisingly, those around me.

As an FTM I am a goer between worlds. This journey has great meaning. Our bodies are important. I have come to understand that manhood is sublime.

May I never take my manhood for granted!

May I never flout it or take advantage of another on account of it!

May I always give this gift of manhood my respect and honor.

May I be filled with gratitude for it.

Scott

I've lived all my life out of sync because my genetics betrayed my true gender. I've finally taken a few steps to match the physical me with the internal me. I've been taking hormones, had chest surgery, a hysterectomy, and changed my name and birth certificate.

Hormone therapy, for me, is easy to deal with. I know the injections of testosterone are bringing about physical changes I want and that feel natural to me. The gradual nature of the changes gives me time to adjust to the transformation, but I'm also impatient for results.

Although chest surgery has been my most serious step so far, it too was easy. It at least gave me half the body that I was meant to have. It freed me tremendously. The results were almost immediate and it affected my daily life in little ways, like being comfortable in my clothes. But, more importantly, I came to be comfortable without my clothes.

Changing my name had a much larger impact on me than the physical changes. Even though the gender issue was paramount in my life, I had lived that life with the name and identity that I had been born with. With one judge's signature, I was now someone else. However appropriate, I'm still not used to it.

Having my birth certificate amended to reflect my new name and sex was thrilling, but I felt some sadness too. Why wasn't I just born who I was supposed to be? Has my life been wasted until now? Will my mother ever accept all of this? Will I be complete and whole?

These and other questions are constant, and only time will be able to answer some of them. What there is no question about is that I'm doing the right thing for me. It's scary, it's frustrating, it's confusing, and it's worth it. This is my life.

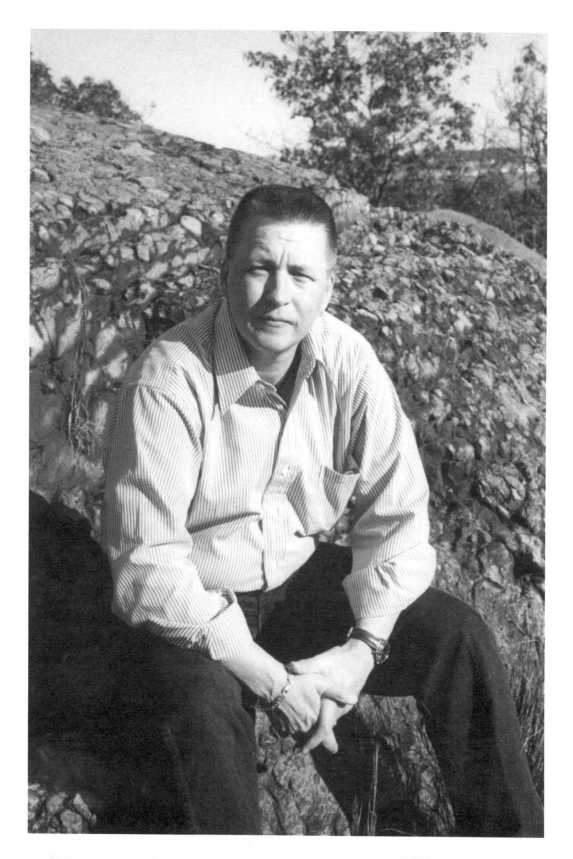

Jeff

A sex change. It sounds so exotic. I was brought up as a girl but felt like a guy. This has always been my reality, but until recently, medical intervention seemed beyond me. I did my best to accept what seemed like a cosmic joke. No one I knew felt like I did. Even my butchest friends liked being female. I finally realized that a lot of the people who felt like I did were shooting hormones. Duh. So at 40, I decided to do what had been on hold since my teens and moved from "bull dyke" to "straight man."

Living as a man feels so right, it's hard to believe it was ever otherwise. What was I thinking, all those years in the wrong body, in the wrong life, not being myself? I have a lot of questions now: Who are you when you're not being yourself? Sometimes the mask is so close to the skin that it seems it must be the skin itself. And when literally being in my own skin was so dissonant, how could I have been genuine? Now that I no longer need to make elaborate psychic adjustments to integrate the inner and the outer, what energies are freed up?

I am too newly transitioned to have a lot of answers yet. I know that I was trying to play the hand that nature dealt me, no matter how perverse. But when I attended the 1997 True Spirit Conference—the first time on the East Coast that FTMs gathered by the hundreds, the third such gathering in recorded history—I joined the nascent FTM culture. I saw that I could wipe the canvas clean and start a new painting.

All my life I'd been a pack rat, saving the detritus of my history to make collages, literally rearranging the pieces to make sense of my past. I had repeatedly drawn and erased on the canvas of female identity until there was no image left. Transition revealed a new picture, drawn on the same durable surface, but with new materials, new colors, new tools, new

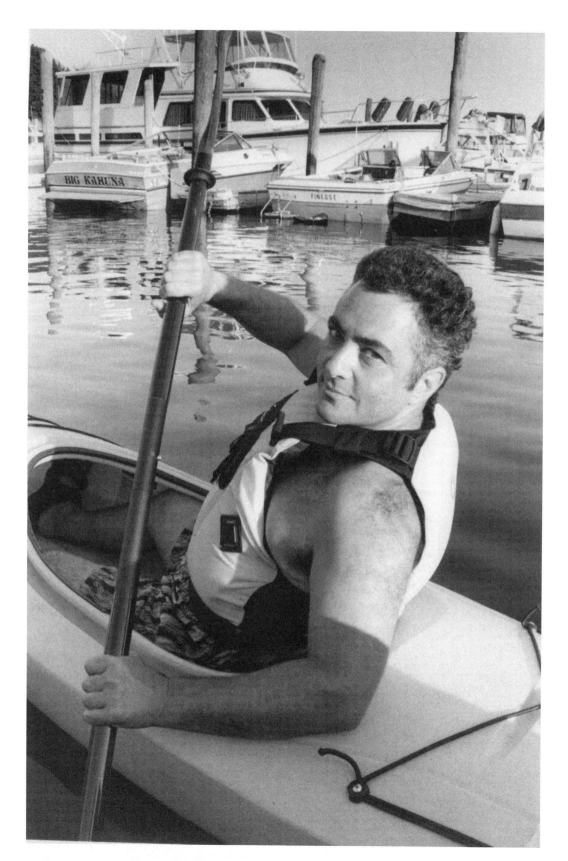

shapes. It was the picture that had always been there, the pentimento under the forgery.

I now wonder, *How did I function before?* It was with the constant visceral awareness that something was wrong, the way one can function while constantly distracted by a persistent headache. These slabs moving on my chest. Underneath that, the kinesthetic sensation of a smooth, flat chest. My brain is wired for the feelings of the unseen parts, knows them concretely like a bodily urge, like thirst. Yet, the extent of my internal maleness was largely a private, wordless experience. I had adapted well enough to the role I was playing that it didn't seem as unutterably sad or lonely as it was.

At age 8, the transistor radio plugged into my ear played Sam the Sham and the Pharaohs growling and howling, "Hey there Little Red Riding Hood / You sure are looking good / You're everything that a big bad wolf could want." An observer might have assumed this pigtailed child would identify with Little Red. Uh-uh. I knew I was the wolf. Others must have seen the tufts of fur sticking out under the sheep suit. But while living in the category of female, I didn't challenge being called "she," even though I was surprised that people really thought it was appropriate. Until I was ready to make medical changes, to talk about feeling male was to confront the shamed helplessness of being born into the wrong category. It was better to live stoically as female and make the best of it.

As a Capricorn, I've used the mountain goat as a symbol of how I moved through the world as a woman, climbing toward an unseen goal with tenacity and resourcefulness, finding my way along solitary slopes one step at a time, surviving on an austere diet. And like a stubborn, tireless, hungry goat, I covered that landscape thoroughly, grazed down every blade of grass, ate every thorny weed, until I had exhausted its possibilities. That's how I do things. Or did things: Don't throw something out until it's beyond repair. I find I'm more able to let things go since I made the big decision. I don't have to cling to scraps from the past as guideposts in my search for meaning. My newfound existential coherence gives me a security that was impossible before.

Part Three
Perspectives and Viewpoints II

The Transsexual Book of the Dead:
Osiris and the Trance Man

Rachel Pollack

Rachel Pollack is a poet, an award-winning novelist, writer on transsexual identity, politics, spirituality, and a tarot card artist and authority on the modern interpretation of tarot cards. Her novel, Godmother Night, *won the 1997 World Fantasy Convention's award. Her earlier novel,* Unquenchable Fire, *won Great Britain's Arthur C. Clarke Award, and was described by the* New York Review of Science Fiction *as "not only the best fantasy of the year, possibly the best of the decade, and the best feminist novel of the decade." Her writings on transsexual issues have appeared in the magazines* TransSisters *and* Spring: A Journal of Archetype and Culture. *She has published 13 books, including* 78 Degrees of Wisdom, *considered a modern classic and "the Bible of tarot reading." Her* Shining Tribe Tarot, *which she designed and drew, utilizes prehistoric images from six continents and 50,000 years. Her books have been published in nine languages. Rachel grew up in Poughkeepsie, N.Y., the setting for* Unquenchable Fire. *After 19 years living in Europe, she returned in 1990 to live in the Hudson Valley.*

Where do transsexual people find their stories? Where do they find the images that will take them beyond the rules that confine them, beyond the shame and fear that stop them from living their lives? Some turn to ideals of physical perfection as a model for their own desires. Some look to politics, creating new possibilities as they organize for immediate needs and a long-term place in society. And some look beyond their time and culture at people (and even gods) like themselves, both in legend and history. Through such discoveries they understand that they are not aberrations of modern life but in fact are part of traditions that go back to the beginnings of human culture.

Here is an old tale. A vengeful man, enraged at his brother's success, kills him. So crazed is he that he cuts his brother into 14 pieces and scatters them as far as he can. But the slain brother's wife is no ordinary woman. She searches until she finds the pieces of her butchered husband and puts him back together. Only, she cannot find his penis. She carves a substitute from wood, and miraculously, this human creation, this female-designed male organ, completes her husband, and he returns to life. Because he has died and come back, he becomes ruler and judge of all those who undergo a death and a rebirth. His name is Osiris.

There is a practice even older than the story. People born female have taken on male identities—in ritual, in trance experiences, and, sometimes, in their lives in society—for many thousands of years. In virtually every culture, people have known the desires and performed the actions that today society identifies as transvestite, transgendered, or transsexual. In many of these places and times, the females who became male signaled this change by wearing not only men's clothes but also some kind of phallus—a dildo made of leather, bone, clay, plant substance, or wood. The phallus does not make a woman a man. It acts as a marker (and, of course, a tool of pleasure). Because it is human-made it belongs to culture and signifies a new kind of experience. We will go back to this idea and its relation to transsexual people's bodies: *trans-formed* bodies; bodies formed out of the passion of transsexual desire.

People act out the impulse to change gender in many different ways. In some tribally based cultures healers take on the clothing and roles of the "other" sex. Such change may come after powerful hallucinations of dismemberment. Spirits seemingly will cut the person in pieces and then reassemble the pieces into someone reborn with power. The spirits may change the skeleton from bone to quartz crystal. And they may tell the reborn healer to change gender. For those who move from female to male this change may include wearing a carved or sculpted phallus. And because they act out experiences, even instructions, gained in otherworldly states of consciousness, they might be called *trance men.*

In the Greek and Roman world that bordered Egypt, cross-gender practices occurred in connection to particular gods and goddesses. Female-bodied worshipers of Artemis/Diana, Goddess of the Moon and the wilderness, wore animal skins and carved phalluses during wild sexual dances. Dionysos, Greek God of Wine and Ecstasy, counted among his followers men who dressed as women and women who wore hides and phalluses. Dionysos's devotees included bands of wild women called *maenads,* who broke all social rules as they ran madly through the countryside, frenzied drunk on their God's liquor. Some contemporary accounts of the maenads describe them as powerfully upright, their whole bodies like divine phalluses. Dionysos himself was transgendered, raised as a girl and described as feminine in manner and appearance. His worshipers created stick figures of their androgynous God, a scarecrow adorned with a beard and a dress.

Like Osiris, Dionysos suffered dismemberment, torn to pieces by spirits. Like the tribal healers, or *shamans,* a word from the Tungus people of Siberia, he did not come into his power until his original form was ripped apart. Something else connects Osiris and Dionysos. The Egyptians credited their God with the invention of wine. For this and other reasons, the Greek historian Plutarch described Osiris as the Egyptian Dionysos. Fermentation is a kind of miracle. Through a mysterious process that seems like decay, raw plants are transformed into an intoxicant powerful enough to break down restrictions of behavior and gender and send people into frenzied runs across open country. Like a phallus on a female body, the wine breaks down cultural controls. And yet, like an invented phallus, it represents civilization itself. The creation of wine takes raw products of nature (grapes for Dionysos, barley for Osiris) and uses an invented method to change them into something special. Hormones and surgery do something similar for the transsexual body.

Cross-gender evidence in Ancient Egypt is limited. Hatshepsut, a female Pharaoh who reigned from 1473 to 1458 BCE, wore an artificial beard to signify her right to the throne. Most people would see that as simply political, not transgenderist, but such distinctions are often illusory. A statue over 13 feet high of Akhenaton, who ruled from 1379-1362 BCE, depicts him with a bearded face and totally naked body, without penis or testicles. Interestingly, most images of Osiris show him beardless, so that he lacks the two most prominent signs of maleness, a beard and a penis. The Goddess Heptet, sometimes a helper of Osiris in the Underworld, appears with a woman's body and the head of a bearded serpent. Conversely, the God of the Nile poured forth the waters of life from female breasts.

According to gay historian Randy Conner in his book *Blossom of Bone,* Nepthys, the wife of Osiris's attacker, Set, was called "Amazonian" and anally penetrated her husband. The Ancient Egyptian tales called *The Secret of the Two Pharaohs* tells us that although Set and Horus, Osiris's son, were enemies, they merged on a mystical level. Dutch Egyptologist H. te Velde called this "a union of homosexual embrace." But it was more than that, for Set becomes pregnant and gives birth to a child fathered by Horus. We might think of those female-to-male transmen who have given birth and carry that experience of motherhood into their lives as men.

Set's baby appears as a golden disk on his forehead. In some accounts the magician God Thoth, ruler of all knowledge, takes the disk and sets it in the sky. The forehead is the place of the third eye, of psychic revelation.

Stories that survive for thousands of years, even beyond the cultures that created them, do not last because of their strangeness. They last because they encode layers of truth. Osiris, colored green in wall paintings and papyrus illuminations, originally represented the plants that die in the desert drought and return to life in the annual flooding of the Nile. The 14 pieces of Osiris's dismembered body indicate that he also signified the Moon, which wanes for 14 days, ending in darkness before it returns to life. The characters in the story

also represent planetary bodies at different times of the year, plus major shifts in culture, such as the move from a tribal society to one based on centralized government and unified religion. True stories do many things all at once.

Osiris's death and rebirth charts in great detail a transformation of consciousness. The pictures, stories, and hymns from five millennia that we call collectively *The Egyptian Book of the Dead* actually bears the title *Pert em hru,* or "Coming Forth into Light." The phrase brings to mind the modern expression "coming out of the closet." In the ancient stories, a soul often journeys through the darkness of death into a new existence. In modern experience, someone hidden, repressed, fearful, emerges into the light of a true identity. This identity has lived inside the person like a seed hidden in the Earth through winter until the urge to come out lets it shine forth, like the secret child who shone as a blaze of light on Set's forehead.

Ultimately, historical evidence of transgender sources for the Osiris story do not matter. We are not trying to make historical claims or set up a transgender outpost in Ancient Egypt. Instead, *mapping* the story of Osiris onto modern transsexual experience may illuminate contemporary truths.

Here, then, is the story of Osiris and his trans-formed phallus.

Nut, Goddess of the Night Sky and wife of Ra, God of the Sun, begins an affair with Geb, God of the Earth. The gods break the rules, especially sexual restrictions, for how else can they make something new in the world? Transsexual people learn this lesson early and then teach it to others so they may better navigate their impossible lives.

When Nut becomes pregnant, an angry Ra decrees that she may not give birth on any day of any month of the year. The story involves the calendar, for the Egyptians conceived of 12 months of 30 days each. Such a regular system, based on the signs of the zodiac, needs to account for those five extra days in the solar year. Now Thoth enters the story. Mysterious, all-wise servant of the Gods, inventor of science, writing, magic, mathematics, medicine, and all things intellectual, Thoth is the perfect model of the *expert.* Transsexual people might identify him as gender counselor, psychologist, and sex-reassignment surgeon all rolled into one.

Because the Moon rules the months, Thoth gambles with the Moon to win $\frac{1}{72}$ of each day. Out of these fragments he creates five days outside of any month for Nut to bear five babies: Osiris, Isis, Set, Nepthys, and the elder Horus (who does not figure much in the story). Thus, the Gods, the figures who can either enforce or change the rigid ways of the world, enter life outside of time.

Set, desert God of Snakes and Scorpions, marries Nepthys, Goddess of Death and Decay. Osiris marries Isis, Creative Queen of Heaven and Earth. The stage is set. The Egyptians mythically imagined themselves before the Gods as wild cannibals, ignorant of any food but each other, slaves to the basest physical appetites. Civilization came because

Osiris and Isis established an ordered society based on knowledge. Therefore, the story describes the change from a natural, barbaric condition to human civilization. Those who insist that transsexuality is "unnatural" or that people should stay "the way God made them" deny an essential human quality, the need to order and reshape raw nature.

Isis discovers wheat and barley. Osiris teaches their cultivation and the creation of barley wine. When he and Isis have developed laws for the people, Osiris decides to leave her in charge so he can travel the world and teach these wonders to humanity.

Where is Set in all this? Representative of the old ways, of the natural state of uncultured humanity, Set becomes more and more jealous of his brother. He needs a pretext to act against him. And what better destructive force than sex? Set dresses his wife Nepthys to appear as Isis and positions her in the dark so that Osiris will come upon her and give way to desire. From this union will come the jackal-headed God Anubis, who later will guide dead souls on their way to meet his father in the Underworld.

Now that Osiris has violated marital fidelity, Set can move against him. He gathers 72 henchmen to help him destroy his brother. They represent the force of conformity, of repression at all costs, even death. Transsexual people know them well. But why 72, that same number as Thoth won from the Moon?

The significance of this number lies in the heavens. In our short lives, we see the stars fixed in the sky night after night. In fact, the constellations rotate, very very slowly. The time they take to move completely around the Earth (the Great Year, as Plato called it) lasts 25,920 years. If we imagine the zodiac as a circle of 360 degrees, then one degree—$\frac{1}{360}$th of 25,920—is 72.

The circle of the Great Year represents the total person, whose life, if not limited, would open to endless possibilities. Set's gang of 72 seek to narrow Osiris to one degree of his infinite nature. They do this through measurement.

While Osiris sleeps, Set precisely measures his brother's body. Set then constructs a special box, jeweled and carved on the outside, but inside formed to be an exact container for Osiris. At a banquet Set pretends to discover this object and proclaims that it will go to anyone who might fit inside it. Like Cinderella's stepsisters, the 72 all try it without success. Finally Osiris lies down in the box and fits so tightly he cannot get out before Set and his henchmen have slammed down the airtight top, nailed it shut, and sealed it with molten lead. They send the suffocated Osiris floating away on the Nile.

To measure a god is to trap him in a physical form, to limit his essence and prevent change. For anyone in a sexual minority this story suggests something very real. When a person lives the lie of a "normal" life, he must conceal and suppress his most intense desires and beliefs. Such a life may feel less like a closet than an airtight box that becomes a coffin for his true self. The box may be attractive, for society rewards confinement. The person gets approval, the love of family, jobs, a place in the community. Only, he cannot breathe.

Believing he cannot get out of a box that completely encloses him, he may feel it carry him further and further away from a life of joy and integrity. For the transsexual man, this box is the fake identity of life as a woman.

Set traps Osiris at a party. At a celebration, or when intoxicated, people who have hidden their sexuality may take some small step to exposure. They may move or gesture in the wrong way, or speak the wrong emotions, even make a clumsy pass at the wrong person. And, too often, the disapproval and shame thrust on them tightens the coffin of their living death.

Earlier we identified Thoth as the image of the helping expert. Set represents the other side of authority, especially those psychologists who measure people in order to confine them. Children whose behavior strays from approved gender standards find themselves tested, examined, and sometimes locked up, like Daphne Scholinski, author of *The Last Time I Wore a Dress,* who describes the years spent confined in a mental hospital, forced to endure electric shock and other coercive tortures because she behaved too much like a boy.

If Set is found in some psychologists, we find the henchmen in all those people, institutions, and rules that enforce the system of measurement—families with their pressure on children not to embarrass them, schools, bullies, dress codes and drag laws, police, prison systems—sometimes even transsexual support groups in which people measure each other and themselves against standards of appearance and behavior. All measurement is a lie. It narrows us to whom we appear to be at just that moment, one degree of the full circle of our truth and our possibilities.

The story of Set and Osiris describes desire and revenge, adultery and murder, because mortals know these things and act them out every day. But we come from the stars as much as we come from the dirt, and the point of seeing ourselves in stories about the gods and goddesses is to understand that the passions that move us connect us to larger patterns. Such passion may even serve to bring some unformed spiritual energy into physical reality, like artists who describe themselves as the servants, not the masters, of the work they produce. Transsexual people may feel the sense of something carrying them along, for there is no passion more powerful than transsexual desire.

Osiris floats away, helpless. Now another figure takes over the story. Isis, whom the later Romans will call the Great Goddess of a Thousand Names, who even today has active worshipers and temples all over the world, goes in search of her husband/brother. We might consider Isis as the F in FTM, the female force in the creation of the transsexual man. While some transmen claim total maleness and want nothing to do with any history of being women, the majority consider this aspect of their lives vital to who they are now. Sean Parker Denison, a transman and Unitarian minister, put it this way: "People who have experienced their lives and identities dismembered in transition do not want to discard any of the pieces when they put themselves back together again."

This determination to honor the past comes partly from transmen's political experiences. Many have suffered the oppression of a culture that treats female bodies as objects, and certain kinds of female bodies—muscular girls, butch women—as objects of ridicule and violence. For many FTMs, to discard the "female" in "female to-male" would dishonor both their own history and all those women with whom they once found community.

Many transsexual men reject the idea of becoming *just men*. Rather than fit into what they consider an aggressive masculine world, they seek to use their special experience to help create "new men," men who open possibilities for male consciousness (the term also plays on the outside world's view of them as newly created). In this they follow Osiris, for when Isis reassembles him he too receives the title New Man, something the world has not seen before. We cannot define the "new men" of the FTMs. To call them "sensitive" or "nurturing" is to reduce them to clichés. Newness does more than extend old definitions or even replace them. At its heart, the idea of becoming new allows transsexual men to search out their own possibilities, beyond all definitions and measurements.

An Internet search for the terms "Osiris+phallus" may turn up a curious chat room discussion from 1995, led by a woman named Solara (an identification with the Egyptian Solar God, Ra). In her chat, held on Sun-day, she described a vision of "the completion of the legend of Isis and Osiris" through the creation of the "New Man" and the "New Woman."

"The woman helps birth the New Man," she wrote. "But then it is the New Man who helps the woman become the New Woman. Only then do they fully unite into One Being." If we translate this esoteric image into the lives of transsexual men, we can say that the transman who refuses to deny his past or to enter into the patterns of ordinary masculinity allows his female experiences to help create the New Man, who then becomes a kind of revolutionary, offering new ideas to the wider society.

Isis discovers that the coffer containing Osiris's body has washed ashore at a place called Byblos, in Syria. Even in death Osiris remains a force for life. An erica tree grows up around the box with his corpse and becomes a pillar of the royal palace. In that region of drought, in a time when few people survived longer than three or four decades, long-lived trees, strong and sturdy, seemed the very emblem of divine power. The Canaanite people worshiped the Goddess Astarte by planting trees. Astarte presided over gender-changing rituals and could even change gender herself. In some accounts of Osiris's story we learn that the queen of Byblos was named Astarte.

The Egyptians especially valued giant trees because they were scarce in their own land. If they wanted to build anything of wood, they needed to import the trees from Lebanon. In the box inside the tree upholding the palace, Osiris's whole body becomes upraised, erect. This image of a god inside a pillar goes back to the Stone Age. In the worship of Osiris it became known as the Djed pillar. A life-size or larger Djed pillar carved from wood was featured in Osirian festivals for many centuries. While we might see this pillar as the

ultimate male fantasy, the eternal erection, it also signifies civilization, for it upholds buildings and continues tradition. Rather than symbolizing the phallus, the Djed pillar actually signifies the spine as the channel for the life energy that can rise from the spine's base to the head, where it can open in the mind like a lotus flower in an ecstasy of divine consciousness.

This distinction between the Djed as representation of the phallus and the Djed as symbol of the spine is very important for a full understanding of Osiris's divine significance. It also can illuminate the difference between transsexuality as a fixation on genitals and transsexuality as an emergence of new consciousness.

The Djed indicates the spine only. There is no head shown, thus no ego. This is not a modern idea. Many Stone Age figurines and paintings display bodies without heads. A very ancient way of offering up dead bodies involves removing the head and leaving the body for vultures to pick off the decaying flesh. Tibetans, whose culture also features a *Book of the Dead,* still enact funerals this way.

What might it mean to consider the life energy of the spine without the head? The head is the site of individual personality. The desire to change gender may appear to others as the ultimate self-indulgence. And yet, many transsexual people experience this need as so intense they can only laugh at the idea that they are choosing a "lifestyle." In a very real way, transsexuality chooses them.

When Osiris travels the world to teach agriculture and wine making, one of the places he visits is India. His transgendered Greek cousin Dionysos also went to India, on his mission to show the world how to ferment grapes. According to the Asian Indian teachings of kundalini yoga, basic life energy lies coiled at the base of the spine like a sleeping serpent. Through meditation and exercises that may include sexual practices called *tantra,* the energy awakens and like undulating snakes moves up the spine to encounter seven focal points, each called a *chakra* (Sanskrit for "wheel"). In order for the kundalini snake to continue, these chakras must open. When the energy travels all the way up the spine to the top of the head—the "crown" chakra—it produces a state of ecstasy. The head actually seems to vanish, along with the distinction between the self and the surrounding world.

While Tantric practices are associated primarily with India, we find evidence of them all over the world. According to Jonathan Cott, in his book *Isis and Osiris: Exploring the Goddess Myth,* the earliest pictorial indication of kundalini knowledge "to exist *anywhere*" is an Egyptian papyrus painting dated around 1300 BCE. The picture shows a portion of the Underworld Judgment Hall where Ma'at, Goddess of Truth, weighs the heart of the dead person on a scale balanced against an ostrich feather. Seven disklike circles emblazon the center pole upholding the balanced scales. Ammut, a mythological monster with the forequarters of a crocodile, the hindquarters of a hippopotamus, and the body of a lion, places his snout between the third and fourth circles. Ammut served an important function in the

judgment of souls on their way to rebirth. He devoured the hearts of those who had not freed themselves of secret sin. The fourth, or middle chakra, resides at the heart. For the kundalini serpent power to move freely the heart chakra must open, but it cannot open if a person has burdened his heart with guilt or shame, the great enemy of transsexual honesty. If the transsexual person takes steps to liberate his outer conditions but does not release shame, a psychic Ammut will stick his snout of panic and fear at the moment the person tries to open the heart.

In the painting, Isis points to the sixth circle. In various places in the ancient world people associated the number six with Goddesses of Passion, such as Aphrodite and Ishtar. These same Goddesses presided over the ecstatic transformations of gender. We find the sixth chakra at the third eye, the place on the forehead where Set's baby, in the form of a disk, blazed forth. Opening this next-to-last chakra may bring psychic knowledge and impressive powers usually thought of as miraculous. Teachers in sacred traditions warn against the seduction of these powers. They can lead to inflated pride and a loss of real purpose. Perhaps Isis points to it both for its importance and as a warning.

We do not need esoteric connections to understand the seductive sensationalism of transsexual experience. Coming out and crossing over produce euphoria. People who open their hearts and begin living a new life experience a surge of power. They may amaze everyone around them. People may admire them for their courage. Such experiences are genuine rewards of living openly after a lifetime of fear and denial. And yet, if transsexual people allow such excitement to seduce them, they can lose themselves in trivial gender bending—for example, acting in ways that will shock and entertain the people around them rather than express their own lives.

At Byblos, Isis recovers her husband's body and sets sail for Egypt. Though released from the tree trunk and the jeweled box, Osiris lies dead while Isis hovers above him in the form of a bird. The beating of her wings arouses Osiris's phallus, and in union with it Isis conceives their child Horus, who will become his father's heir and avenger. Isis hides Osiris's body among papyrus reeds, the plants that will later become the paper on which the scribes will record Osiris's tale so the world will know of it. Isis then goes in search of help.

Now Set returns. Hunting a boar under the full moon, he discovers a greater prize, his hated brother. Set spears Osiris's body and cuts it into 14 pieces. He hides the parts throughout Egypt. One part, the penis, he throws into the Nile, where a fish swallows it and takes it to the bottom of the river or out to sea so that it becomes forever lost.

Set finds Osiris near the city of Buto, once the capital of the Snake Goddess who ruled Lower Egypt before the Pharaohs. Set himself was called a serpent, with a double tongue and a double penis. From the coiled snake of kundalini to the cunning serpent of the Bible, from the Feathered Serpent God of Mexico to the Rainbow Serpent of Aboriginal Australia, snakes slither through virtually every mythology. Dale Pendell, writing of India in his book

Pharmako/poeia, tells us, "The simplest wayside shrine consists of a tree, a stone, and a snake."

Snakes represent primal energy, liquid fire. They evoke the phallus by their tubular shape but also the complex form of female genitals by their sinuous coils. Snake venom, especially from cobras, can produce ecstatic visions. Teiresias, the archetypal seer of Greek mythology, changed sex, first from male to female, then seven years later from female to male, when he/she discovered snakes copulating and each time killed one of the pair.

It is too simple to call Set evil. If he dismembers Osiris as a serpent, then we find ourselves back in that hallucinatory world of the shamans, with Set an agent of that demonic force (we would say from deep in the psyche) that rips apart the outer form of an ordinary member of the tribe in order to let loose the magical transformation that gives him his shamanic power. As we map the story onto the actual lives of transsexual men, the serpent Set becomes transition itself, in its aspect of destroyer—destroyer of socially acceptable lives, of masks, of official identities.

Modern psychobabble reduces all change to "healing," as if everyone is spiritually sick in some way. Transsexual people not only learn to see their desires as sick but are offered a deal: Describe yourself as mentally ill (currently, with a disease called "gender identity disorder"), and the doctors will give you the means to change your body and even your legal gender; refuse to call yourself sick and you get nothing. Think of Osiris. Osiris as a ruler is not sick in any way. He is successful, admired, a gentle teacher. He does not need Set to heal him. He needs Set to *kill* him because his very success means he cannot change in any other way. Osiris could not become God of the Underworld if Set did not first dismember him. For transsexual men and women the outer persona must die to make way for something new, and as with Osiris, psychological dismemberment and reconstruction opens the way to new life and wisdom, not just for themselves, but for all those around them.

Sean Parker Denison, an FTM minister whose information and insights have informed much of this essay, speaks of healing, but not from a sickness. Instead, accepting himself as male allows him to inhabit his body in a way he could never do when he tried to see himself as female. "The desire to be whole," he wrote in a personal letter in the winter of 1997, "was not just an emotional or mental kind of desire, it was also a longing inside my body."

Denison speaks of a recurrent dream he had over the years before his transition. He would look in the mirror and not see any reflection. Then he would wake up crying and frightened. Like many transpeople, Denison took his first steps by meeting transsexual men. These became his guides—his mirrors. Shortly after his first FTM meeting, his dream changed. Again he looked into an empty mirror, but now a voice told him to turn the mirror around. When he did so, he saw a male face. Once more he woke up scared, but this time not because he did not know who he was, but because he did.

The spirits who tore apart Dionysos came at the god out of a mirror. Sean Denison, for

whom a mirror proved so powerful a symbol, says that his transition so changed his life that he often thought of shamanic dismemberment. Though he speaks of transition as a healing, he describes transsexuality itself as "a gift, a choice, and a radical act of self-love."

According to Lydia Afia, a researcher of Egyptian myth and author of *Stories From Egypt and Beyond,* Nepthys was the Goddess of Decay and Decomposition. Osiris begins as a pure spirit detached from mortality. When he gives way to desire and mates with Nepthys, he enters the world of change, of death. Transsexual people afraid of their strange yearnings sometimes deny them by emotionally separating from their bodies, as if they can become pure thought or simply present a socially acceptable mask. Sean Denison has said that as a woman, even a butch lesbian, he could never feel anything. A dream body who looked in the mirror and saw nothing.

The first step of transitioning requires transsexual people to take chances, to expose their true feelings and desires. But even that is not enough. They need to allow that serpent power of desire to dismember their old selves so that they can put themselves together in a new form.

Set's concealment of the pieces of Osiris is no match for the determined will of Isis. And yet, it is not just her reassembling of the 13 pieces that brings Osiris back to life wiser and more powerful than before. It is the constructed creation, the carved wooden phallus that Isis attaches to Osiris's body to replace the missing 14th part.

Osiris's wooden phallus makes him a part of human culture. It also links him to a world older than the animals, the vegetable world. Once a tree imprisoned him; now a wood carving will mark his power. Women in Ancient Egypt would celebrate Osiris's annual restoration and the return of life to the desert by parading with puppets that displayed giant genitals. Similar celebrations continue even today. In carnival parades in Italy women sometimes carry giant phalluses. In a yearly Spring festival in Komaki, Japan, a line of people carries an eight-foot-long wooden phallus through the streets. None of these people worship male genitals; instead, the wooden phallus embodies the surge of nature that defeats drought or the darkness of winter.

A wooden phallus is a kind of visual joke on male fantasies of a penis that remains always erect and powerful. A wooden phallus, or any dildo, never loses its erection. Like the tree, it remains firm no matter what else is happening. And yet, everyone knows that it can come off. The meanings becomes more subtle if the constructed penis belongs to someone born female, like the maenads of Dionysos, or the dancers who worshiped the lesbian Goddess Artemis, or the healers who live as men. Their maleness, like that of the modern transman, is more complex, more cultural, than that of a man who never goes through a trans-formation. The phallus in such situations represents a complex play of physicality, desire, and identity.

The transman, ancient or modern, brings himself to new life with a psychic phallus, an

inner knowledge of manhood that may or may not show itself with an actual penis. A great many transsexual men have stated that phalloplasty may be very significant but it is not the ultimate goal. They can embody their maleness in a whole range of other ways, from the way they shape themselves with hormones and chest surgery to the ways they act in the world and in relationships. They do not need to imitate non-transsexual men. Instead, like Osiris, they become New Men.

The myths of Osiris directly link his story to mummification. Like many ancient peoples, the Egyptians gave a mythological source to their technological discoveries. Thus we find that mummification originates with Osiris and that expert of experts, Thoth. Dropping to Earth from his job of guiding the Sun God's boat through the sky, Thoth teaches both the science and magical spells of mummification to Isis, Nepthys, Horus, and Anubis. Many gods take part because actual mummification did in fact require a team of embalmers and assistants. Transsexual people may consider that teamwork an evocation of the modern gender clinic, where a surgeon, psychologist, endocrinologist, and other helpers all may work under the same roof.

Mummification was not an overnight process like modern embalming. According to the ancient texts it took 70 days (this number is probably symbolic rather than actual; seven times 10 is a magic number in many cultures). Similarly, a "sex change" is not the quick process implied in tabloid news stories. For transmen it involves a long period of hormone therapy as well as several operations. Most importantly, the real point of both mummification and sex reassignment is not to produce a medical marvel but to make possible a new existence.

After mummification, the Egyptians raised the body upright for a ceremony called the "Opening of the Mouth." This ritual follows a moment in the Osirian myth when Horus opens his father's mouth for the final act that brings him back to life. Once again, there is an analogy to transition. The transsexual person claims a place in the world through an act of language, the statement "I am a man," or "I am a woman." Everything else depends on this assertion, for all the hormone therapy and surgery cannot create a life without the willingness to make that outrageous statement.

Speaking also figures in the tests described in the *Pert em hru.* In order to come forth, the soul had to appear for judgment before a kind of Underworld court with Osiris as the arbiter. The person speaks on his own behalf, using various formulas and passwords to influence the judgment. Right away, many transsexual people might think of the process of gaining consent for hormone therapy and surgery. There, too, the transman needs to convince a judge or judges of his worthiness. And just as the dead person in search of rebirth learns the right passwords, so the transsexual candidate learns how to say what the gatekeepers want to hear, phrases such as "I feel like a man trapped in a woman's body."

The term "password" suggests *passing,* that great monster of the transsexual world. In

earlier years, all transsexual people wanted to pass, or so everyone assumed, and transsexual men and women ranked themselves for their passing skills. Now many people, especially transsexual men, who tend to pass fairly easily, have pointed out that when someone passes, he or she effectively becomes invisible, for without their history, who are they? Passing can become another jeweled box, one that hides the past. For the person who passes with some uncertainty, every encounter becomes a test. And for the one who passes completely, the past becomes a threat, a land mine of discovery that anyone may step on at any moment. And yet, the man or woman who does not pass must endure the stares and possible bigotry of everyone he or she meets.

The debate on passing is far from over. It is interesting, however, to consider the moment of judgment described in the *Pert em hru*. Armed with the right *pass*-words, the candidate appears before the assembled gods, where he must proclaim himself to be free of sin. And yet, according to the texts, it was possible to deceive the gods. To those of us who have grown up in religions that worship an omniscient god who observes every flutter of a sparrow, such deception sounds absurd. And yet, it goes back to a viewpoint far older than the Jewish or Christian God, conceived as an all-powerful "Eye in the Sky." In many shamanic and pagan cultures, humans engage the gods, even struggle with them. Often they will trick the gods to get what they need to ease human suffering. This might be compared to the transsexual person who works the gender system, who might even fake a suicide attempt to wrest the magical technology of sex changing from the doctors. Many transsexual people also have used the skills of passing to get jobs or legal papers.

All this may seem like trickery, even fraud. And yet, many cultures look on trickery as an almost divine trait. Hermes, the Greek equivalent of Thoth, was not only the God of Science, Magic, and Art, he also was the God of Swindles and Theft. The Greek Prometheus stole fire from the gods to raise humans from animal helplessness to civilization, something Osiris does through education.

The transsexual man who "swindles" surgery from the gatekeepers, or who passes as a non-transsexual, takes on the role of the *trickster* found in so many mythologies. Tricksters break down the boundaries that limit people's sense of reality. Whether transsexual men and women reveal themselves or not, their very existence shatters the supposedly rigid categories of male and female. Even when the transsexual person passes—maybe more so—those categories become meaningless.

Lewis Hyde, in his book *Trickster Makes the World,* comments that tricksters do not only break down boundaries, they sometimes make people aware of boundaries they did not know existed. Most people consider anatomy, gender identity, sexual preference, and behavior as all one package. They believe that someone born with a vagina will become a woman, desire men, and act in a feminine way. The trickery of the FTM transsexual demonstrates that qualities people think of as all the same are really very different. Someone born female

can identify as a man, desire a man or a woman as a sexual partner, and sometimes act masculine, sometimes feminine. What better example of a trickster can we find?

After the dead person's declaration of innocence comes the moment when the heart of the deceased is weighed against an ostrich feather. Freed from the burden of guilt, the dead person could "come forth" to a new life. If the heart weighed down the scales, Ammut would devour it. For the transman, letting go of shame and fear is not a moralistic issue but something close to an emotional necessity.

The person who passed these ordeals was dressed as Osiris and brought before the God, who opened the way to the afterlife. Though this account does not involve gender crossing, it may remind transsexual people of the power of clothes. Despite our modern, complex understanding of gender, clothes are still the most visible markers of identity. This is why Daphne Scholinski was locked in a hospital for refusing to wear a dress, and why the drag laws demanded that females wear feminine underwear, and why butches would risk imprisonment and beatings to wear boxer shorts that no one would see except their lovers (and the police).

The wearing of gender-marked clothes carried a ritual meaning in many cultures. Even today, many people treat cross-dressing and drag as semi-magical (see, for instance, such movies as *Paris Is Burning* and *The Adventures of Priscilla, Queen of the Desert*). For transsexual people, clothes help to bring to life that secret truth hidden in the body.

The transsexual sense of a secret self finds an interesting metaphor in the complex Egyptian understanding of the soul. Western people think of the soul as one unchanging essence. The Egyptians conceived of several different souls. The immaterial part of a person they called the *akh*. The person's character they called the *ba*, envisioned as a bird with a human head. They also recognized another soul aspect, called a *ka*, a kind of secret double created at birth to grow with the person. The *ka* lived in a person's dreams until death, when it emerged to travel to the next world. Maybe we could describe transsexual people as those who find their *kas* at odds with their physical bodies. Some of the older stories of transgendered persons, from times when almost no one could cross over, poignantly describe how they saw their real selves in dreams or vividly imagined how their real sex would emerge in the afterlife.

For transpeople, a hope of releasing the true self after death is a surrender to repression. Unlike the Ancient Egyptians, who shifted emergence entirely to the supernatural afterlife, transmen come forth into the light in this world. They do this through transformation of the body—the body formed partly through hormones, partly through clothing, partly through attached phalluses, but above all, through the intensity of transsexual desire.

For the final word on this subject we will turn to the *Pert em hru* itself, as translated by Normandi Ellis in her book *Awakening Osiris*.

From Incantation 55 of *The Egyptian Book of the Dead:*

At the end of the universe is a blood-red cord that ties life to death,
man to woman, will to destiny…Give me not words of consolation.
Give me magic, the fire of one beyond the borders of enchantment.
Give me the spell of living well…I am the Knot where two worlds meet.
Red magic courses through me like the Blood of Isis, magic of magic,
spirit of spirit. I am proof of the power of Gods.

REFERENCES

Afia, Lydia. (1998). *Stories from Egypt and beyond,* Neteru Editions, Stone Ridge. (Information also from private conversation.)

Budge, Sir Wallis. (1959). *Egyptian religion.* University Books.

Budge, Sir Wallis. (1961). *Osiris.* University Books.

Campbell, Joseph. (1974). *The mythic image.* Princeton University Press.

Conner, Randy P. (1993). *Blossom of bone: Reclaiming the connections between homoeroticism and the sacred.* HarperSanFrancisco.

Cott, Jonathan. (1994). *Isis and Osiris: Exploring the goddess myth.* Doubleday.

Denison, Sean Parker. Private correspondence and conversations.

Doty, William G. (1986). *Mythography: The study of myths and rituals.* University of Alabama Press.

Elder, George R., ed. (1996). *The body: An encyclopedia of archetypal symbolism.* Volume 2 of 2. Shambhala Press.

Ellis, Normandi. (1988). *Awakening Osiris.* London.

Grof, Stanislav. (1994). *Books of the dead.* Thames & Hudson.

Harding, Esther. (1955). *Woman's mysteries, ancient and modern.* Pantheon.

Hyde, Lewis. (1979). *The gift: Imagination and the erotic life of property.* Vintage.

Hyde, Lewis. (1998). *Trickster makes this world.* Farrar, Straus, & Giroux.

Jung, C. G. (1967). *Symbols of transformation.* Princeton University Press.

Lamy, Lucie. (1981). *Egyptian mysteries: New light on ancient knowledge.* Thames & Hudson.

Leeming, David Adams. (1990). *The world of myth.* Oxford University Press.

Leeming, David Adams. (1998). *Mythology: The voyage of the hero.* Oxford University Press.

Neumann, Erich. (1954). *The origins and history of consciousness.* Translated by R. F. C. Hull. Princeton University Press.

Neumann, Erich. (1955). *The great mother: An analysis of the archetype.* Translated by Ralph Manheim. Princeton University Press.

Pendell, Dale. (1995). *Pharmako/poeia: Plant powers, poisons, and herbcraft.* Mercury House.

Scholinski, Daphne. (1997). *The last time I wore a dress.* Riverhead Books.

Solara. Chat room discussion on the Phallus of Osiris with author, available at http://www.nvisible.com

Te Velde, H. (1967). *Seth, god of confusion.* Translated by G. E. van Baaren-Pape. E.J. Brill.

Thompson, William Irwin. (1981). *The time falling bodies take to light: Mythology, sexuality, and the origins of culture.* St. Martin's Press.

We Were There:
Female-to-Male Transsexuals in the Civil War

By Ken Morris

Ken Morris is a graduate of Massachusetts Institute of Technology and is working as a biological illustrator. He is active as a Civil War reenactor and has been involved as an activist for transsexual rights.

On a monument in Vicksburg, Miss., commemorating the service of 36,000 Illinois soldiers in the Civil War, the name "Albert D.J. Cashire" is inscribed. And in the Chalmette National Cemetery in Louisiana, among the graves of men who died in the war, stands a small headstone marked "Lyons Wakeman—N.Y." What most people don't realize is that these two soldiers were born female.

In her 1887 *My Story of the War,* Mary Livermore of the U.S. Sanitary Commission (a forerunner of the Red Cross) wrote that "the number of women soldiers known to the service" was about 400, although she suspected that the actual number was larger. Some of these female volunteers were quickly discovered and sent home, but a significant number managed to elude detection and serve for months, even years. Today one wonders how this could be possible, but in the 1860s, physical examinations were cursory at best. One soldier recalled, "When we were examined we were not stripped...All that we did was show our hands and feet." And a female's ability to pass as male was aided by the fact that many beardless boys served in the military.

What motivated these individuals to subject themselves not only to the danger and privation of war—the long marches, the often inadequate food and shelter, and disease—but also the constant stress of keeping their identity a secret? Some women, such as Loreta

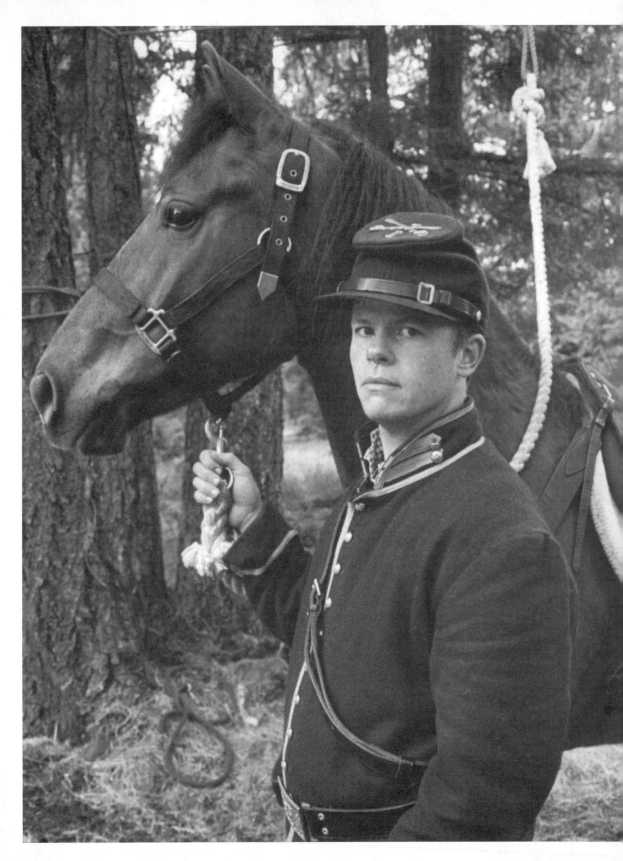

Janeta Velasquez, wrote that they served out of a feeling of patriotic duty or a desire for adventure—reasons shared by many of their male comrades. Some, such as Frances Day (Sgt. "Frank Mayne") of the 126th Pennsylvania, followed beloved husbands or lovers into service. But others enlisted, as author Geoffrey Ward noted, for "more complex psychological reasons." In his *The Life of Billy Yank: The Common Soldier of the Union,* historian Bell Irvin Wiley acknowledges that some females cross-dressed for reasons other than patriotism or familial loyalty—unkindly referring to them as "freaks and distinct types."

Ward and Wiley were alluding to the famous case of Pvt. Albert Cashire (spelled "Cashier" in some accounts), born Jennie Hodgers in Clogher Head, Ireland, in 1843. As a youth, Hodgers stowed away on a ship bound for the States and soon after was working as a farmhand and shepherd—apparently, in male attire. In 1862, Hodgers enlisted in the 95th Illinois infantry under the name of Albert Cashire and thereafter amassed the longest continuous service record of any female in the war—over three years, including participation in 40 battles and skirmishes—without detection.

After the war, Cashire returned to Illinois and continued to live as a man nearly until the end of his life. In 1890, he applied for a military pension. His request was denied because he refused to take the required physical examination, but a later request was granted. In 1911, a car struck him and fractured his femur near the hip. While treating him, doctors discovered that he was actually a female. For a time he was able to prevail upon them to keep his secret, and he was allowed to live in the Illinois Soldiers' and Sailors' Home in Quincy, with the commandant's consent. None of the other veterans there knew his secret.

But in 1913 Cashire was deemed mentally incompetent, committed to the Watertown State Hospital for the Insane, and forced to wear a dress. The day after his commitment, the *Washington Sunday Star* ran a story: "POSED AS A MAN 60 YEARS: 'Albert' Cashier [sic], Who Served in Civil War, Committed to Insane Asylum." Other reporters came to interview and photograph the old soldier. Fellow veterans also came to visit, but what they saw shocked and saddened them. When Charles Ives visited his old comrade, he found Cashire "broken, because on discovery she was compelled to put on skirts." According to Ives, Cashire was "awkward as could be" in a dress, fell, and reinjured his hip. Despite "every possible attention" given by doctors and nurses, he never recovered from the injury and died not long afterward, on October 10, 1915. But I suspect that Cashire's death had as much to do with being stripped of his manhood as his actual injuries. This formerly tenacious individual simply lost his will to live.

After his death, Cashire's comrades took care of their own. The Saunemin post of the GAR (Grand Army of the Republic) arranged for the funeral. Cashire was buried not in a dress but in his uniform, with full military honors. And his tombstone, provided by the War Department, bore only his male name. (Years later, another stone was added that disclosed his birth name.)

Pvt. Lyons Wakeman, of the 153rd Regiment, New York Volunteers, was born Sarah Rosetta Wakeman, the eldest child of nine, in January 16, 1843, near Binghamton. Wakeman is the only female soldier for whom letters written during the war have been found—discovered in an attic by a relative in 1976 and subsequently compiled by Lauren Cook Burgess in *An Uncommon Soldier: the Civil War Letters of Sarah Rosetta Wakeman.* Burgess appears entirely unfamiliar with gender identity issues and treats Wakeman as a woman without question, yet in reading Wakeman's letters I find evidence that he did not view himself as such. It is my belief that Cashire and Wakeman were not cross-dressing women but female-to-male transsexuals.

Freed from the constraints of their upbringings and the expectations of their families, many men used the Civil War as an opportunity to remake themselves—or were remade by their experience. Men who had not traveled 10 miles from their hometowns now found themselves covering great distances. Men who had been defined by their family connections, class, and ethnicity (or their past mistakes) now found themselves relatively anonymous individuals in a vast crowd, to be judged on their own merits. The psychological effect of this cannot be underestimated. I believe that Cashire and Wakeman also experienced a shift during the war. Before they left home, society had defined them by their bodies. Their war experience showed them that they could define themselves.

It must be remembered that transsexualism is a rare condition, and most of the women who served the Civil War (and many other wars) did not identify as male. Sarah Emma Edmonds served for two years in the Second Michigan Volunteers as Pvt. Franklin Thompson. After illness forced her to leave the army, she continued to serve the war effort as a nurse. In 1864 she published a well-received memoir of her exploits, titled *Nurse and Spy.* In an interview with the *Lansing State Republican* (June 19–26, 1900), she said, "I think I was born into this world with some dormant antagonism toward man…In our family the women were not sheltered but enslaved; hence I naturally grew up to think of man as the implacable foe of my sex." From this quote it is obvious that Edmonds identified strongly with women, not men. She apparently never cross-dressed after the war was over (she showed up at a reunion of her regiment in female clothing), and she continued to be a strong advocate for the equality of women. In 1897, she gained admission to the GAR, its only (or at least its only *openly*) female member. (Curiously, Edmonds is profiled in Jonathan Ned Katz's 1976 *Gay American History,* despite the fact that she married a man after the war—an apparently happy marriage that endured until her death in 1898. In so doing, Katz makes a common error in interpretation: assuming that all women who cross-dress are lesbians.)

Some gay and lesbian historians have questioned the existence of transsexualism prior to the 1930s, when medical treatments to change a person's physical sex were first applied successfully. They view the condition as a medical "construct": Before hormones and surgery there were no transsexuals, only masculine women and feminine men. But one must

remember that it is not having had surgery that defines a transsexual but rather a person's underlying conviction that he or she is really the opposite sex. Whether medical treatment is available is another matter entirely. So what I am doing here is making a posthumous "diagnosis" of gender identity, based on the historical evidence.

Clearly transsexualism, like other medical conditions, existed long before doctors gave it a name or developed treatments for it. Records of individuals attempting to change their sex (through self-administered surgery or various "home remedies") go back a long way. Male-to-female transsexuals were performing surgery on themselves in Roman times. Female-to-male transsexual Alonso Diaz Ramerez de Guzman (born Catalina de Erauso in 1592), who lived as a man from the age of 15 until his death in 1650, used a poultice to cause his breasts to "disappear." Guzman/Erauso claimed that although this treatment hurt a great deal, he was very happy with the results. And in 1913—two years before Albert Cashire died—-surgery (a hysterectomy) was given to another female-to-male transsexual in Oregon named Alan Hart, based solely on a psychiatric diagnosis of cross-gender identity.

Katz and others point to social and economic reasons for females of that era to assume a male identity: to "legitimize...socially unsanctioned [lesbian] relations" or to gain access to higher-paying, male-dominated jobs. While these motives appear to figure in many cases of historical female cross-dressing, proof that they applied in either Cashire's or Wakeman's case is lacking. First of all, there is no evidence that Wakeman or Cashire ever had a lover of either sex. The argument of economic opportunity, though, perhaps has some validity: Private Cashire came from a poor family, while Private Wakeman, in his letters, wrote of wanting to help his father pay off debts. However, thousands of men joined the army for precisely the same reasons, so this argument alone cannot be used to rule out the possibility that these people identified as male.

What do we know about Cashire's motivations? Since he was illiterate, he left no letters or diaries. However, some clues can be found in interviews with his surviving comrades, preserved in the newspaper articles that followed his exposure, and his pension files.

First of all, for him, presenting himself as a male was not a temporary disguise, as it was with Edmonds and Velasquez, but a lifelong activity. Cashire had begun living as male before the war and continued to do so afterward. It is also notable that Edmonds and Velasquez flaunted their service in male disguise after the war—both wrote books about their exploits—while Cashire and other lifelong cross-dressers preferred to remain anonymous and were discovered only upon their death or incapacitation.

Several photographs of Cashire taken during his years of service survive, and perhaps these speak loudest as to his mental state. In his eyes are a deep, haunting sadness. Perhaps this sadness was caused by the social isolation imposed by his condition. One of his comrades, Harry G. Weaver, testified to the Bureau of Pensions that Cashire "was of very retiring disposition and did not take part in any of the games." He would sit apart, puffing on a

pipe, apparently lost in thought. Although handsome, Cashire was not blessed with a natu-rally masculine physique or great physical strength. Weaver recalled that he "had very small hands and feet" and was "the smallest man in the company." Given this, it is no wonder that he avoided physical contact with the other soldiers.

But what Cashire lacked in size and strength, he made up for in endurance, agility, and steadiness. In his marksmanship he was "the equal of any in the company." At one point dur-ing the Vicksburg campaign, his company had marched and fought for 20 days without a rest, but Cashire's comrades recalled that he seemed tireless. Here his small stature may have been an asset, helping him endure the Mississippi heat more easily than the larger men.

Historian Richard Bell wrote that the 95th's commander, Capt. Elliott N. Bush, "often selected Cashier [sic] for foraging and skirmishing duty because he was considered very dependable, was in vigorous good health, and was apparently fearless." Charles Ives recalled an incident where their unit was crouched behind a barricade of trees, too outnumbered by the Confederates to advance. "Al hopped on top of the log and called [to the Confederates in hiding]: 'Hey! You darn Rebels, why don't you get up where we can see you?' On another occasion, Cashier scrambled up a tall tree to fly the Union flag after it had been shot down. This habit of making himself a target seems to go beyond bravery; Cashire was unnecessar-ily putting himself in danger. Today, risk taking and/or self-destructive behavior is common in female-to-male transsexuals who have not received medical treatment.

However, after the war—perhaps because he was freed from the stress of trying to main-tain his identity under field conditions—Cashmire seems to have mellowed and become much more social. He enjoyed visiting with other veterans and recalling their adventures. Ruth Morehart, who as a child knew the elderly Cashire, recalled that every Memorial Day, "Albert would dress in his Civil War uniform and lead the parade." After the parade was over, he would treat Ruth and the other children to ice cream.

Near the end of Cashire's life, Ives asked him why he had done what he did. Cashire replied, "Lots of boys enlisted under the wrong name. So did I. The country needed men, and I wanted excitement." Nowhere is there an admission of being female: Cashire consid-ered himself, to the end, to be one of the "boys."

As in the case of Cashire, Private Wakeman's letters paint a portrait of a male-identified person, in stark contrast to female soldiers such as Sarah Emma Edmonds.

Wakeman left home in August 1862 at age 19 and worked briefly in male attire on the Chenago Canal as a boatman. At the end of the month he enlisted in the army and was sent to Washington City (Washington, D.C.) in October. There he spent over a year in training, and posting guard duty at Carroll Prison, before being sent to the front in February 1864.

From his letters, several facts of Wakeman's life before leaving home are clear. He was familiar with, and had been allowed to participate in, work traditionally considered male on the family farm. His family may have accepted his keen interest in "male" duties because a

son was long in coming to the family and his father truly needed the help. There are also hints in his letters that his masculine behavior had created problems for him even before he left home: "I know my business as well as other folks know them for me. I will Dress as I am a mind to for all anyone else [cares], and if they don't let me Alone they will be sorry for it."

On June 5, 1863, he wrote: "I can tell you what made me leave my home. It was because I had got tired of staying in that neighborhood…I am not sorry that I left you. I believe that it will be for the best yet. When I get out of this war I will come home and see you but I Shall not stay long before I shall be off to take care of my Self…. If I ever own a farm it will be in Wisconsin…" (Despite this statement, Wakeman obviously felt close to his family and was constantly sending home money or small gifts for his siblings.)

Twice, Wakeman expressed doubt or shame about how relatives felt about him. A letter of December 28, 1863, hinted of tensions at home: "I don't care anything about coming home for I [am] aShamed to come, and I sometimes think that I will never go home in the world." And on January 20, 1864, he wrote: "I wish you would write a letter for Robert to me and let me know how he feels about me. Tell Robert I would like to see him or have him with me." We do not learn how Robert felt, but two months later Wakeman acknowledged getting Robert's photograph in the mail.

From these letters, it is clear that Wakeman was painfully aware that other people considered his behavior strange but that he was determined to continue it. His comment about buying a farm in Wisconsin hints that he desired, after the war, to move somewhere where his past history would not be known—most likely, in order to be able to continue living as a man. "I will never go home in all the world": To me, this comment signals that Wakeman had crossed a divide from which there was no going back.

The army life agreed with Wakeman. A recurrent theme in his letters is how he felt and how much he liked being in the army. He wrote on September 20, 1863, "I am well and enjoy myself first rate for a soldier," and on October 9, "I have got So I can drill just as well as any man there is in my regiment." Later that year—apparently unafraid of his secret being divulged—Wakeman visited two friends from home, 1st Lt. William Austin and Pvt. Perry Wilder of the 109th New York Volunteer Infantry.

But did Wakeman actually identify as male? Unfortunately for present-day historians, Private Wakeman was not prone to analyze or explain his feelings. However, one of Lauren Cook Burgess's remarks is telling: "It is notable that (Wakeman's) perceptions of army life and war are remarkably similar to those of hundreds of thousands of men who served in the Civil War military. Indeed, the reader must remain sensitive to Rosetta's true identity to catch many of the gender-related nuances in her letters." In fact, not one of the "nuances" indicate that Wakeman actually identified as a female; they merely acknowledged the pain his behavior had caused himself and his family. Entirely absent from Wakeman's letters are any comments about feeling different from the other soldiers, the loneliness and isolation

of being one woman among a sea of men, or "deceiving" anyone in relation to his sex. In fact, when reading his letters, one is struck by how comfortable he seems to feel as a man among men. From his letters he both thoroughly enjoyed being a soldier and made friends easily— apparently more easily than he had at home, where people knew him as female. In his December 28, 1863, letter he said: "I have enjoyed my self the best since I have gone away from home than I ever did before in my life…I find just as good friends among strangers as I do at home."

These "omissions" were not necessarily motivated by a desire for secrecy. Letters were not opened and censored during the Civil War as they were in later conflicts, and soldiers commonly shared intimate confidences with their loved ones. In fact, Wakeman wrote to his father that he "needn't be afraid to write anything prisye" (privy, or private). And, for the first year of his service, Wakeman signed his letters with his birth name. Some letters are signed with both his birth name and a male name, and others with the male name only. In one letter the birth name is scratched out and the male name substituted. I speculate that the longer Wakeman served in the army, the more comfortable he became in his male identity. Eventually, perhaps, signing his birth name simply felt too strange, the last remnant of another life long ago and far away.

In other letters, Wakeman actually used language that portrayed himself as male or equated himself with men. In a letter of 1862, he boasted of his good health: "I am the fae- lest [fattest?] fellow you ever did see." And in a letter of June 5, 1863, he said, "Tell him [Alfonso, his father's hired hand] that I can make the best soldier than he would." On July 27, 1863, he wrote: "Col Edwin Davis is so strict with the men that *we* [emphasis added] don't like to stay here. We had drother go to the front." Burgess does not comment on the possible implications of these particular "nuances."

In late 1863, Wakeman sent a photograph of himself, taken in uniform, to his family and remarked dryly: "How do you like the looks of my likeness? Do you think I look better than I did when I was to home?" The photo shows a confident, tough-looking Wakeman. Nothing in his appearance suggests a female. Although short (five feet), he had large, thick-fingered hands and masculine facial features, which undoubtedly helped protect him from discovery. His strength (he bested a man seven inches taller in a brawl) and masculine appearance gave him an easy physical confidence that Albert Cashire seemed to lack.

Wakeman's dream of a farm in Wisconsin was not to be. In early 1864 his company was sent to Louisiana to take part in the ill-fated Red River campaign. They took a steamship to Louisiana and then were led on a forced march of 200 miles in 10 days. On April 9, his 19th Corps bore the brunt of the Confederate attack on Pleasant Hill. Wakeman was in the front lines and in the fiercest fighting during the four-hour battle, which ended in darkness. At midnight the Union army retreated, making 40 miles in a day and a half. A letter posted a few days later showed Wakeman in good spirits. He advised his father to "buy the Ham

farm" and said that "[his brother] and my self can work both of them farm like everything."

That letter was the last his family received. Following a second fight, he developed chronic diarrhea. Wakeman reported to the regimental hospital on May 3 and was transferred to a hospital in New Orleans, where he died a month later, on June 19. Amazingly, his secret was never revealed. It seems unlikely that his nurses did not know that Wakeman had a female body. Wakeman probably asked for, and received, the nurses' help in keeping his secret. Was this out of concern for the shame it might bring his family? Probably not, since they all knew what he was doing. He probably wished to avoid the humiliation of exposure in front of men he had served with.

Many soldiers of the Civil War period were aware that women sometimes attempted to infiltrate their ranks, and today such involvement of women is a continuing source of controversy among Civil War reenactors. As with their predecessors, the reaction of the male "soldiers" to the idea of women in uniform varies. Some are supportive, as long as the female can do a credible and historically accurate "impression" of a male soldier. The opposing view was expressed succinctly by a fellow in one company: "If it can't stand to pee, it doesn't belong in the unit."

Of any Civil War reenactors, one might ask: Would they be as accepting as some of Cashire's mess mates, who continued to call him "Albert" and "he" to a puzzled pension review board even after they had been informed that Cashire was "really" a woman named Jennie Hodgers? Would they be as understanding as the unknown nurse who tended to Lyons Wakeman during his final days, who must have known his secret but kept it, allowing him to die with dignity and to be laid to rest as a man?

References

Burgess, Lauren Cook. (1996). *An uncommon soldier: The letters of Sarah Rosetta Wakeman.* Minerva Press.

Davis, Rodney O. (Summer 1988). Pvt. Albert Cashier as regarded by his/her comrades, *Journal of the Illinois Historical Society,* pp. 108–112.

De Erauso, Catalina. (1995). *Lieutenant nun: Memoir of a Basque transvestite in the New World.* Translated from the Spanish by Michele Stepto and Gabriel Stepto. Beacon Press.

Edmonds, S., and Emma E. (1864). *Nurse and spy in the Union army: Comprising the adventures and experiences of a woman in hospitals, camps, and battle-fields.* W. S. Williams and Co.

Gilbert, J. Allen. (1920). Homosexuality and its treatment. *Journal of Nervous and Mental Disease* 52(4): 297–322.

Hall, Richard. (1993). *Patriots in disguise: Women warriors of the Civil War.* Paragon House.

Horwitz, Tony. (1998). *Confederates in the attic: Dispatches from the unfinished Civil War.* Pantheon Books.

Katz, Jonathan Ned. (1976). *Gay American history: Lesbians and gay men in the U.S.A.* Crowell.

Livermore, Mary. (1887). *My story of the war.* A.D. Worthington.

Meyer, Eugene. (January 1994). The soldier left a portrait and her eyewitness account. *Smithsonian* 24(10): 96–104.

Wakeman, Sarah Rosetta. (1994). In *An uncommon soldier: The Civil War letters of Sarah Rosetta Wakeman, alias Private Lyons Wakeman 153rd Regiment, New York State Volunteers,* edited by Lauren Cook Burgess. The Minerva Center.

Ward, Geoffrey. (1990). *The Civil War: An illustrated history.* Alfred A. Knopf.

Wiley, Bell Irvin. (1952). *The life of Billy Yank: The common soldier of the Union.* Louisiana State University Press.

Alan Hart

By Margaret Deidre O'Hartigan

Margaret Deirdre O'Hartigan has worked as a typist and secretary since obtaining publicly fund-ed sex-reassignment surgery in the 1970s. She has been an eloquent spokeswoman and effective advocate for transsexuals for most of her life.

> *I will not do them wrong; I rather choose*
> *To wrong the dead, to wrong myself and you,*
> *Than I will wrong such honourable men.*
> —Marc Antony, from William Shakespeare's *Julius Caesar*

She was born October 4, 1890. Her parents named her Alberta Lucille Hart.

In the second decade of this century, Hart consulted a psychiatrist, underwent a hys-terectomy, and changed her name to Alan L. Hart. After graduating from the University of Oregon Medical College in 1917, Hart consistently presented a male persona to the world for four and a half decades until her death in Hartford, Conn., on July 1, 1962, at the age of 71.

I refer to Hart as "she" and "her" with no little trepidation. After all, as a male-to-female transsexual, I don't relish the prospect of being posthumously referred to through the use of male pronouns as though I had never changed sex. I don't like to contemplate the possibil-ity that—despite the fact I've lived as a woman for longer than I did a boy—I may be sub-jected by historians to a postmortem sex change.

But, then, with what arrogance do I presume to escape the fate that has befallen Dr. Hart? Despite living as Alan for 45 years, the bulk of the good doctor's life has been vari-

ously minimalized, sensationalized, and objectified—not to mention being subjected to the wrecking ball of postmodern "deconstruction." The majority of Hart's biographers insist upon viewing the doctor as a woman in disguise, without regard for Hart's self-identification as a man, medical treatment, and legal documentation.

Among these modern-day spiritualists conjuring Lucille back from a death that predated Alan's by nearly a half century are historians, academicians, newspaper reporters, and political activists. They are heterosexual, gay, lesbian, and even transsexual. In the decades following his—excuse me, her—graduation from medical school, Dr. Hart became one of this country's leading radiologists as well as a published novelist four times over. Yet despite these achievements Dr. Hart is best remembered for having once been a woman.

> 'Tis his will: let but the commons hear this testament—
> Which, pardon me, I do not mean to read—
> And they would go and kiss dead Caesar's wounds
> And dip their napkins in his sacred blood,
> Yea, beg a hair of him for memory,
> And, dying, mention it within their wills,
> Bequeathing it as a rich legacy
> Unto their issue.
> —Marc Antony, from William Shakespeare's *Julius Caesar*

An excerpt from Hart's will appeared in 1993's "The Lucille Hart Story," published in conjunction with the annual Lucille Hart Dinner, hosted by an Oregon gay and lesbian rights organization known as Right to Privacy. Established as that organization's premier fund-raiser for gay and lesbian political causes in Oregon, the Lucille Hart Dinner was for 14 years faithfully attended by Portland's liberal elite, straight and gay alike, and regularly produced more than $100,000 in contributions. The excerpt read: "In her last will and testament, she requested that she be cremated, and that 'no memorial be erected or created or contributions made in my name to any charitable, educational, medicinal, or religious institution.'"

In a July 14, 1996, newspaper article about Dr. Hart, *The Oregonian*'s Tom Bates reported that Right to Privacy "called her hysterectomy 'the unfortunate result of the psychotherapy' she received." Nearly a year earlier, Right to Privacy's executive director, Barry Pack, had claimed: "Through our research on the story of Lucille/Alan Hart, we continue to believe that Lucille Hart made a choice to represent herself as a man based on the oppression of society at large. Her goals toward medical science and living a 'normal life' necessitated her adoption of a man's identity…It is our belief that by honoring the beginning of her life as a woman, as well as the end of her life as a man, we bring greater dignity and respect to one of Oregon's greatest lesbian and gay heroes."

In the face of such persuasiveness, my personal opinion that Dr. Hart was a man—whatever his origins—must surely be an empty conceit, inflated out of all proportion by my own experience of changing sex. To achieve her goal of living a "normal life" as Pack claimed, Lucille risked death to undergo invasive surgery years before the use of antibiotics or even sulfa drugs. Too weak-willed to directly confront society's prejudice toward women physicians, according to Right to Privacy, she took the coward's way out and changed her sex in order to avoid society's oppression.

Subtitled "An Unconventional Fairy Tale," Right to Privacy's "The Lucille Hart Story" was coauthored by two gay men: Tom Cook, an amateur historian who later became the president of the Gay and Lesbian Archive of the Pacific Northwest, and Thomas Lauderdale, who graduated with a degree in history from Harvard University but is best known as the pianist for the musical group Pink Martini.

Cook and Lauderdale have consistently imposed upon Hart a female identity despite the doctor's transition and surgery. In "The Lucille Hart Story," for example, they wrote, "Her picture in the University of Oregon yearbook, *Oregana,* is the first known photograph of her in her new male guise. As Alan, she married Inez Stark…Hart later met and fell in love with the woman who was to become her second wife, Edna Ruddick."

Lauderdale was himself the topic of a newspaper article in the January 29, 1996, cover story of the Portland weekly, *Our Town.* "He's working on two books: one on the life of William Jamison, who died last year from AIDS, and one about Lucille Hart, a woman who graduated from the then-University of Oregon Medical School in 1917 and disguised herself as a man for 45 years."

And in Bates's article about Hart in *The Oregonian,* Lauderdale asked—and left unanswered—the question, "Should we use quotation marks around 'Alan'?"

In 1995 Cook presented a lecture and slide show at Portland's Reed College in conjunction with the school's celebration of Lesbian and Gay History Month. The presentation was titled "The Legendary Life of Lucille Hart, alias Dr. Alan Hart." And at the conference "Do Ask, Do Tell: Outing Pacific Northwest History" at the Washington State History Museum one autumn weekend in 1998, Cook's photomontage of Hart's life featured such affirming captions as "Letter from Alan Hart to W.W. Norton dated April 30, 1936, commenting on her second novel," and "The apartment building at 9101 N.E. 43rd St., Seattle, where Alan Hart wrote four of her novels."

Cook and Lauderdale were hardly the first gay men to honor Hart as a lesbian. It was Jonathan Ned Katz who first reversed Hart's sex-reassignment surgery, 14 years after the physician's death. In his 1976 book, *Gay American History: Lesbians and Gay Men in the U.S.A.,* Katz categorized Hart as "clearly a lesbian, a woman-loving woman," adding that she "illustrates only too well one extreme to which an intelligent, aspiring Lesbian in early twentieth-century America might be driven by her own and her doctor's acceptance of society's

condemnation of women-loving women." But, then, as Pat Califia remarked in his 1997 book, *Sex Changes,* Katz's book "is unfortunately tainted with a heavy dose of transphobia."

Katz also cast Hart in the role of a lesbian in his 1983 book, *Gay/Lesbian Almanac.* Little wonder. In a footnote Katz referred to his unpublished paper " 'Transsexualism': Today's Quack Medicine; An Issue for Every Body," stating, "An historical study needs to be made of the medical and autobiographical literature on 'transsexualism'; it will, I think, reveal the fundamentally sexist nature of the concept and of the associated medical treatments."

Even without Katz's assistance, Hart has received far more press as a dead lesbian than as a man. Although Hart's books were reviewed in *The New York Times* and *Saturday Review* at the time of their publication, in recent years it is the doctor's private life—and private parts—that have received the bulk of the attention.

The cover story of the September 1993 issue of Portland's *Alternative Connection* was titled "The Incredible Life and Loves of the Legendary Lucille Hart," and the introduction labeled Hart "Oregon's most famous lesbian." The October 20, 1995, issue of Portland's *Just Out* included Hart in an article titled "Historical Homos." And in what is perhaps the most unkindest cut of all, in the Summer 1995 issue of *Transsexual News Telegraph,* transsexual historian Susan Stryker referred to Hart as "the butch half of a butch/femme relationship while an undergraduate at Stanford University in 1911–1914. While her college sweetheart went on to marry a man and become a mother, Hart decided to pass as a man. As Alan, Hart twice married women and became a prominent public health physician and author."

Stryker defended her portrayal of Hart in the following issue of *Transsexual News Telegraph.* "As an historian favoring 'social construction' approaches to questions of identity, I have reservations about using the word 'transsexual' to refer to people before the mid-20th century who identify in a profound, ongoing manner with a gender that they were not assigned to at birth."

Favoring social construction approaches to questions of identity would seem to me to also preclude portraying Hart as "the butch half of a butch/femme relationship," but what do I know? I'm just an uneducated ex-whore who counts myself lucky to have made my way from the street to the secretarial pool. It is Stryker, with her Ph.D. in history from the University of California, Berkeley; a seat on the board of directors of the Gay, Lesbian, Bisexual, Transgender Historical Society of Northern California; and a postdoctoral fellowship in sexuality with the history department at Stanford University, who has the academic credentials to render historical judgment upon the life of Dr. Alan Hart. What need have I to beg a hair of Dr. Alan Hart for memory?

Speaking of academicians, Jacob Hale, an associate professor of philosophy at California State University, Northridge, and a female-to-male transsexual, defended Stryker in the Summer 1997 issue of *Transsexual News Telegraph.* And the following year Stryker edited an issue of *GLQ: A Journal of Lesbian and Gay Studies* that included Hale's article, "Consuming

the Living, Dis(re)membering the Dead in the Butch/FTM Borderlands." In his article, Hale referred to Hart as one of "three butch/ftm border war figures," adding that Hart's "location relative to the categories 'butch' and 'ftm' was at issue in a recent transgender community controversy." In a footnote to this passage, Hale commented, "It might not be entirely accurate to classify Alan Hart as female bodied since he, evidently, used hysterectomy to change his legal and social sex/gender status."

Dr. Hart would have surely been moved by Hale's magnanimity—if he wasn't already turning in his grave.

> Cry 'Havoc,' and let slip the dogs of war;
> That this foul deed shall smell above the earth.
> —Marc Antony, from William Shakespeare's *Julius Caesar*

Hale's comment that Hart was an "issue in a recent transgender community controversy" is curious given the publicity that surrounded transsexual efforts to end Right to Privacy's appropriation of Hart as a lesbian poster child. But then, Hale was writing in the *Journal of Lesbian and Gay Studies,* after all. It was safer for him to give the erroneous impression of infighting among transsexuals than to acknowledge the cooperation between transsexuals or the alliance that developed between transsexuals and lesbians, leading Right to Privacy to rename the Lucille Hart Dinner.

The opening shot in the struggle to restore Hart's manhood was fired in 1994 by Candace Hellen Brown, a male-to-female transsexual residing in Portland. In a letter to the editor published in the October 7, 1994, issue of *Just Out,* Brown wrote:

> The Right to Privacy Political Action Committee in Oregon has a big fundraiser every year that is called the Lucille Hart Dinner. When I am asked if I am going, I indignantly answer, "Not until they stop using the wrong name and gender for one of our heroes! His name is Alan. Dr. Alan L. Hart was born in 1890 with female genitalia and raised, unhappily, as a girl child. Upon reaching mature, educated adulthood he took steps, including psychiatric counseling and surgery, to live his life as a man, even marrying twice. He made a slow transition while going to medical school, then started a practice in Oregon in 1917. He was outed soon after by a medical colleague and was forced to move. He never wavered from his identity as a man, and upon his death his widow continued to insist that he was a man. Why would such a straight man be called a lesbian by the gay community when today we would certainly call him a female-to-male transsexual? Is it because he did not call *himself* that? How could he? The term was not coined until 1949 and not widely used until the '60s...Historic labels aside, we should not

misidentify him today. He was a transsexual or, at least, a transgenderist—a true pioneer. One who is seen as a hero by today's transsexual community. Alan Hart is one of our heroes. Please don't let him be taken away from us by allowing his old name to be used as though it were a badge of honor. At best it is unthinking, at worst, insulting. My, how it rankles me to hear folks today using the wrong pronoun and name. Yes, his parents may have named him Alberta Lucille Hart, but he named himself Alan!

Over the course of the next year, Brown and other Portland transsexuals organized to bring Right to Privacy to heel, forming in the spring of 1995 the Ad Hoc Committee of Transsexuals to Recognize Alan Hart. On July 1, 1995, transsexual activist Rachel Koteles addressed the Portland chapter of the Lesbian Avengers and persuaded them to hear a presentation from the committee. And on August 26, Brown, Koteles, and female-to-male transsexual Ken Morris gave a presentation to the Avengers that convinced them that Alan Hart was no woman.

Only a week earlier yet another letter to the editor from a transsexual had been published in *Just Out*. It read, in part: "What is beyond question is that Hart chose to be known by the name of Alan and referred to himself with male pronouns. Accordingly, all of us who would honor this individual's memory, and in doing so honor the struggle which all of us share as members of the sexual minority community, can give no greater honor than to respect Alan Hart's wishes, by referring to him [with] the name he chose to be known by."

In the face of continued intransigence on the part of Right to Privacy, the Lesbian Avengers and the Ad Hoc Committee of Transsexuals made plans for a public protest at the upcoming Lucille Hart Dinner and at other events. Brown and Morris traveled to Seattle and enlisted the aid of female-to-male transsexuals living there, including Kaz Suzat and Jason Cromwell.

At the start of Thomas Cook's October 11 lecture at Reed College on "The Legendary Life of Lucille Hart, alias Dr. Alan Hart," members of the Ad Hoc Committee unfurled a 20-foot banner that proclaimed, HIS NAME WAS ALAN! Visibly shaken, Cook almost immediately began referring to Hart with male pronouns during his presentation.

Three days later, on the evening of Saturday, October 14, people entering Portland's convention center to attend the Lucille Hart Dinner were met by more than a dozen transsexuals and their supporters wearing buttons with the legend HIS NAME WAS ALAN HART! Transsexual men from Seattle—including one accompanied by his wife—stood with Portland lesbians and Brown, Morris, Koteles, and others to hand dinnergoers a bright yellow flyer sporting the headline HIS NAME WAS ALAN and urging that "Right to Privacy and the Queer community join the Transsexual and Transgender communities to recognize Alan Hart for what he was: a Transsexual Hero." The flyer also contained "A Message from the Lesbian Avengers" reading, "We view Right to Privacy's use of 'Lucille' instead of Alan as dis-

respectful and divisive…The Lesbian Avengers call upon the Right to Privacy to respect Alan Hart and stop referring to him with a name he rejected."

Among the 800 individuals attending the 14th annual Lucille Hart Dinner were Oregon governor John Kitzhaber and U.S. representative Elizabeth Furse, who were also the featured speakers.

The Oregonian ran an article by Tom Bates the following day that reported on the protest: "A group of transsexuals protested the naming of the annual dinner after Lucille Hart when Lucille Hart was, they claim, in reality a man named Alan. 'Rather than a lesbian unable to bear life as a woman,' stated a flier handed to dinner guests, 'Hart should be recognized for what he was, a transsexual man who had the courage to be true to himself.'"

In a follow-up piece, Bates quoted Rachel Koteles as saying: "Viewing Dr. Hart as a lesbian hero is a problem for us. He identified as male. They (Right To Privacy) are rejecting his own choice of name and co-opting one of our heroes."

The transsexual activists went to great pains to avoid castigating the majority of gay men and lesbian women by distinguishing them from Hart's detractors. In a guest editorial in the November 3, 1995, issue of *Just Out,* for example, Candace Brown wrote: "Transsexuals have been snubbed and trashed by a minority of the gay and lesbian community for the past 25 years. We are heartened that some in the community are reaching out to us. The Lesbian Avengers joined our recent efforts to have Alan L. Hart recognized as a transsexual hero. They worked alongside transsexual men and women at the Right to Privacy dinner handing out flyers to educate and explain who Dr. Hart really was."

Right to Privacy proved to be as resistant to changing the name of its fund-raising dinner as it was reluctant to acknowledge Hart's own change of name. In an article in the December 1, 1995, issue of *Just Out,* Right to Privacy chair Lisa Maxfield argued: "How do you or I know the truth about whether Lucy was a lesbian or a preoperative transsexual? I'm not yet convinced that was the case…People know this event as the Lucille Hart Dinner. For that reason alone there is some reluctance to change it."

Undaunted by Right to Privacy's intransigence, the transsexuals continued to apply pressure to Right to Privacy. As the February 2, 1996, *Just Out* reported: "Brown was among a group of seven transsexual activists—five of whom are from Seattle—who met with RTP's executive director, Barry Pack, and two board members for a three-hour meeting in which transsexual activists shared their concerns about the name of the RTP political action committee's flagship fundraiser, the Lucille Hart Dinner."

The end to the conflict was almost anticlimactic; finally confronted with the irrefutable proof of Dr. Hart's surgery and self-identification as a man, Right to Privacy's objections collapsed. In an article titled "Grievance Addressed," the March 1, 1996, *Just Out* reported: "The board of Right to Privacy has decided to change the name of its flagship fund-raiser, the Lucille Hart Dinner, following a Feb. 10 meeting with transsexual rights advocates.

'We're not sure what we're going to call it yet, maybe just the Right to Privacy Dinner,' says Portland attorney and RTP board cochair Lisa Maxfield. 'The arguments presented to us were very convincing and certainly influenced our decision.'"As that same article reported, one factor contributing to the decision was the single-mindedness of the transsexual activists: " 'We went into that meeting with one issue on our list—getting the name of the Lucille Hart Dinner changed. It's a very emotional matter for us,' says local transsexual activist Candace Hellen Brown, who along with Ken Morris presented their case before RTP's board...'RTP probably thought we were going to come in there with a long list of gripes, but we didn't,' says Brown, who estimates that the meeting lasted about a half hour. 'We simply wanted to talk about the dinner, and that's what we did.... Every year when [RTP's dinner] was held, it was a very personal and painful experience for the transsexual community,' she says. 'At least now we won't have to go through that.' "

Even *The Oregonian* took notice of the transsexual victory, in an article by Tom Bates: "The debate about Hart's sexuality—was she a lesbian or a transsexual—entered the political arena in October when transsexuals picketed what has come to be known as the Lucille Hart Dinner. The protesters demanded a change in the name of the annual fundraiser for pro-gay political candidates...In deference to transsexuals, Oregon Right to Privacy no longer will use the name Lucille to identify its dinner."

Nearly 15 years after Right to Privacy summoned Lucille Alberta Hart from beyond the grave, it seemed as though Dr. Alan Hart would finally be allowed to rest in peace.

> *Here wast thou bay'd, brave hart;*
> *Here didst thou fall; and here thy hunters stand,*
> *Sign'd in thy spoil, and crimson'd in thy lethe.*
> *O world, thou wast the forest to this hart;*
> *And this, indeed, O world, the heart of thee.*
> *How like a deer, strucken by many princes,*
> *Dost thou here lie!*
> —Marc Antony, from William Shakespeare's *Julius Caesar*

As an adult, Hart gave of himself unstintingly in treating the sick, advancing the science of medicine, and, in his novels, advocating for the downtrodden, disabled, and working class. In the 1937 novel *In the Lives of Men*, Hart's protagonist Geoffrey says, "It's like having a pack of dogs after you. You run and run, and all the time you know that in the end the pack will get you, because you're different."

Run to earth years after his death, Hart's life has been transformed into fodder for conjecture, his memory repeatedly subjected to character assassination. In a 1996 article on

Hart, *The Oregonian's* Tom Bates quoted Portland lawyer and book collector Brian Booth, one of Hart's biggest fans: "Here's a person who, in the 1920s and '30s, carried on as a successful writer and scientist, but who had to hold something back, to be careful about how he looked, what he said. He must have had nerves of steel."

And yet Jonathan Ned Katz asserted that Hart's transformation from female to male "illustrates only too well one extreme to which an intelligent, aspiring Lesbian in early twentieth-century America might be driven by her own...acceptance of society's condemnation of women-loving women." That I believe Booth to be the better judge of Hart's character means nothing; I am but a former whore, and Katz an honorable man.

Hart's own psychiatrist, Dr. J. Allen Gilbert, wrote of her in 1920, "She is a man. And if society would just let her be, she would fill her niche in the world and leave it better for her bravery." And yet Right to Privacy's Barry Pack stated unequivocally in 1995 that "Lucille Hart made a choice to represent herself as a man based on the oppression of society at large." That I believe Gilbert to be the better judge of Hart's character means nothing; I am but a former whore, and Pack an honorable man.

Dozens of transsexuals and lesbians in the Pacific Northwest joined forces in 1995 to end the exploitation of Hart as a fund-raising tool for a political action committee. And yet Jacob Hale portrays lesbians and transsexuals to be in conflict over Hart, calling the doctor a "butch/ftm border war" figure. That I believe those who witnessed the events of 1995 and 1996 to be better judges of events than Hale means nothing; I am but a former whore, and Hale is an honorable man.

I confess that my motives regarding Dr. Hart are suspect. I have a vested interest, as a sex-change, in seeing his—excuse me, I mean her—life accorded due respect. How presumptuous of me to think I should have the right to be referred to as—let alone to be—a woman, when so many honorable men see fit to question that man's sex.

Enough.

He chose the name he wished the world to know him by.

That name was Alan Hart.

> *Good friends, sweet friends, let me not stir you up*
> *To such a sudden flood of mutiny.*
> *They that have done this deed are honourable:*
> *What private griefs they have, alas, I know not,*
> *That made them do it: they are wise and honourable,*
> *And will, no doubt, with reasons answer you.*
> —Marc Antony, from William Shakespeare's *Julius Caesar*

AFTERWORD

Candace Brown moved to California in 1997. Ken Morris and Rachel Koteles continued their activism as board members of the Filisa Vistima Foundation, an Oregon nonprofit providing assistance to transsexuals in need of medical care and legal aid. As of this writing, Thomas Lauderdale has still not published a book about Hart. After battling pancreatic cancer, *The Oregonian* reporter Tom Bates died in late 1999 at the age of 55. Susan Stryker subsequently became executive director of the Gay, Lesbian, Bisexual, Transgender Historical Society of Northern California.

Months after agreeing to cease calling its annual fund-raiser the Lucille Hart Dinner, Right to Privacy changed its own name to Right to Pride and for several years held the "Right to Pride Dinner." In the summer of 1998, Barry Pack resigned as executive director of the organization, and in 1999 Right to Pride dissolved, with some board members joining another gay and lesbian political group, Basic Rights Oregon. On September 22, 2000, BRO resumed the practice of using Alan Hart as a fund-raising tool by holding the "17th Annual Hart Dinner." Its dinner program referred to Hart as "she," "her," "her/his," and "her/him," but never simply as "he" or "him."

Part Four
The Surgeries

Introduction

By Dean Kotula
Photographs by Dean Kotula

Surgeons must be very careful
When they take the knife!
Underneath their fine incisions
Stirs the Culprit,—Life!
—Emily Dickinson

The surgical photographs are shocking, but you can distance yourself from them—they are about other people. It was difficult for me to maintain this distance; I witnessed the physical trauma involved in these major operations with the knowledge that my own body would one day be subjected to the same treatment.

I was ambivalent about intruding into these very private experiences but decided I could remain an "outsider" and record events objectively. I was mistaken. I knew full well the impetus behind the decision to undergo surgery; so, as I observed, I was not only filled with awe but sadness (over all that necessitated the procedure), exhilaration (these men would finally actualize themselves), fear (should something go wrong), and gratitude. I was grateful for the extraordinary opportunity to witness these surgeries and for the surgeons themselves, who have truly committed their skills toward transforming our bodies and our lives.

Nearly 13 hours into a phalloplasty operation, a doppler was placed on the newly constructed penis to check for a pulse and bloodflow. Along with the magnified sound of coursing blood came startled gasps and the triumphant laughter that broke an intense and uneasy silence.

During the course of photographing these various sex-reassignment surgeries (SRS), I

periodically slipped out of the operating rooms to report the progress being made to the patient's friends and family members anxiously pacing in the waiting room. I masked my mortification, fear, and excitement, offering only hope and accolades of success, which they were more than willing to accept. Throughout the ordeal I was terribly impressed by the show of support they had paid the men.

The knowledge and understanding that these surgeries were desperately needed and took extraordinary means to obtain (the vast majority of SRS procedures are paid for out of pocket since insurance companies won't cover them), helped to offset my response to the invasive nature of the procedures. When I joined these men in their recovery rooms I could see the relief and exhilaration in their eyes, even through heavy sedation and the aftermath of physical trauma.

The demand for these surgeries, despite their cost and invasiveness, testifies to the psychological pain of going through life in the wrong body. These decisions are neither superficial nor the result of a whim. What the public has yet to understand is that it is not surgeries per se that make us men but rather the psychological impulses that compel us to have these surgeries in order to make our bodies congruent.

The surgeries documented here: liposuctioning of breast tissue, a bilateral mastectomy, metoidioplasty, and radial forearm phalloplasty, represent the work of three leading surgeons specializing in SRS. While there are numerous surgeons qualified to do breast reduction (liposuction, mastectomy), only a small percentage of them have the knowledge and experience necessary to sculpt a male chest from a previously female one. There are far fewer surgeons worldwide who are doing genital surgery (metoidioplasty, phalloplasties). Given numerous considerations (location, cost, results, aftercare), I have chosen to highlight the work of doctors Brownstein, Meltzer, and Reardon, since they all have a wide following, have years of experience, and render consistently good results. It is not my intention to make recommendations but to offer some direction to persons electing to undergo sex reassignment. Of these doctors, Toby Meltzer is the only one of the three who performs both "top" and "bottom" surgery.

I have chosen to devote a portion of the book to the surgeries since they are the crux of the matter for transsexuals and the source of fascination for the general public. Surgery is the defining difference between transsexuals and those who define themselves as "transgendered." There are small numbers of people who consider themselves transsexual yet don't fit the definition since they have no desire to transform their bodies through surgery (occasionally they will take hormones). If one looks at the etiology of the term *transsexual,* they will find it to be a medical term (albeit a mental health designation) used to describe, among other things, one who finds their sexual anatomy inappropriate, believing they were born with the body of the opposite sex. The prefix *trans* implies action, in this case changing from female to male. Furthermore, as technological advances permitted one the option

of "changing sex," the term *transsexual* was applied to describe those that persistently demanded hormones and eventually followed through to have surgery. Exceptions that may apply are postponement due to cost or debilitating health risks.

In a time of political correctness, I believe that we are too quick to defend someone's right to self-define. We all want to take people at face value, but when each person represents a part of a whole, a member of a particular population with whom they claim alliance, I think we need to look at whether their behaviors and motivations support their assertions. A transsexual may consider themselves "transgendered" as well, but a transgendered person cannot rightly claim to be transsexual (I don't know why one would want to) without the desire for SRS. FTMs are attempting to normalize their lives and are acting from an internal calling rather than responding to societal dictates. Theoretically they may agree with feminist principals and object to rigid definitions of gender, but this is an entirely separate issue from their identification as men.

On the other hand, a "transgenderist" may simply include someone who defies rigid gender roles. They may empathize with both feminine and masculine roles and feel a balance between them, but they do not see themselves having been born in the wrong body and therefore they do not pursue SRS.

It is my hope that in educating the reader (both transsexuals and non-transsexuals) with this material, they will no longer have the curiosity that compels them to intrude on the privacy of transsexuals. It has been my experience and that of every transsexual I've come across that when someone first learns of an individual's transsexual status, their instant response is to ask questions pertaining to the state of the individual's sexual anatomy! If I were in turn to ask my questioner about the condition, size, and function of their genitals, would they begin to understand their impertinence? While all relevant questions regarding our bodies are answered in this book, notice that the surgical photographs, along with the captions, don't identify or allude to a particular person. They serve the purpose of informing without sacrificing privacy or risking humiliation.

The techniques illustrated in this book are a reflection of SRS procedures taking place in the United States. While there is some variance in these techniques abroad, the final outcome is not substantially different. Phalloplasty and metoidioplasty operations are not as common as one might think. Obviously FTMs are seeking to rectify their bodies to conform to their identities as men, but given the cost of surgery, rate of complication, and imperfect results, a vast number of FTMs are holding out for future possibilities. Given strides in tissue engineering, improvements in immunosuppressant drugs, and advances in medical science as a whole, penile transplants may be a possible solution to the FTM's body dysphoria in the very near future.

Interview With Toby R. Meltzer, MD

By Dean Kotula

Toby Meltzer has a private practice in Portland, Ore., where he specializes in sex-reassignment surgery. He is also on staff at East Moreland Hospital, lectures at both gender and professional conferences, and is a member of the Harry Benjamin International Gender Dysphoria Associates.

DK: How did you get started doing sex-reassignment surgeries? Were you approached to do them, or were you looking to do these kinds of procedures?

TM: After my formal training, I was hired by Oregon Health and Science University (OHSU). My training was in general surgery, plastic surgery, and a fellowship in burns. I had received no formal training in sex-reassignment surgery. The previous chief of the division of Plastic and Reconstructive Surgery at OHSU had done a few cases and was looking to train someone to carry on his work in anticipation of his retirement. I assisted him with a few cases and found that I thoroughly enjoyed working with patients who were seeking SRS. The patients were very appreciative and receptive. I knew I wanted to continue to do the surgery and to learn more.

DK: Did you have any ethical considerations about doing this type of surgery?

TM: No. My only concern was my lack of formal training for these types of procedures. Though I had received training in a variety of surgical techniques, there are actually no formal training programs for SRS procedures.

DK: So, how did you come to learn your techniques if they weren't taught in medical school?

TM: In addition to watching, assisting, and discussing these procedures with other surgeons, I began researching and reading as many articles on the subject I could find. I quick-

ly realized that reading about the procedures was insufficient. When working with cadavers it is difficult to get a true appreciation for the feel of the perineum when working with preserved tissues. I understood that the procedure required the skills and knowledge of a team consisting of plastic surgery, urology, and gynecology. I realized that the university had some very talented and well-trained surgeons to look to for assistance. I worked with the pediatric urologists who had worked with infants and children born with ambiguous genitalia. The pediatric urologists were able to teach me the anatomy and help me familiarize myself with several techniques. I credit a great deal of my understanding of the anatomy and success in doing the procedures to my working with these surgeons. I then turned to the division of Obstetrics and Gynecology.

DK: What about consulting with other doctors doing SRS?

TM: I went to Trinidad, Colo., to watch Dr. Stanley Biber do a male-to-female surgery. I also corresponded with Dr. Donald Laub of Stanford Medical School. Dr. Laub was doing a procedure that was named by him and is now known as the metoidioplasty, a.k.a. clitoral release. It was very similar to the procedure being done by Dr. Robert Demuth (a plastic surgeon) and Dr. Edward Tank (a pediatric urologist). The urologist and I worked very well together, and he taught me a lot in both MTF and FTM surgical procedures. We continuously learned and improved on our techniques. You have to be willing to try different techniques to make improvements. However, it is important to know your limitations, and both he and I were well aware of our limits and our abilities.

DK: What percentage of your procedures are SRS-related?

TM: At least 80%. I do approximately 150-plus SRS cases per year. This count does not include chest surgeries and breast augmentation.

DK: *Wow*...were you expecting that?

TM: No, in fact, the increase in procedures led me to start a private practice in 1996 so that I could concentrate on this portion of my practice.

DK: Are you familiar with Professor Gooren in Amsterdam and his research?

TM: Yes, I have read his articles.

DK: He is quoted in a recent book as saying, "It would be absolute medical incompetence and even abuse not to rehabilitate a person with a sex error of the body." Do you agree with this statement?

TM: Yes, for the most part. I do believe the individual must be prepared and desirous of the procedure. Hopefully, his research and that of Dr. Swaab gives credence to the transsexual population and will assist in educating others and convincing insurance companies that the procedure should be covered. Many people, including insurance companies, view transsexualism as a choice and do not acknowledge or agree with biological factors playing a part nor of surgery being a part of the medical treatment. Most insurance companies still view SRS as being experimental and not medically necessary.

DK: So you think SRS should be covered by insurance?

TM: Yes. In fact, other countries do cover the cost of SRS as well as a few select U.S. insurance companies. I am one of the providers that BC, Canada refers their patients to.

DK: Government foots the bill?

TM: Yes, in certain countries/provinces.

DK: People in the medical profession have a clearer idea of all that can go wrong in utero, such as ambiguous genitalia. I would think that these professionals would be more open to accepting transsexuality as a biological possibility.

TM: In an ideal world, yes, but not everyone in the medical field is so open-minded. Unfortunately, there are still prejudices and biases that exist. However, it is nice to say that there are signs of changes. In recent years, the medical community has taken a greater interest in learning more about the process and the surgery.

DK: I appreciate your candor and would like to delve into this a bit more. What kind of criticism have you gotten for doing SRS?

TM: Most criticism is from individuals that don't understand what I do. They perceive transsexualism as being purely a psychological problem or a lifestyle choice. They are unaware of everything a transsexual must go through before and after surgery. They do not understand that surgery is only a part of the process. In addition, there are those that have religious objections and view this as genital mutilation.

DK: What was your opinion of transsexuals prior to being exposed to them?

TM: I grew up in Jackson, Miss. I am Jewish, and there were a total of about 100 Jewish families in Jackson. In addition, my mother was active in theater, and we had a number of gay friends. I was taught to be open-minded at an early age and not to judge people. When I was 12, a very impressionable age, we moved to New Orleans, and in New Orleans everything goes. I remember this one kid in my 10th-grade class—in retrospect, you knew he was transitioning. He was very feminine and dressed as a female, although we knew him as male. Also, there was an MTF in my medical school. I never really thought anything about it. My parents have certainly been supportive of me doing this. Though I never had a conceptual problem with doing the surgery, I did have concerns about doing the procedure correctly.

DK: And it's a huge responsibility.

TM: Yes. Many of these procedures are not reversible. Also, even though patients know that this is not a cure or an end-all, there are those that think the surgery will change their life overnight. It is important to understand that this is only one step in their transition, not a cure.

DK: What about selectivity? How do you determine who is an appropriate candidate for surgery?

TM: Actually, I usually know it when someone walks through my door. I am generally able to pick up on whether someone is ambivalent about surgery. Though most of the people are

sure of what they want, there are those that come to my office for a consultation and they are not aware of the process and have not started therapy. I recommend to these individuals that they see a therapist. We now do a great deal more screening over the telephone and require at least a letter of introduction.

DK: I've heard you say that if the diagnosis of "gender identity disorder" (transsexualism) is dropped, you will not do the procedure?

TM: This is not a simple question. In actuality, my point here is that I believe the decision regarding which individuals are appropriate candidates for SRS should not be a surgeon's decision and that this decision belongs with the therapist. The important issue here is working within the Harry Benjamin's Standards of Care (SOC). Ideally, there would be a medical diagnosis for gender identity disorder used as the final determination for surgery, rather than the current use of a psychological one due to the inherent stigma attached. Unfortunately, this is unlikely to happen without further scientific evidence of a genetic basis for the condition. I also believe it is important to have psychological evaluations to rule out or deal with underlying issues before surgery.

DK: I agree that there should be both medical and psychological evaluations prior to surgical consent regardless of whether the diagnosis is medically or psychologically based. Obviously a medical diagnosis would be advantageous, but until one is put in place, it is critical that a psychological one remain in order to have some criteria from which evaluations can be made. Without this diagnosis, the responsibility for determining who is appropriate for SRS would be left solely in the hands of the surgeon, which is, of course, unfair.

TM: Yes. I support and stand by the SOC. I believe that there can be some departures from the SOC. However, a properly trained and credentialed therapist should determine when these departures are appropriate.

DK: I'd like to switch gears now and go on to discuss actual FTM surgical procedures. What do you believe is the best we can expect from phalloplasty operations in the future?

TM: Conceptually, the best procedure we presently have is the radial forearm phalloplasty. Using skin from the forearm, you can make something that closely resembles a genetic male's penis, get sensation in it, put an erectile device in it, and create a urethra through it using skin from the forearm. However, there are two big problems that need to be overcome. The first is the problem of scarring at the donor site. The best thing would be to use an expander on the donor site preoperatively. The second and biggest problem is with strictures at the junction of the neourethra and the native urethra. You are joining two different types of epithelium together. The lining of the urethra is different from the skin of the arm. Therefore, you are likely to have problems when you join them together. Regardless, the morbidity and complication rate is enormously high compared to the other types of opera-

tions we do such as the metoidioplasty. In my opinion, the best way to get around the problem of strictures is to do a two-stage operation. The first stage is a vaginectomy and urethral lengthening. The second stage would be the phalloplasty and urethral hookup.

DK: Are you going to continue to do phalloplasties?

TM: I no longer do radial forearm phalloplasties. I believe the inherent risks and cost associated with the procedure are too great. In the worst-case scenario, you can have an extensive operation and are left with nothing but a scar on the arm. I also believe this operation should be left to those who do it on a regular basis. I still do the pedicle flap phalloplasty for patients that want an option to the metoidioplasty. The pedicle flap procedure provides bulk and length unlike the metoidioplasty. Unfortunately, there are several disadvantages to this procedure as well. The neophallus is insensate, and the urethral lengthening procedure cannot be combined with this procedure. The placement of an erectile device in the pedicle flap phalloplasty is riskier because the phallus is insensate.

DK: If there are so many problems involved, why do you think there are surgeons continuing to do radial forearm phalloplasties?

TM: When everything goes well, there are several advantages to this procedure. Physicians who do the procedure frequently and specialize in microvascular surgery stand a much better chance at a positive outcome and are better prepared to deal with adverse outcomes. Nonetheless, this procedure should only be done for patients who have a clear understanding of the risks and complications associated with this procedure.

DK: So, you prefer doing the metoidioplasty?

TM: Yes. This is a very safe procedure with minimal complications. You can do the urethral lengthening at the same time using the labial tissue or as a separate operation using buccal mucosa from inside the cheek. This is very similar to the procedure done by a pediatric urologist to correct hypospadias. You are not dealing with the same stricture issues associated with the radial forearm procedure—especially if the urethral lengthening is done at the same time as the metoidioplasty. You also burn no bridges. The major drawback to this procedure is that most people will not have enough length to achieve penetration for intercourse, and some people will find that unacceptable.

DK: What about transplantation of sexual organs?

TM: The main problem is with the immune therapy that is required. To suppress the immune response enough to get the transplant to take is potentially life-threatening.

DK: They must be working on improving anti-rejection drugs.

TM: Yes. However, even current studies state that the primary challenge is decreasing the morbidity associated with chronic immunosuppressive therapy when dealing with improving the long-term outcome of organ transplantation. These studies also acknowledge that recent developments in immunosuppressive drugs have allowed for better results across wider immunological differences. So there is hope.

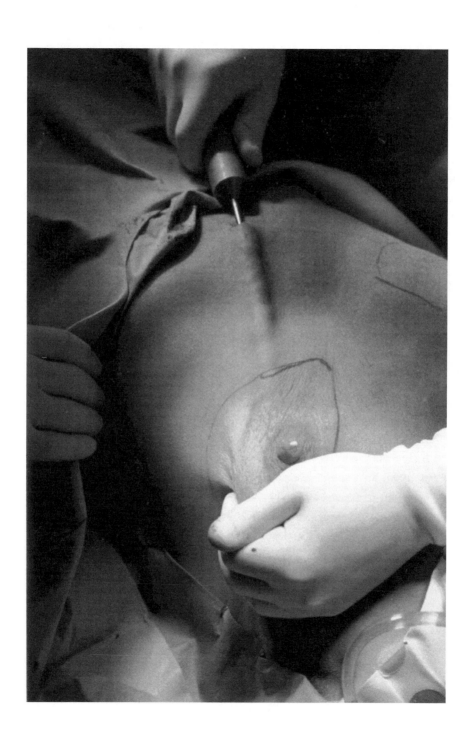

Liposuctioning Breast Tissue

Operation performed by Toby R. Meltzer, MD, PC, in Portland, Ore.

All that was necessary to produce male contours on this patient's chest was liposuction, since he had small breasts. Breast tissue is very fibrous, and a strenuous effort is required to remove it. This results in heavy bruising. Once the bruises heal and the skin has adhered to the chest wall, one can expect a beautiful result, given a skilled surgeon.

Bilateral Mastectomy

Operation performed by Michael Brownstein, MD, in San Francisco

The following procedure is typical of the technique Dr. Brownstein uses on patients with large breasts. Incisions are made at the mammary folds, enabling the removal of excess tissue, fat, and skin on the sides of the chest. The areola and nipple complex are removed, resized, and repositioned higher on the chest. Further manipulation of the tissue may be necessary to create proper masculine contouring.

UPPER LEFT *Marking for incisions; patient's face deliberately blurred*
UPPER RIGHT *Numbing the breasts with localized injections of anesthesia (patient has
already been sedated and has had his chest swabbed with antiseptic)*
LOWER LEFT *Marking graft sites (both grafts are taken from a single, large areola and will
be grafted higher up on the chest)*
LOWER RIGHT *Both grafts are removed and will serve as smaller areolas in new site*

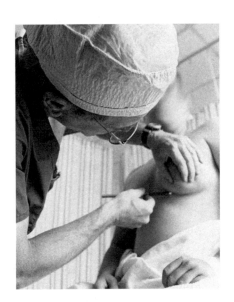 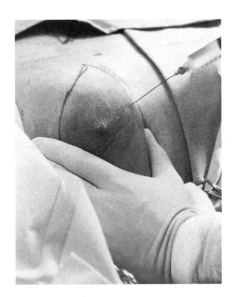

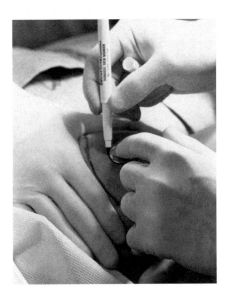 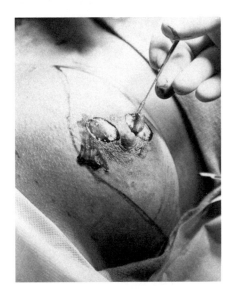

BILATERAL MASTECTOMY

UPPER LEFT Nipple and portions of original areola saved for use in new site
UPPER RIGHT Removing breast tissue with a scalpel and cautery iron
LOWER LEFT Drainage tube has been put in place and incision is being stitched up
LOWER RIGHT Graft sites are marked by tracing around a nickel (as this approximates
the average size of male areolas)

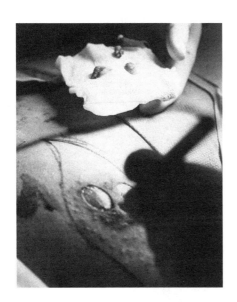 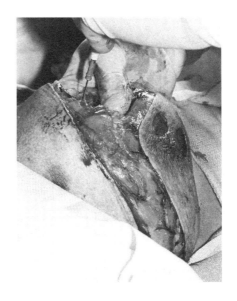

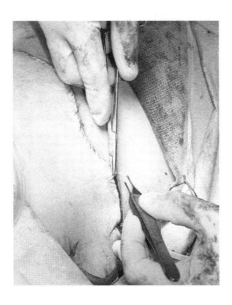 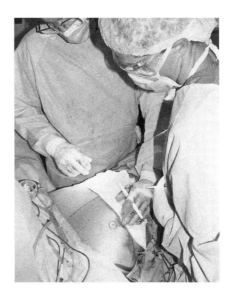

UPPER LEFT Epidermis removed at new graft site
UPPER RIGHT Areola has been stitched in place and nipple is being prepared
LOWER LEFT Stitching on areola and nipple on opposite side of chest
LOWER RIGHT Completion of newly constructed chest, displayed with breast tissue that
was removed. The thread used to stitch around the areolas is cut at intervals and left long to
tie around and secure the gauze used to protect them.

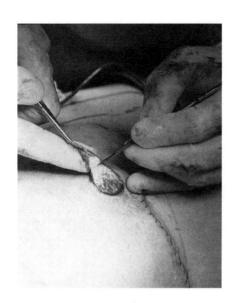 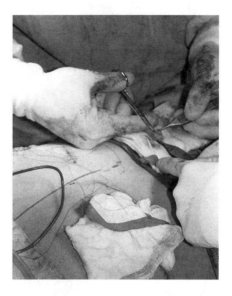

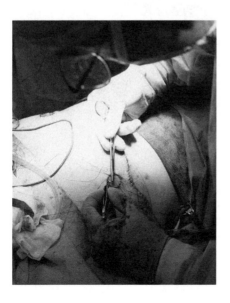

Metoidioplasty

Operation performed by Toby R. Meltzer, MD, PC, in Portland, Ore.

The metoidioplasty operation, developed by Dr. Donald Laub in Palo Alto, Calif., is one option for FTM genital surgery. This procedure, considered the safest, maximizes the potential of the patient's enlarged clitoris (enlarged through prolonged use of testosterone) to form a micro penis. The clitoris is released by cutting the suspensory ligament and surrounding labial tissue. A scrotum is developed by inserting tissue expanders in the labia majora and then, once the expansion is sufficient, testicular implants are put into place. With this operation, a urethral lengthening is possible with the use of tissue from either the vaginal wall or inside of the facial cheeks, allowing the patient the ability to urinate through his newly constructed penis. The advantages of this operation are: It is a safe operation with a low complication rate; results are aesthetically pleasing; the penis is highly sensate; the patient can urinate in a standing position; and no bridges are burned should the patient elect to undergo a different procedure down the line. The disadvantage of this operation is the size of the penis. Most people will not have enough length to achieve sexual penetration.

UPPER LEFT Shaving for surgery (shows enlarged clitoris due to prolonged use of testosterone; size varies with each individual, as does the surgical outcome)
UPPER RIGHT Stretching the clitoris to expose surrounding tissue
LOWER LEFT Releasing suspensory ligament and labial tissue surrounding the clitoris
LOWER RIGHT Freeing the clitoris off the pubis

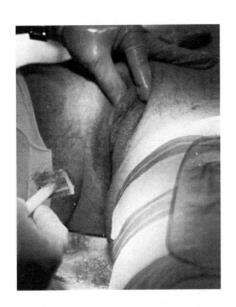
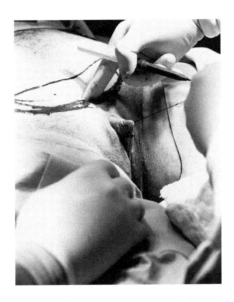
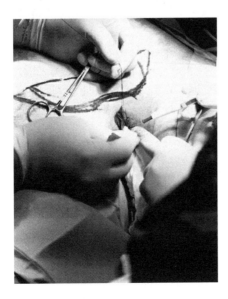
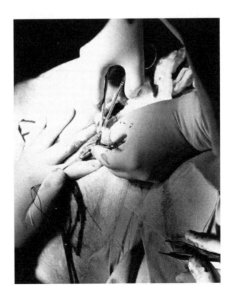

METOIDIOPLASTY

UPPER LEFT Surgeons preparing to sew up underside of newly constructed penis
UPPER RIGHT Sewing underside of penis (long view)
LOWER LEFT Stitching underside of penis (abdomen is marked where a "tummy tuck" will also be performed on this particular patient. Access to the labia majora will also be gained through this entry, allowing tissue expanders to be inserted)
LOWER RIGHT Cutting the final stitch on the penis

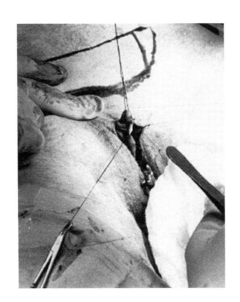 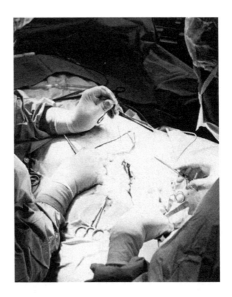

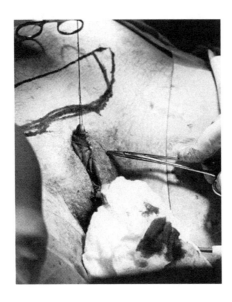 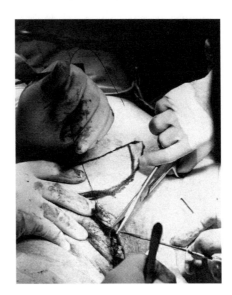

UPPER LEFT *Checking the position of the penis for possible adjustments*
UPPER RIGHT *Shows where skin and fat were removed to reduce stomach area*
LOWER LEFT *Checking positioning of penis in relation to forthcoming tummy tuck*
LOWER RIGHT *Close-up of tissue expanders. These will be inserted into the labia majora and periodically injected with saline to incrementally expand the skin in preparation for testicular implants and formation of a scrotal sac.*

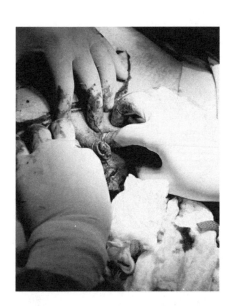 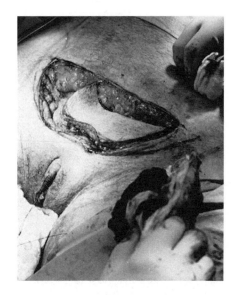

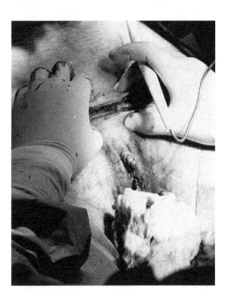 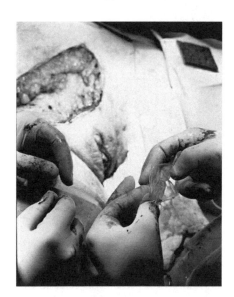

UPPER LEFT Suctioning fat
UPPER RIGHT Inserting tissue expanders
LOWER LEFT Saline injection sites in place
LOWER RIGHT Stitches to secure and anchor the repositioned penis/scrotum. The round
plastic spheres dangling from the abdominal cavity are the injection sites for the tissue
expanders that have been put into place

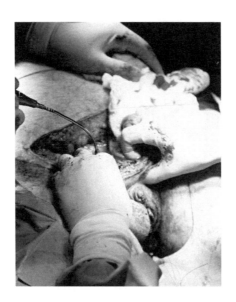
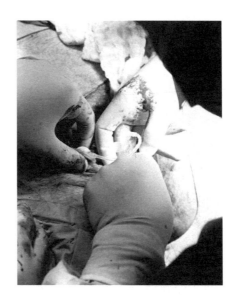
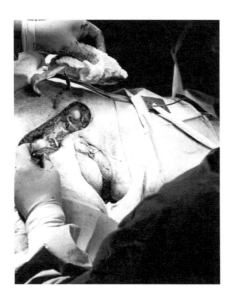
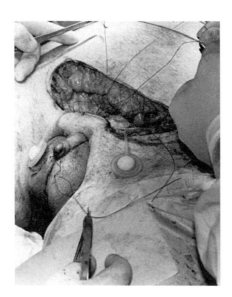

UPPER LEFT Cauterizing the abdominal incision
UPPER RIGHT Injecting saline into the tissue expander
LOWER LEFT Removing labia minora
LOWER RIGHT The final result, prior to healing and testicular implants. In this particular case, the patient chose not to undergo the urethral lengthening but will return for a final operation in which the two hemispheres that make up the labia majora will be joined together to create the scrotal sac that will house the testicular implants

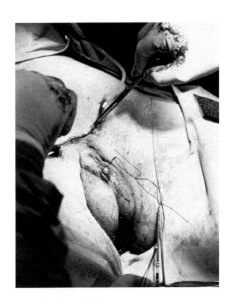
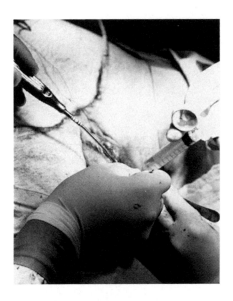
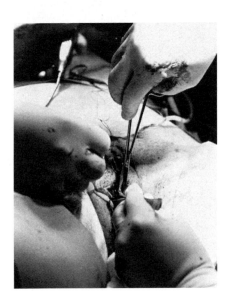
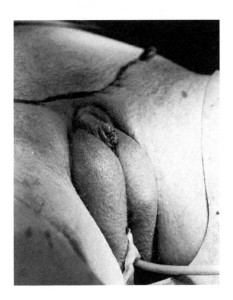

Another one of Dr. Toby Meltzer's patients who had the metoidioplasty and testicular implants. In addition, this patient had a urethral extension that allows him to urinate through his penis.

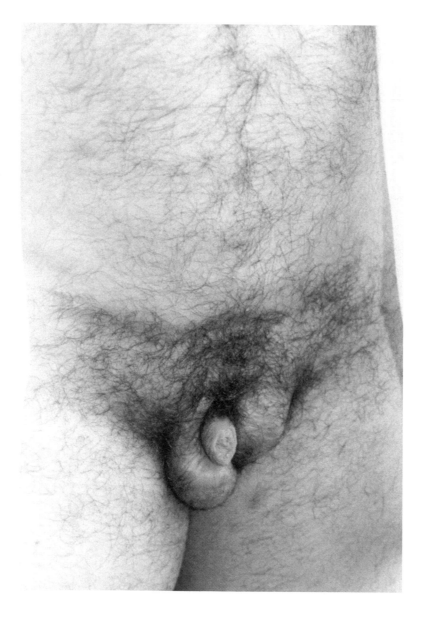

Radial Forearm Phalloplasty

Operation performed by Drs. Meltzer, Skoog, and Shaefer at OHSU, Portland, Ore.

The procedure documented in the following photographs took 16½ hours and cost $60,000. (Prior to this surgery the patient underwent a five-hour operation involving a hysterectomy, oophorectomy, and vaginectomy.) The patient's mother sold her house to pay for her son's operation. Skin, nerves, and veins from the forearm were used to construct the penis. The operation was very successful. The patient now has an aesthetically pleasing, highly sensate penis from which he can urinate and perform intercourse with the aid of a pump (the pump was installed in a successive operation).

UPPER LEFT *Determining dimensions and size of flap*
UPPER RIGHT *Mapping out the location of the gracilis muscle; the base of the urethra will*
be buttressed with this muscle juncture so it will be less likely to leak
LOWER LEFT *Dividing blood supply as it exits the flap*
LOWER RIGHT *Operating on the forearm and perineum simultaneously*

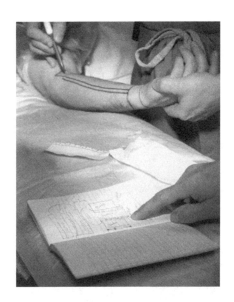

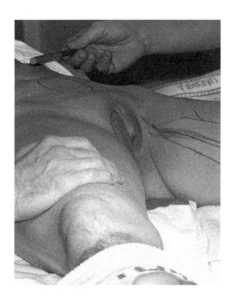

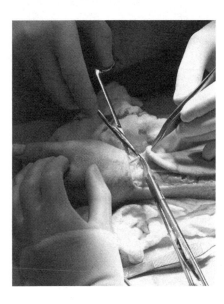

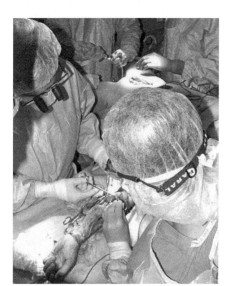

RADIAL FOREARM PHALLOPLASTY

UPPER LEFT Clitoral shaft; taking down suspensory ligament
UPPER RIGHT Preparing urethra
LOWER LEFT Shaping penis
LOWER RIGHT Penis on the arm; disconnecting blood supply

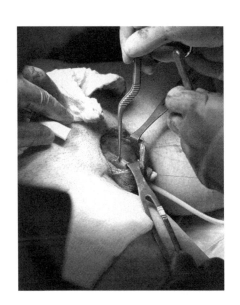
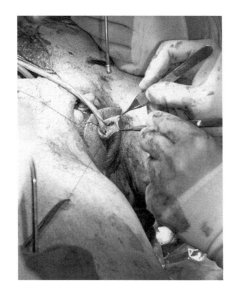
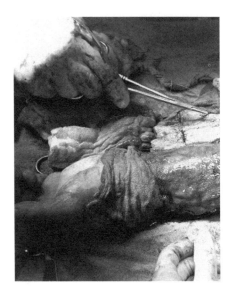
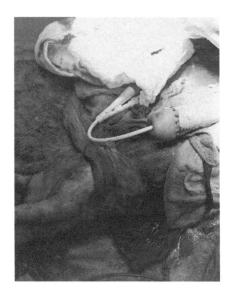

UPPER LEFT Orientation
UPPER RIGHT Sewing native urethra
LOWER LEFT Joining the penis and scrotum
LOWER RIGHT Connecting nerves, arteries, veins

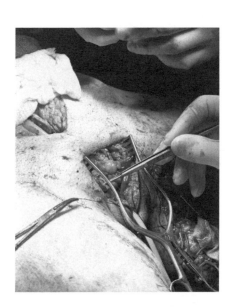

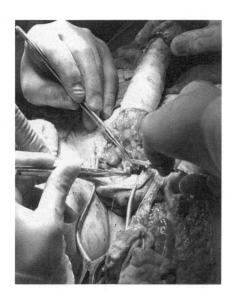

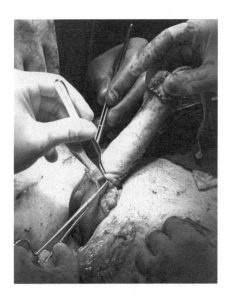

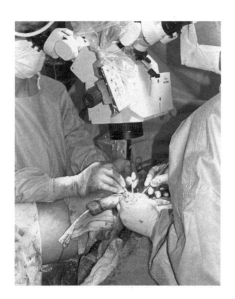

RADIAL FOREARM PHALLOPLASTY

UPPER LEFT Taking graft with a dermatome
UPPER RIGHT Closing leg
LOWER LEFT Stitching grafts onto forearm
LOWER RIGHT Building a structure that will keep the penis erect to facilitate healing

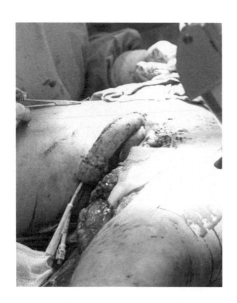
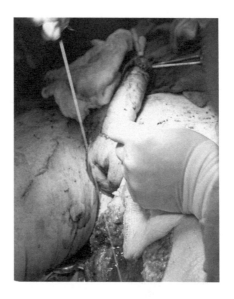

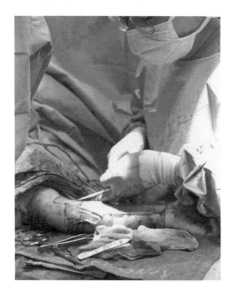
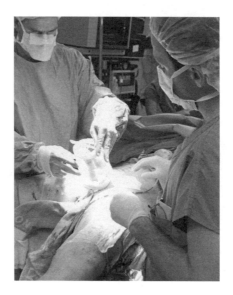

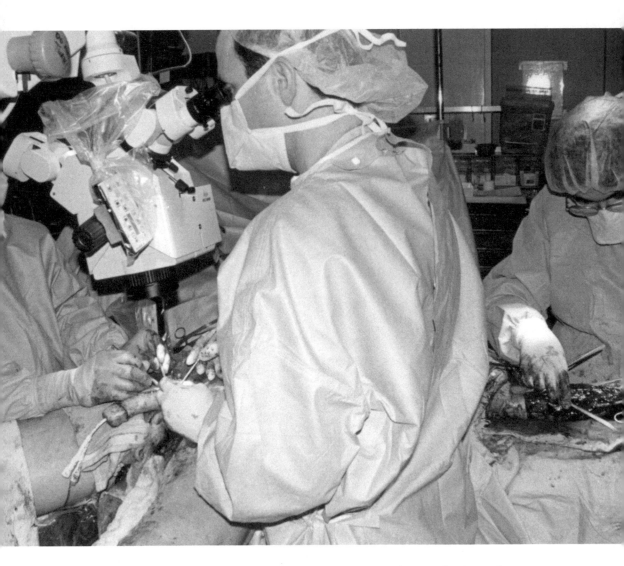

Connecting the penis while simultaneously preparing the donor site (forearm) for skin grafts.

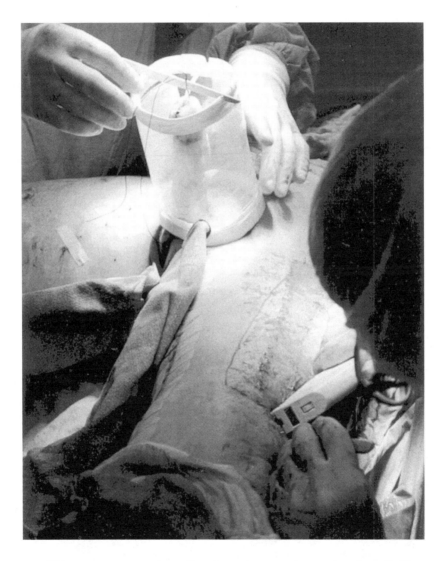

This structure was made to allow the penis to remain erect in order to facilitate healing. The surgeons have deemed this structure the "Phallus Palace"

Radial forearm phalloplasty results after healing; photographs demonstrate patient's ability to achieve an erection with the aid of an implanted pump and the ability to urinate through his penis. Patient will later undergo an operation for testicular implants

Interview With James J. Reardon, MD

By Dean Kotula

Dr. James J. Reardon is a Manhattan-based, board-certified reconstructive and plastic surgeon who has performed over 25,000 operations over the course of his career—including the McKissock chest reconstruction shown in the photograph on page 208. Reardon is sensitive to gender transition issues, has lectured on the subject, and is aware of all ramifications of the transsexual condition.

DK: How many years have you been doing chest reconstruction surgeries?
JR: I have been performing cosmetic surgery for 27 years and gender-transition chest reconstruction for 22 years.
DK: Since the systematic study of severe gender disorders have just 25 years of collective experience, you were performing the procedures very early on. How did you start?
JR: Much of my practice already involved chest reconstruction in general—whether recontouring the female breast or treating gynecomastia (enlarged breasts in males). Essentially, female-to-male chest reconstruction uses a combination of these techniques, so when I got my first referral, it wasn't really a problem.
DK: What motivated you to continue working with this population?
JR: The satisfaction from the patients themselves. I could see that surgery provided tangible relief from a very real problem.
DK: All of your patients are concerned enough about their appearance to come to you for a surgical solution. How do FTM patients differ from the others?
JR: Patients resort to surgery for a number of reasons—some are purely cosmetic, to change

a feature they aren't pleased with. Others seek correction of more serious deformities due to birth defects or injuries. Still others want to turn back the effects of time. The FTM patient's distress is much more severe. As you know, it goes beyond mere vanity. FTMs have a profound need to live as men, and they feel isolated, fearful, lonely, and incomplete as males living in female bodies. In most cases, they have known they were male for as long as they can remember and are convinced that there was some kind of genetic mistake that made their bodies female. These patients regard the procedures they undergo not as sex-reassignment surgery but, rather, sex-confirmation surgery.

DK: How do patients find out about you?

JR: Many are referred by their treating therapist. Others hear about me from satisfied patients—through word of mouth or in chat rooms on the Internet. I have a Web site and advertise in transsexual/transgender publications.

DK: Is there a typical patient?

JR: Yes. Many have an education beyond high school and college and include professionals and self-employed businesspeople who have responsible positions. Most have been on hormones for at least a year and appear as male. Large, unbound breasts are often the only thing that hinders their ability to "pass" as a man.

DK: How has your practice changed over the years?

JR: Today, therapists are referring younger patients who are making gender decisions earlier in life, preferably before entering college or their careers.

DK: What age are you referring to?

JR: Although many patients report having had the feeling of being in the wrong body since early childhood, I believe that no operation should ever be performed before or while puberty is occurring and without some form of psychotherapy. However, if the patient is in their late teens or early 20s, is absolutely sure of their decision, and is at one of life's natural crossroads, I think it is reasonable for them to start adult life in their preferred gender.

DK: What does a patient need to do to prepare for this operation?

JR: Chest reconstruction can make a significant difference in being successfully perceived as male, so it is often done early in the sex-reassignment process—after a program of psychotherapy, an extended series of hormonal treatments, as well as living and working in the male role. Exactly when depends on the patient's desires, supported by the therapist's approval. Because chest reconstruction is such a permanent procedure, I never accept any FTM patient without a referral from a psychotherapist. Younger patients, in particular, require an in-depth psychological evaluation, frequently a second opinion, and will certainly benefit from parental support and interaction in the decision-making process. Complete gender transition, including mastectomy, hysterectomy, oophorectomy, and genital surgery, requires stricter guidelines, developed by the Harry Benjamin International Gender Dysphoria Association.

DK: What makes a candidate ideal for these procedures?

JR: First, I want to stress that I never diagnose the transsexual condition. That is the therapist's realm. However, it has been my experience that the best patients have these characteristics in common: They have identified as the opposite sex for as long as they can remember and find it extremely difficult to adapt to or live in their biologically assigned gender role. They have the capacity to "pass" convincingly in their chosen gender. They do not cross-dress for fetishistic reasons. Many have some college education and are stable, holding long-term jobs and relationships. They realize that gender transition is a complex process and are willing to undergo psychotherapy pre- and postoperatively. Ideally, they have some social and/or family support systems, and finally, their therapist feels they are ready for surgery.

DK: What constitutes a poor candidate for any sex-reassignment surgical procedure?

JR: The characteristics of a poor candidate would include active or recent thought disorders, cross-dressing for exclusively fetishistic purposes, a major loss which precipitated the impulse for hormones and surgery, a history of antisocial behavior, and/or active substance dependence. Multiple suicide gestures and attempts, including genital or breast self-mutilation, are also signs of a poor candidate. Some have delusional and magical expectations of surgery. Others attempt to illicitly obtain hormones. Lack of social and/or financial support systems also makes the process very difficult.

DK: Describe your initial consultation with a patient so someone interested in seeing you might know what to expect.

JR: I conduct at least two in-depth preoperative consultations with the patient, fully explaining the procedures involved. I also show "before" and "after" photographs of surgeries I have performed and frequently refer them to other patients who have had a similar operation. I perform the chest reconstruction surgery and provide all follow-up care. All procedures are performed under local anesthesia with supplementary IV sedation in my ambulatory facility. We also provide local transportation following surgery and will assist those from out of town with accommodations.

DK: What does your method of chest reconstruction involve?

JR: There are three basic aims in mastectomy and chest contouring surgery. First, to resize the nipple-areola complex to the male dimension, approximately one inch in diameter. Second, to reposition the nipple-areola complex to about one inch above the new chest fold and approximately five inches from the breastbone. Third, to create natural male contours. Generally, these goals are easily accomplished in the flat-chested or thin individual but are often difficult to achieve in the large-breasted patient with peripheral fat development. With small breasts, resizing the nipple-areola complex and then recontouring the chest with simple liposuction often achieves the desired results. For very large breasts, advanced surgical methods for extensive reconstruction are needed. The surgical removal of breast tissue and

the contouring of surrounding fatty tissue leaves excess skin that needs reshaping. The most advanced procedure I perform includes the McKissock technique, which, because it keeps the nipple-areola complex intact, retains better sensation and more natural color than traditional nipple grafts. Following the natural chest folds, incisions are made to enable the removal of excess tissue, fat, and skin on the sides of the chest. But the nipple-areola complex is left attached to a vertical "ribbon" of tissue. It is then resized, then repositioned to a higher level, and masculine contours are created. The "ribbon," once it's positioned correctly, actually mimics a well-developed pectoral muscle. In a nipple graft, which is used for extremely large breasts, the nipple-areola complex is removed completely along with the

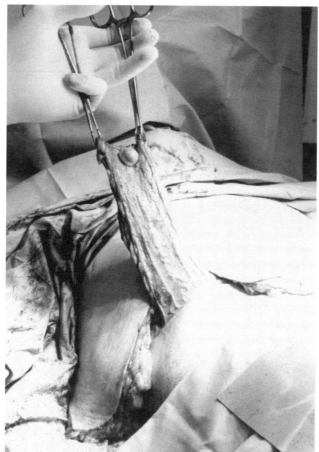

Dr. Reardon performing McKissock chest reconstruction.

breast tissue, then resized and repositioned after the contouring is complete.

DK: Having seen you perform the McKissock procedure, I have to admit I was largely impressed. By now, I have witnessed a variety of available surgical procedures, having been in several operating rooms. I have also seen a lot of FTMs bare their chests to

display the results of their surgery for comparison's sake, and I've noticed that there is a lot of variability in terms of scarring, which seems to depend on the original breast size and surgical technique. Aside from this, I've heard that the thickness of the scars can sometimes be determined by the ethnicity of the patient. Being that scarring is a common concern, what do you do to minimize them?

JR: While a complete mastectomy can result in significant scarring, results today are considerably more aesthetic than in the past. Whether the McKissock method is used or a nipple graft is necessary, there are no vertical scars under the nipples. In most cases, scarring is discreet and is easily camouflaged by natural chest creases or body hair.

DK: Realistically, what results can a patient expect?

JR: This surgery creates masculine contours and can make one feel more at ease in their chosen gender. In the hands of an experienced surgeon sensitive to the issues, the result is a well-contoured, natural-looking, masculine chest.

DK: What are the risks and possible complications involved?

JR: While not simple, chest reconstruction is normally safe when performed by a qualified and experienced plastic surgeon. While the surgery can result in slightly mismatched breasts or uneven placement of nipples, asymmetries can be corrected with a minor secondary procedure. Too much fatty tissue may be removed peripheral to the breast, creating a flat chest wall that looks unnatural. This can be corrected with fat injections. Occasionally, only partial take of the graft may occur, requiring some minor procedures later. Some patients may experience a permanent loss of feeling in the nipple or chest area. Rarely, the nipple and areola may need to be rebuilt, using skin grafts from elsewhere on the body. Because residual amounts of breast tissue always remain, the regular risk of future breast cancer is not eliminated and annual mammograms are recommended.

DK: How long does it take to recover from these procedures?

JR: One or two weeks out of work for the more invasive procedures. The stitches are removed in one to two weeks. A surgical halter should be worn for several weeks. Although the patient may resume light exercise within a week, there should be no strenuous activity for three to four weeks. Most of the bruising and swelling will disappear in the first few weeks, and the chest will settle into its new shape in a few months.

DK: What would you like to see happen in the future in terms of sex-reassignment surgeries in general?

JR: Many will argue about the causes and nature of this identifiable, severe, and incapacitating condition for years to come, but for surgery to answer the needs of the transsexual patient several goals must be reached. A diagnostic selection process should be developed to allow uniform screening of patients with gender dysphoria: This would help us more clearly identify those who may not be helped by sex-reassignment surgery. Hopefully,

advances in technology and techniques will allow uniformly high-quality operations that give improved aesthetic and functional results with reasonable cost and risk. A careful, systematic follow-up of unselected groups of patients over a 10- to 20-year period would provide a better evaluation of the psychological and social effects of surgery. Medical schools also need to teach students much more about this subject. More understanding will come with time and as technical progress continues to be made.

DK: Dr. Reardon, I want to thank you for contributing your insights and for having served the transsexual population for a great many years. These surgeries not only change the quality of your patients' lives but are often lifesaving.

JR: It's been my pleasure. Thank you for asking me to be a part of your book.

Part Five
Gender Memories

Self-portrait by Dean Kotula

Perceptions and Plights

By Dean Kotula

Until I transitioned, my greatest triumphs and periods of joy were tainted with the knowledge that I was considered and looked upon as a girl, then a woman. Closer to the truth, I was judged a "tomboy" and a "mannish woman," which made me self-conscious of my every move.

To everyone looking, I had a "pixie" cut, but in my mind I was shorn to best the likes of Caesar. And it was a small blond girl they saw traversing the trees by lashing ropes around branches then sliding the crotch of a forked limb over the rope while grasping the ends. In my eyes, I was Tarzan.

I had all the requisite gestures befitting a boy, not simply because I was desirous, or the costuming struck my fancy, but because I was a miniature replica of a man—if not in body, in mind, heart, and soul. The boy apprentice in the Italian Renaissance, Oliver Twist's artful dodger, the shepherd of the mores, an ancient mariner. The male body I've come to possess may be the happenstance of modern medicine, but my psyche has always been kin to generations of men.

Now I want to recover my childhood, to be viewed as a boy and young man, to act freely and naturally, without hesitation or jeers. I want what was rightfully mine. So, at age 42, when I should be grooming myself for the altar or beginning preparations for retirement, I want to revel in the mud instead; lather the cool ooze onto my naked chest, whoop and holler with wanton abandon, experience the pure, primal, unabashed feeling of being alive.

When I tire of my pals I want to pelt them with a shower of spitballs, snap their suspenders, and kiss their girls. I want to know raucous, endless laughter, low and guttural, surging upward from tickled toes. I want to wear a smile so generous it engulfs my head,

and to live in moonlit madness, pumping some pungent pussy in back of the proverbial Chevy.

I want to see my opponents waver, buckle at the knees from the force of my advancing blows while tasting the salt of my exertion and hearing the crowd as the spotlight catches the glistening sweat working its way down my brawny physique.

I want to be poised at the prom in a dapper suit with a carnation-laden lapel, hoisting my date in the air, rollicking on the dance floor, enraptured by her beauty and gloating at the soundless envy.

I'd like to walk alongside my dad and have him wrap an arm around me and call me "son." I want a freedom I can't even imagine.

PORTRAITS

At 10 years old, I whiled away countless hours sketching. I drew portraits of men sporting various styles of mustaches and beards. The collection was replete with medieval knights, Indian maharajas, Spanish conquistadors, and various artists from the Italian Renaissance. In addition, I paid homage to such notables as Auguste Rodin, Salvador Dalí, Julius Caesar, Wild Bill Hickok, Abraham Lincoln, and Herman Melville.

I was more enterprising than talented and could scarcely produce a genuine likeness, but just as a man could compensate for a weak chin by growing a beard, I could conceal my inability to render facial contours by drawing in thick masses of bristly hair. At least, this was the explanation I gave for always drawing men.

In truth, hair was far more difficult to draw. One could suffer the tedium of rendering each single hair or choose to draw hair en masse, an impression of hair, made up of values light and dark. I usually chose the latter. I would press a charcoal-smudged finger to the paper and swirl it around to establish a ground color, then I would add more charcoal to darken certain areas. Finally, the drawing would come to life when I'd pluck out the highlighted areas with an erasure to create the illusive third dimension.

When I wanted to indicate whiskers, I could crosshatch to shade the furthermost planes of the face, then, using a softer pencil to produce the richest possible black, I could create a stippled effect to simulate stubble. Sometimes I simply resorted to the method used to depict bandits in cartoons and comic strips—whereby a few days' growth was clearly delineated by a single shade of deep gray covering a full half of the character's face.

Only once did I elect to get a model for a portrait, or rather, I appealed to the neighbor kid's vanity (of which he had an abundance). All at once our statuses were elevated from mere children to "artist" and "model." To Dickey's way of thinking, I was surely a great artist with a profound talent to have secured such a fine specimen as he (he was rather rotund

and bore no resemblance to whom I had in mind) and to attempt to capture his image on paper. Of course, *capture* was the operative word. Just as soon as he sat down to strike a pose, he stiffened like a skunk preparing to release an offending odor. He was about as natural as rigor mortis, with the exception of an incessant tic around his left eye—just signal enough to indicate a pulse!

Needless to say, Dickey didn't get his 15 minutes of fame; he was instead released from his duties and relegated back to "stupid neighbor kid." I kept the title "great artist" since I didn't have the chance to prove otherwise.

Aside from that one futile attempt, I had always used my own face as a model, but I varied the structure to appropriate a wide range of characters. It was deliriously satisfying to watch every last vestige of my femaleness disappear into the throes of virile manhood with simple strokes of a pencil.

My face became taut, supple leather, canopied over heavy ridged brows, sunken cheeks, and an abundant jaw. Painstaking effort was made to pencil in a healthy crop of whiskers and particularly generous sideburns. The crowning glory was the cleft chin and dark brooding eyes.

My likeness was transformed into men who were formidable, gaunt, and haggard, with noses off plumb and eyes that reflected back bottled whiskey. Parted lips invariably revealed missing teeth and just a hint of spittle.

Other transformations included men who were more genteel—rarely a dandy among them, but their aspect suggested a more temperate disposition.

These men had done deeds great and small; both good and bad. Some were humble, poor, and proud; others were arrogant and driven, had unwittingly amassed unheard-of fortunes and hid them in coffers underground. They were all keenly instinctual, liberated from pretense, and in a constant state of preparedness. Like wind, they could surreptitiously find the source of any shadow.

I lived through them vicariously, sublimating my fears. We would band together in formation, like buckshot, targeted at injustice.

Each day I would ceremoniously return to the sketches to add another day's beard growth in lieu of a daily shaving regime. I had no need of a shave; my cheeks were covered with wisps of fine white down, and like dandelion pollen, one day the wind would just whisk it away...or so I thought.

CHILD'S PLAY

A kid's play can be pretty simple. I remember crafting toys from hand—whittling a staff, a slingshot, creating makeshift bows and arrows. Anything was possible until I grew older and

was introduced to the sophistication of adult toys, or, more accurately, motor-driven implements of destruction, disguised as recreational vehicles or yard maintenance equipment.

First thing I was told was that I could lose fingers, toes, or my entire life by operating these machines. This didn't exactly endear me to the idea of using them, but as there was generally a crowd gathered around to watch me perform my virgin flights, I'd say to myself, *Heck yeah, I'll take the challenge!* I wasn't about to acknowledge my dreaded fear.

On one of these occasions, I was to test out the family's newly acquired Polaris minibike. It was some used, boxy looking thing that appeared to have been conceived by some semi-inventive metal shop worker out of his garage on some extended weekend. Someone hell-bent on drafting without a compass and refusing to use a band saw—there wasn't a rounded edge to be found. Had there been a Darth Vader–mobile, this bike would have inspired it, had it not been for the color—school-bus orange! It wasn't the kind of slick, brand-name dirt bike like the neighbors up the street had but some ugly, formidable looking gadgetry that made you want to wear a helmet just to conceal your identity.

My dad just couldn't manage to forget those few occasions while out fishing that my line caught and got entangled with nearly everything but a fish, so every day hence, he thought of me as somewhat of a klutz and figured he had to prepare me as best he could for this virgin flight on the minibike. Over the roar of the engine, his words cut through the trail of sooty fumes spewing out the exhaust as he pointed out and explained something about the brake, gears, and throttle. The loud noise of the bike unnerved me, as did the expectations of my dad and the anxious onlookers. I was impatient with his instruction, knowing he was thinking about the fishing line…well, damn it, this was no big deal, I'd show him! I remember thinking, *He said "gears," so that means there has to be a clutch…must be that lever on the left handlebar…on regular motorcycles you change gears by squeezing the clutch and lifting the shift mechanism with your left foot…I saw guys doing it a bunch of times.* I did a quick checklist in my mind and took a cursory look around until I was satisfied that I was ready to go.

"Ready?" my dad asked, trying to inject confidence and enthusiasm in his voice. I nodded. "All right then, take off!"

I stood alongside the bike, grasped the left handlebar, and swung my leg over the bike just like I had straddled my cousin's pony the summer before. While my leg was still launched in the air, I grabbed the right handlebar and the bike shot off like a wild stallion. I had inadvertently grabbed the throttle and held it wide open! Hovering over the bike rather than secure in the seat, I was dumbfounded and helpless to react.

The merciless machine only halted once it had leaped up onto the hood of the family car and revved its engine as it tried burrowing its way into the windshield. The impact of the crash had forced my grip off the throttle, and the momentum catapulted my body over the car's roof and landed me square on the trunk in a swollen heap. Stupefied, dazed, and embarrassed, I crawled off the trunk and gathered my composure with the thought that, just

maybe, someone may have thought that my actions were deliberate—that I was launching an early career as a stuntman. After all, Evel Knievel had nothing over me, other than the fact that he used a full-size motorcycle to jump over multiple cars at once, was intent on doing so, and in fact succeeded. But who was I to quibble with the details? If I had made the comparison in my shaken state, surely someone else had too.

I rounded the front of the car and shuffled over to the group to read the expressions in their faces. I decided they weren't thinking about Evel, nor did they appear to think about me, for that matter. When I tried to engage a single pair of eyes, they flitted away in another direction.

Apparently, it was presumed that I was OK, given that I was on my feet, but no one dared ask. Aside from bruises and scrapes, it was my pride that had been injured, and they knew it. When I was finally addressed, it was my dad who spoke. "What were you thinking?" he bellowed out. I began to explain that I mistook the handbrake for a clutch...I soon realized he didn't want an explanation at all. He was shaken up over what had happened too and was looking to me to release his emotion. I looked at him sheepishly then turned to walk away in order to do battle with my own feelings in private. Half tripping over blades of grass, I had pushed my feet across half the front lawn when my dad called me back.

I worked my way back, and when I stood alongside him, he said, "Get back on and go for a spin." I hardly believed what I was hearing. The last thing I wanted to do was to get back on that damn bike but knew I *had* to. I had to save face, win both my confidence and my dad back. So, like nothing, like a veteran biker, I hopped on the minibike and sped off.

I've gotten accustomed to certain adult toys over the years and have tried my hand at tinkering with engines, but I've never grown complacent. I'm always a little suspicious, a little ill at ease, expecting something to go awry...like severing the frayed pull cord on the lawn mower, losing an axle while driving through a downtown tunnel during rush hour, having the battery shift in a VW and seeing flames pouring out of the engine through the rearview mirror, or having my motorcycle careen toward a brick wall after spinning out in an oil patch.

As luck would have it, it's all happened to me. Even if there's no fault with the handler, it's inherent in the machine; parts wear out, misalign, and fail altogether. It's a fact of life—however prepared or informed we are. I prefer to keep things simple.

I saw a boy speeding down the road on a skateboard today. His bright orange hair shot across the landscape like a fireball (or my minibike—after I had grown in confidence as a kid), burning an indelible impression in my mind. With that simple implement, a couple of casters arranged on a board, he was just barely upgraded from self-propulsion into the realm of freedom and mobility, but he was in his glory. It brought me back to my days of skateboards, surfboards, climbing trees, and fistfights—when things were simpler...when you knew the odds of getting hurt before you defied them.

PUBERTY

When puberty arrived, it was not only awkward but devastating—not like the Christmas I got a nightgown instead of the walkie-talkies I had my heart set on, but much, much worse. I had no one to complain to or hold accountable for the changes that were occurring to my body. I was shocked, I didn't understand, and was far too humiliated to call the event to anyone's attention. I had older sisters, so I knew the gist of what was happening, but not why it was happening to me. It was like my heart had broken and the blood exiting my body was proof. As the blood flowed out my body, self-loathing took its place—like rats entering the dungeon that became me. They encircled in hordes, sniffed and taunted, until I was left with little choice but to poison them on a sojourn through the netherworld of drugs.

JOURNAL ENTRY: ABOARD F/V BEIRAMAR TRES

Dearest Sara,

There are heavy gales tonight and a 40-knot wind. The seas are raging with an indomitable fury. I am lying in my bunk below decks, and I hear the water sloshing past the porthole. Drops of seawater seep through despite the equalizing pressure, trickle down the walls, wetting my side. The pitching motion is incessant and constant. It's as though I am being rocked to sleep in an underground tomb. The deck planks overhead creak like boughs crackling in the wind. It would be tranquil, mesmerizing, even hypnotic if it weren't for this disarming fear. One cannot negotiate an act of mercy with the forces of nature.

To the best of our knowledge, we are off course by approximately 80 nautical miles to the southwest. The compass has sustained damage from the storm and the primitive electronics have been rendered useless by lightning. No other ship has been sighted since we set sail some 50-odd days ago. I hasten to say, we are lost and despairing.

The rodents who boarded the ship in port are availing themselves of the ship's stores—fattening their little bodies while most of the crew lie weary and exhausted, covered in sweat, puke, and their own excrement. Who knows what diseases these fetid creatures may be harboring!

Regrettably, I might die, but worse is what I may have accomplished had I lived. Ironically, I have lain all hope of wholeness on this voyage, the very voyage that may lead to my demise! I had hoped to raise the surgeon's fee, that which would prompt him to make me the man I know myself to be. Am I doomed instead to die a humiliating death? I would prove content to have my body found awashed upon the shore in perfect bloated putrefac-

tion, so long as a shark had gnawed healthily upon my groin! To make a splendid mess of the male genitalia I would likely be perceived to have had; to mask the origin of my sorrow.

The thought that I will be lost and forgotten is terrifying—who do I have to succeed me, to preserve my memory, but you? A solitary life such as mine is meaningless, inconsequential, to the hordes that exist. Our love, personified through childbirth, shall never be. This is truly a grievous sorrow.

My life has been tumultuous, like this very voyage, somehow always off course. A geographical clue, a fixed position on the horizon, could spare our precious lives, just as life's ceaseless agony subsided when I fixated on your loving tenderness. You've made me feel the man I am as near as anyone can.

These are likely our final days. While our chances for survival dwindle, so do my ambitions, down to the barest of needs. More than all that has been known to me—warmth, food, drink, and the expectation of another day, I confess that my only remaining desire is to lie with you knowing the full capacity of a man.

You, Sara, are my heart's last memory of love. When I manage sleep, I dream of you, and in this dream your arms wrap around me like the crescent moon and I am safely home. The ship has returned to harbor and the lines are fastened to the pier.

Journal entry: Aboard F/V Beiramar Tres, nearly a fortnight later

Dearest Sara,

As each day passes, I grow weaker and weaker. In my vulnerability I wish to surrender all that I have been reticent to disclose, before my thoughts elude me.

My hubris has kept me from admitting what I can't disprove and know to be true. I fear that in the telling, my propensity for drama will stand in the way of being believed. I have always been truthful, but now I wish to share the greatest truth I have come to recognize.

I speak of fear, but in all honesty, I am impervious to it. On numerous occasions throughout my life I have been protected by a power I cannot readily discern. This power might well be called God. I have learned, not through theoretical means but through experience, that God is not a separate entity but the connection to all that exists. Through God, when I am attentive to the fish, they listen and respond, and when a full moon shines over the water

and not a single fish is to be found by even the most expert of fishermen, I know where they are. I live among them as I do all creation. I have seen souls emerge from dying bodies and spirits revisit the Earth.

With God, I am endowed with an unencumbered vision—where life is stripped to its essentials, without an imposed superficial reality, and what remains is truth. What has become so profoundly clear is that our thoughts, our ideas of separateness, our creation of self, act as a barrier which closes us off from God and eternal bliss.

With my psyche and body at odds, I have never had a clear sense of self. I have disavowed a physical existence, denied my body, and, therefore, couldn't separate. Without a shell, without a boundary, I am an integral part of the force of life. I was one with God—weightless, timeless, and in that very state of bliss—a state that could only be sporadic, unable to be sustained for great periods of time, having been borne of rejection. After a time, rejecting my body only allowed its burden to return full force, with a vengeance.

Like a great balloon tethered to the Earth, I could explore loftiness but couldn't soar the heavens, or like a ship at anchor, I could bob the waves but couldn't sail the seas—I was bound, my freedom limited. I must actualize a self, go through my body, forge it, transform it, reveal its truth, before I can finally transcend it.

I look out the porthole and every so often when the ship reaches the crest of a wave, I can see the horizon. My body and the horizon are one the same—a hoax, a mirage, an endless destination—a dividing line between heaven and Earth.

Ironically, with my life so near an end, I beg to honor my calling. I plead that this trembling heart keep beating within the walls of this once despicable form—that it cling to life like barnacles to the hull…the very body I despised, I now cherish as a true companion before death.

Peace Corps

In one of the Peace Corps' recruitment brochures, under the caption "Diversity," it states: "Peace Corps strives, through its volunteers and staff, to represent the richness and variety of the many people who make America what it is. A diverse group of volunteers shows the world a true picture of our country and capitalizes on the strength of our own multi-culturalism."

I was an excellent candidate for the Peace Corps; I had practical skills to impart and had the experience of living and traveling abroad. A stint in the Peace Corps would be in keeping with family tradition. My parents heralded education as being one of life's priorities, and they committed over three decades of their lives to teaching worldwide.

I applied to the Peace Corps, and within a few weeks I was called in for an interview. I

met with a recruiter, and she enthusiastically said she would nominate me for the program. I was thrilled, but this was only the beginning. I would still have to endure a lengthy, rigorous screening process that involved medical, legal, and dental assessments before receiving an invitation for an assignment.

The entire process took over eight months to complete. I had to supply numerous documents, undergo a physical examination, have four wisdom teeth removed, and wait what seemed to be an interminable length of time. From the onset, I was preparing myself both mentally and emotionally for the separation from family, friends, and work. I structured my life around the expectation of living abroad for 27 months.

At long last, I got invited to serve in Thailand as an aquaculturist. I was elated! I had previously lived in Thailand as a child and revisited once as an adult. I was looking for an opportunity that would allow me an extended stay, and now I had it. Besides, I believed, overall, in what the Peace Corps was trying to achieve. I'd always had concerns about Western intervention in developing countries, but here was an opportunity to assist in the most fundamental way—by helping to provide a means by which people could feed themselves.

I had witnessed the ravages of hunger growing up and felt exceedingly helpless and ineffectual in my ability to act. This time, as an adult, I would have the support, guidance, and materials to effect change. Although I believed this, I had no illusions of altruism. I knew I would be the greatest benefactor in the end.

Once I was notified, I had one month to prepare to leave. I quit my job, notified my landlord, and began packing. A week into my preparations someone broke into my apartment and stole my photographic equipment. Not having insurance, I was forced to spend nearly all of my meager savings to replace the equipment—I never would have considered going without it.

I put the remainder of my belongings into storage, said my heartfelt goodbyes, and flew to San Francisco, where I was to attend a three-day orientation prior to departing for Bangkok. This is where volunteers would have an opportunity to meet Peace Corps staff as well as other volunteers going to Thailand, and to be indoctrinated into the culture in which we were about to embark.

When I entered the hotel meeting room, the room was charged, abuzz with the energy of enthusiasts about to explore new frontiers. Agonizing delays had culminated into these final days before takeoff. Prospects had become a reality.

Introductions were made, and then we listened to a speech about the history of the Peace Corps and its role in global relations with the United States. *We were a part of something greater...we would be a part of Peace Corps history...* The moment was ripe for allegiance to the flag. The government had sanctioned us as our nation's representatives and we stood tall, as though we were exemplary, and could stake claim to great accomplishments. It was all very heady and seductive; perfectly synchronized to the speech were my own

righteous thoughts, recounting various charitable acts I had to my credit. A certain piousness and sentimentality loomed in the air as we assessed ourselves and one another. Well, maybe we were just proud, having been bestowed this honor. But with honor came responsibility, and I suspected that soon enough we would find ourselves humbled countless times a day as self-doubt came to bear.

Nevertheless, there was a feeling of belonging, of oneness, as we acted from the assumption that we were all adherents to the same principals of justice, freedom, and human dignity. Being in the Peace Corps meant you not only ascribed to these principals, you worked to uphold them as well.

At the close of the day, Anne, the staging director, announced, "Tomorrow, we are going to be *ribroy.*" This is the Thai equivalent of *politically correct.* "Men are expected to wear dress pants and shirts, and the women are to wear dresses or skirts." My heart stopped as adrenaline surged through my body. This couldn't be happening! I had specifically asked about a dress code over the phone on numerous occasions, prior to coming, in order to circumvent any possible conflict. I was told, in no uncertain terms, that I would not be expected to wear a dress or skirt at any time, being that I would be working in rice fields farming fish.

As the group began dispersing, I hunted Anne down and pulled her aside. "Can I talk privately with you for a moment?" We moved to an adjoining room, where I proceeded to tell her that I hadn't worn a dress or skirt for 25 years and had no intention of starting at that point. I also mentioned that I was told several times that it would never be a requirement. She said that there is a specific dress code for the period of time set aside for language training and that all volunteers were expected to adhere to it.

I was beginning to see that this wouldn't be a simple matter. Her defenses began to rise. I didn't want to appear belligerent, this would do me no good, so I naïvely resorted to the truth, hoping to elicit understanding and compassion. I explained that I believed myself to be male and that I would feel as equally humiliated in a dress as any man would. I explained that I fully expected to be addressed and treated as if I were female while in the Peace Corps but that it was my intention to undergo a sex change once I got out. Furthermore, I mentioned that I was not on hormones, in no need of medical care, and that I would keep the information to myself. No one had reason to know.

She was slack-jawed and wide-eyed for a full 30 seconds; then, flustered, she stammered and paced for another 60. Finally, she turned to me and said in the bravest voice she could muster, "Well, at least wear a dress tomorrow and I'll get back to you." She obviously didn't get it. I replied, "I don't own one, and what I said still applies." She escaped by saying, "Well, OK, I'll see you in the morning." As she was running off, I called out, "I would be willing to wear a Thai sarong!" Even wearing a sarong was a stretch for me, but I could justify it as unisex clothing. She dismissed my comment by shaking her head.

The following morning we were escorted to a medical facility to get a battery of inoculations to ward off the possibility of contracting diseases abroad. I was familiar with the routine, having been out of the country on several occasions, but I didn't relish the thought. I reminded myself that it was a small price to pay for the privilege of going. Besides, it appeared as though I hadn't jeopardized anything by being truthful to Anne. Why would they send me for shots if my going to Thailand was being called into question?

After a quick lunch, we returned to the hotel. Upon arrival, Anne approached and pulled me aside. "I've been talking to my colleagues about your situation and now they'd like to discuss it with you. Follow me." I didn't like her tone. I immediately felt as though I was being led to an execution without knowing the crime.

We entered a boldly lit room. The space was consumed by a massive conference table and little else. A dozen or so people were seated around the table. From the tension in the room, I expected an inquisition. Who were all of these people? What was the big deal? Was I on trial for my thoughts? Surely this couldn't be happening in a democracy! In the 1990s! If it hadn't been for the dress code, they wouldn't have known and would have embraced me as "one of their own."

Anne waved a hand, directing me to a vacant chair. I wanted to bolt out of the room! I wanted to gouge out those greedy little eyes, fascinated by the sight of me, now that they knew. Everything changed with that one confession. Those *liberal humanitarians* discovered limits to their tolerance. I sidled over to the chair and sat down.

They announced that they had spoken to "Washington, D.C., and the Thai government" and that it was decided that I would no longer be accepted into the Peace Corps. I had sensed that it was coming, but the premonition didn't begin to soften the blow. I was stunned and mortified.

They encouraged me to speak, which only struck me as an effort to ease their own discomfort. I felt like a circus freak being poked, prodded, and asked to perform. The decision had already been made—by anonymous people! They didn't even afford me the decency of saying who was responsible for the decision, nor did I learn how Anne presented the information. They simply wanted to make a clean sweep of this mess! No names, no recourse. Somebody had really fouled up to have let a transsexual slip by this far!

I couldn't counter their arguments since I didn't hear their justification—just a lame retort: "It's for your own protection." At that point, I lost it! I had nothing more to lose, so I let them have it. "If you actually gave a damn about my well-being, you wouldn't be doing this to me. People have committed suicide for less than the situation you're leaving me with! You're thrusting me jobless, homeless, and humiliated out into the streets! So much for peace and diversity—you're a bunch of hypocrites!"

Completely devastated, I walked out into the streets of San Francisco with my last $100.

BODY DYSPHORIA

Overall, I believe people generally don't see beyond the artifice of presentation, the banal banter of propriety, or themselves. The crack in the sidewalk tends to go unnoticed until the lost lick from a Popsicle attracts a bevy of ants. And even if one is observant enough to notice discordant cues and recognize their significance, there is often a refusal to consciously acknowledge them, as they might lead to unfathomable destinations.

Unfortunately, my body displayed enough of these discordant cues for people to take notice, and they often stared, attempting to discern my sex. My body showed like neither exclusively girl nor boy but of both. With slight hips, well-defined muscles, small breasts that were easily concealed, and a closely cropped haircut, it was difficult to tell. Once strangers asked questions in an effort to determine my sex by the sound of my voice (their motivation was always apparent), they were answered by a voice, deep and resonant, that conveyed no sign of femaleness. I despised these invasive, deceptive inquiries and the inordinate amount of attention I was paid, so when, in a final effort to discover my sex, they asked me my name, I would further confuse them by substituting a gender-neutral name for my female one. This all begins to sound like the characterization of "Pat" on *Saturday Night Live*. Admittedly, I found some of the episodes humorous, but I can assure you, I did plenty of cringing as well. It is not nearly as funny if you have to live the experience—the constant scrutiny and disparaging remarks.

I learned repeatedly that my appearance was unsettling. Not because I was ugly or disfigured but because what people saw confused them. Their own decisiveness was disturbing; they had to conclude that one was either a boy or a girl, a man or woman. They couldn't know the extent of their cruelty—that I too was confused and that how they reacted to me magnified and echoed my inner torment. I didn't feel like a girl, nor a woman, but my sexual anatomy was decidedly female. The fact that I was most often regarded as a boy was of little comfort; there were obvious limits in my ability to defend the designation. There was no escape, reprieve, or privacy—the enigma was modeled in my flesh.

I felt safest in the dark, when my fears of people recognizing and fixating on my female body were unsubstantiated. In the dark I was formless, elusive. The light from the street lamps created shadows that would stretch my body across the sidewalk and along the trees into shapes that went from short and squat to tall and menacing, just as in a fun-house mirror. With my body transformed, so were the feelings about myself. My thoughts were no longer about hating my body but about protecting it from potential assailants. I could accept the fear that arose from actual danger—that was natural; everyone had some fear of the dark. But girls and women seldom ventured alone in the dark, and this gave me all the more assurance that I would be assumed to be a male, and my sense of freedom outweighed any fear.

In the night, when I encountered another person, I would simply judge them friend or foe; they were *what,* not *who;* not an individual but a threat or non-threat. The rustling in the bushes was animal or human; connections were instinctual rather than baited with thought. In the blackness my senses were pure, unfiltered, not quelled by the barrage of random stimulation encountered in the daylight—when my eyes filled with a world doubled by harsh reflections and my ears would ring, overwrought by the piercing sounds of machinery, or my flesh would shrink from crowds to avoid touch—the stray hand that would inevitably sweep a feel of breast. I trusted my experience to be common—believed that in the night I would cease being seen in the usual way.

On these late-night excursions I became fascinated with moths, admiring the way they braved the light. I would watch them reel around the street lamps, then I'd catch one between my palms, and just when I'd go to take a peek the moth would fly off on a zigzag course. I'd rub my hands together to feel the traces of satiny powder left behind. I went on to collect insects memorialized in the fins of the bestial 1966 Buick my mother owned. That car had a radiator similar to a cow catcher on a train and was just as proficient at catching moths and butterflies. I would cull the finest specimens, including an encrusted assortment of dragonflies and beetles, to create little still lifes with their mangled remnants.

In 1968, when I was 12 years old, I was living with my family in Thailand. Living in Bangkok, the various oddities could incite me to think about things beyond myself. Aside from being introverted, I was in the throes of puberty, and it took a lot to distract me from thinking of myself as an oddity. I'd think about the dead white horse I saw lying on its back in a ditch like an upended table, with its stiff, swollen legs turned to the sky; the water buffalo whose horn grazed the upper portion of my arm as it stomped past me on my way to school; or the brown, shriveled bodies of men with rags wrapped about their groins, squatting on the sidewalks like ducks with their flat, outstretched, weblike feet spilling forth from worn sandals as their eyes stared out from another world, a world beyond their toothless grimaces, their lips swollen and stained red from betel nut.

Thailand was a welcome refuge—there was far too much stimuli for anyone to pay me much mind. The attention I did get was focused on my blond hair and not the ambiguity of my sex.

Because my physical presentation always carried elements of both masculine and feminine characteristics, I had to ask myself prior to transitioning how much societal response had influenced my sexual identity. While the instances I've related had a debilitating effect, I could have, with some effort, thwarted what was confusing to others by attempting to appear more feminine. But I could not. What had undoubtedly contributed to the confusion was my manner of dress, the activities I engaged in, and my attraction to girls and women. Clearly I made no attempt to enhance a feminine appearance, nor did I find comfort masquerading myself as a lesbian. I have seen myself as male as far back as my memory goes, so I loathed the feminizing effects puberty had on my body.

Assuming the life of a woman impressed me as a complete and utter deception—a lie. Having been subjected to and inured with certain aspects of female socialization, I had greater insight then most men into the many aspects of a woman's character, and from a distance I witnessed certain "tricks of the trade," borrowing traits that were in line with my nature and those that were the least offending in betraying my own inclinations. This socialization allowed me a measure of inconspicuousness and enabled me to survive and conspire to enjoy relative success in the role of a woman. Fortunately, during the height of feminism, I had little difficulty engaging in professions and exhibiting competencies previously assigned most often to men.

Inwardly, I felt a fraud, and I believed it was only a matter of time before everyone recognized what was behind my awkwardness and futile attempts at womanhood. Finally, in my mid 30s, I had established the necessary connections and had the financial means to put an end to my misery and begin to live my life as a man. By the time I jabbed that first needle beneath the surface of my skin and released testosterone into my bloodstream, I had exhausted all other alternatives. I knew with an unwavering certainty that it had to be done. Through trial and error I learned that there wasn't enough alcohol, prayer, drugs, or love to change the self-loathing I felt. I looked upon myself as a freak, and the tormenting self-awareness was all-pervasive. There was nowhere to hide; alone, locked inside my room, I looked upon myself with scorn.

The night before my doctor's appointment, I imagined my rocketing emotions being charted out on a seismograph as I thrashed fitfully in my bed until my body finally succumbed to fatigue in the predawn hours of the morning. My mind was centered on what would occur the following afternoon—I would be injecting a substance that would literally transform my body and, assuredly, my mind as well. The physical changes would come gradually, in intervals, giving my mind time to adjust. Or would they? Just how radical or subtle the transformation would be or at what rate I could expect changes to occur could only be guessed at; some would come slowly, while others would come in a rush, leaving me ill-prepared. My fear was that there would be an onslaught of changes, that overnight my body would be teeming with clumps of coarse black hair and I'd be discovered in the throes of madness howling at the moon!

In those fearful hours I was utterly alone—there was no advice to be sought. The words of those attempting to dissuade me battered my ears, but I was determined—no one could deflect my inner voice. I could no longer be content with the enticement of friends, family, or lovers so long as their support was contingent upon my ability to fulfill a given role. I had allowed external factors a prominence that assailed my self-esteem and interrupted my most productive years, and now I was prepared to make amends to a self I had utterly ignored. I was ready to unleash the ungarbled and immutable truth.

I removed the plastic sleeve surrounding the needle, penetrated the contents of the vial,

and drew the plunger until 1cc of the thick, oily substance collected and bubbled in the syringe, then pushed the plunger to release the pocket of air. With over 20 years of wanting, I was no less eager than a junkie. I held the syringe stiffly in my hand as I acknowledged what I was about to do. I savored the moment by re-creating my life: This was my christening, induction into the Boy Scouts, Little League, Indian Guides, the prom, frat parties, the draft, my bachelor party…all rolled into one. I staked a claim to all the rites of passage and privilege bestowed upon boys and men; all that I was entitled to and never enjoyed. Then, I relaxed my leg muscles, and with a single plunge I forced the full length of the needle into my thigh and released the hormone.

As successive doses of testosterone dispensed magic throughout my body, I became transfixed with each and every nuance of change; I watched the hair slowly recede from my forehead, examined my toes and chest as newly sprouted hairs situated and arranged themselves into precisely ordered compositions. My libido shot into orbit, and the universe became illuminated with neon breasts and buttocks. My body regularly demanded sexual stimulation and wouldn't be ignored. Emotionally, I felt calmer and had better control—during my first years on testosterone, I learned that tears are linked to biology far more than to socialization; while I had reason to cry, I couldn't access a single tear if my life depended on it.

Life isn't perfect now, but it is a whole lot better. I accept what I see in the mirror for the first time. All my life, I envisioned resembling my male peers: My childhood face, framed behind the slingshot, was to look something like one of the Little Rascals; in my teen years I was to be endowed with the physique and demeanor of James Dean. I never saw myself as a middle-aged man replete with frown lines and less-than-taut skin. So while I am terribly pleased to see a male figure peering back from the mirror, it still doesn't feel quite right. I wasn't able to see my age progression as a male, the embodiment of Dean as a boy and young man. The essence of Dean always existed, but he didn't make a physical appearance until he was 38. I can't help but be shocked by this from time to time.

The world now sees me as I see myself: as male. Yet under close scrutiny I am revealed to possess certain physical aspects attributable to my biological origins. Even the most skilled of surgeons cannot compete with the Almighty Creator, so oftentimes I feel like a decoy, nestled in the bulrush, positioned to lure some unsuspecting hen. Exhibited in the likeness of a man, there remains the damnable fact of this trace evidence—evidence one might call upon to question the veracity of my sex, negating all other signs of maleness manifest in my being. And there will always be other men, hunters in the blind, prepared to seize the hen who falls for the ruse. Unlike the decoy, invulnerable and inert, I am flesh and blood—prey to fear, desire, shame, and anger, staving off dangers lurking and present, real and imagined.

CLOCKWISE FROM LOWER RIGHT Author at age 12 with pet monkey Jo-Jo (photo by John D. Kotula); Dean (right) at age 21, preparing to leave Minneapolis with a friend for the Michigan Womyn's Music Festival; graduating from taxidermy school at age 20

Chimney Repair

There was scaffolding sprawling one length of the house—ladders to the roof line on another. Ladders of varying sizes and types were tied together on the roof, straddling the hip, and yet another ladder, supported on rubber cups, led to the chimney top. We gained access to all perimeters of the house, infiltrating like a network of ants on a sugar pile, crawling up and down and along the roof, hauling tarpaulins, cement, and tools—systematically filling chinks between the chimney bricks.

A brigade of workmen scaling ladders with such precision and ease was like watching a performance played out on an Escher motif, where ascending or descending stairways are nebulous and only lead to one level. There was little regard to heights; the focus was the work at hand, and it was carried out with an economy of synchronous motion.

Goggles, face shields, and hoods shrouding us, we worked our grinders in a torrent of dust. In a concentrated effort, grasping tools in cramped, blistered hands while attempting to maintain a stance on the roof, I hardly recognized that it was raining. Rivulets of mud flowed across my face shield in the wind, down my slicker, and into the valleys to collect in the gutter. Steam spiraled off the roof with occasional sunbursts parting the clouds, while marked shadows mimicked our actions.

I worked my way off the roof and went to the truck to replenish the pail with cement. Alternately scooping sand and cement, I forced the mixture through a sieve, and as I rounded the truck in search of a hose, I noticed the woman of the house exiting the garage door. She appeared a bit harried, having suffered the intrusion of whirring grinders, thumping feet, and voices overhead—as though the house was her property but no longer her domain.

She was slight, short in stature, around 5 foot 1, and appeared intelligent and alert in her casual attire and buoyant, short red hair. She peered about reluctantly; it was obvious that she needed to relay some information and was working up the nerve for an approach.

As I shifted my weight from one leg to another, she was startled into noticing me and caught me looking at her. In the split second our eyes held to one another, I read in her expression all that she had determined about men—particularly working-class, blue-collar men.

She was unnerved. I stood innocently before her, caked with mud, beaded sweat on my brow and forearms, with a pail in one hand and a trowel in the other. I could just as easily have held a pail in one hand and hard cock in the other—the reaction would have been the same. She was afraid, and in that fear I saw disdain, confusion, anger, and excitement.

I was a man to be shunned and admired simultaneously. In her estimation, I was uncouth, unkempt, uneducated, aggressive...yet hard-working, strong, and attractive. She was perplexed; her reaction wasn't what she had prescribed for herself. She would have preferred to not have reacted at all, to remain aloof and uninterested. But here she was, naked and frozen in a spotlight, seduced by the heat. Raw sexuality had permeated thought.

I too was nearly senseless from arousal. I yearned for her and her mind's version of my naked male torso, complete and bursting for relief, yet nothing could pervade the interminable awareness of being transsexual. Foremost in my mind was the question: *Would she be shaken to this same stupefied state if she knew?*

THE ORGAN GRINDER: JOURNAL ENTRY, NOV. 21, 1986

Thrown like a star in my vast sleep
I opened my eyes to take a peep
To find that I was by the sea
Gazing with tranquility;
'Twas then when the hurdy gurdy man
Came singing songs of love.
—Donovan

The song came as a resounding revelation. I had heard it numerous times before. In fact, it was among my repertoire of favorite songs, for no reason other than the melody. I had never recognized its full import until today, when the meandering intonations of the sitar led me to the lyrics, and I found myself swept back to the shores of Bombay, India.

In 1970, I too was by the sea, gazing with tranquility, when I was startled by a strange melodic sound coming from behind me. I peered over my shoulder to discover an organ grinder, a hurdy-gurdy man, with a windup wooden music box perched on a wooden peg and supported by thick leather straps that hung around his neck. His sidekick, a small capuchin monkey wearing a porter's cap and woolen topcoat, bobbed up and down in the fashion of a jig, keeping rhythm to the music while darting his eyes, prepared to catch the glimmer of coins being offered for the spectacle. When these would appear, the agile monkey would dash over, extend his paw to receive the coins (which he gave to the organ grinder), and then leap back into position to continue dancing.

I was thoroughly charmed by the performance, particularly since I was already longing for the pet monkey I had to leave behind when leaving Thailand just the week before.

I was a child, only 13 years old at the time, but I remember thinking of India as a place that had all the magic and intrigue I would ever need. It was a place that had organ grinders with monkeys, snake charmers, wild peacocks in golden fields, snowcapped mountains, sandy beaches, elephants, tigers, fortune-tellers, women with lustrous black hair bedecked with jewels, ancient palaces, and holy men. It was a place with every imaginable oddity—the perfect place for me. I already knew I was different.

The years ahead were filled with more misery than magic. My need to live and be rec-

ognized as a man became an all-consuming passion. Every obstacle toward transition seemed to be standing in my way, and I lived moment to moment for the next 23 years with the need and hope of having the body of a man. Finally, at age 36, I began to realize my dream.

My life is better now. The most notable difference is that I don't wake up hating myself upon looking in the mirror. Yet an unusual amount of self-consciousness still exists. Having gender identity disorder is traumatic, and the brain records trauma; it doesn't change overnight. I've yet to have a dream where I am simply a man. I am always aware of being transsexual in my dreams, and am wary of being detected, just as in my waking hours.

Gender is the core of who we are—a starting place—and the process of recognizing our gender is something that occurs as naturally as the recognition of ourselves as human. Most people have the luxury of never having to think about it. But when you have gender identity disorder it is difficult to proceed with life: You feel like a lost soul looking for a place to reside. Many transsexuals talk about "lost time," about how they felt their lives were on hold until they were finally able to transition.

Transsexuals generally don't credit themselves for having had the courage to transition; rather, most will say, "I had no choice; it was either transition or die." I think it is important to recognize that we did it with inherent risks; we did it without knowing, with absolute certainty, that it would be the solution. We couldn't know what we would wind up looking like, whether or not we would be accepted as men (or women, in the case of male-to-female transsexuals), or what the medical risks might be, but we did it anyway. We cared enough about ourselves to give it a chance.

I was prepared to transition 25 years ago but couldn't find anyone to help me. Once I found help, the financial costs were more than I could afford. Eventually I found a psychiatrist who wrote me a prescription, and I started taking male hormones four months after beginning work as a shipyard machinist. Within weeks, the physical changes were evident and my transsexualism became known. Shipyards tend to be microcosms of the worst perpetrators of bigotry, and this one was no exception. The harassment that ensued came from not only the workers but management. I suffered the agony of working there for four years under conditions that were both physically and emotionally brutal. I tolerated it as best I could, knowing it was my only chance to raise money for surgery. And it finally paid off.

I look at my life and I am enormously proud. However faint at times, I never lost sight of my own voice. I challenged and fought every fear that presented itself. On days when I begin to doubt myself, I have countless experiences to draw from, any of which will tell me that I can succeed.

Transition doesn't end with living in a new body. This is where it begins. This is when we can finally focus on the common concerns of humanity…on living! We can't get complacent and say we've done enough; we must continue taking risks. I have come to believe that the

same passions and convictions that were inherent in my ability to transition to living as a man can be used to help me achieve most anything, and I am now living full speed ahead, making up for my own "lost time."

Apart from feeling I was born into the body of the opposite sex, I have often felt I was born into the wrong century! I have always been comforted by objects from the past, and I am currently involved in a partnership, dealing in antiques. As part of the business I am in constant pursuit of merchandise to buy. Some months ago I was perusing an online auction site and was thrilled to discover a roller organ, a hurdy-gurdy, patented in 1897, for sale. Instantly I knew I had to have it! There were two days remaining in the auction, so I put in a high bid and waited. The day the auction was to end, I had gotten so anxious that I left work early. I sat in front of the computer screen and watched as the clock ticked off the remaining minutes. I was still the high bidder. Ten minutes before closing, bids starting rolling in! The price kept soaring, but my maximum bid still put me on top. The numbers continued to move. It was obvious by now that someone was trying to learn what my blind bid was in order to surpass it. My heart was now exploding in my chest! My hands were sweaty and awkward as though they were carved out of wood. As the bids came in just under mine, I realized I had better put in another one or I was bound to lose the hurdy-gurdy to another buyer. I just had to have it! To me, it was priceless…I'd worry about paying for it later! My hands froze up and my mind went numb. Frantically I attempted to put in another bid. The keys on the keyboard melded together into one big blur. My mind raced as my hands moved in slow motion. Finally! I had placed my bid—only to learn it arrived too late! I was exhausted! Perspiration spilled from every pore. I knew I had to scroll up to the top of the page to verify the results, but I knew I had lost. It felt like I was about to crawl on hands and knees over broken glass to get to the top of Mount Everest! I agonized as I watched the screen, and once it hit the top, I was jolted by learning that I had won by a $10 margin! It was meant to be mine!

My partner and I had been racking our brains trying to develop a name and theme for our antique business. Now there was no question. I would live out my childhood dream of becoming an organ grinder and use this as our theme.

The art of entertaining with a roller organ and monkey originated in Egypt over 500 years ago, then spread through Europe and finally America. The practice basically died out in the 1940s and is now being revived somewhat. There are currently six organ grinders living in the United States who perform with their monkeys. I will be the seventh just as soon as I find a suitable monkey to train.

This is part of the enormous pleasure I am experiencing in making myself into the childhood image I had of myself as a man, and I look forward to the opportunity of bringing a little magic to another child's life just as the organ grinder in India did for me.

Sharon (3rd from top) and "Debbie" (3rd from bottom)—the middle kids—and four other siblings

Metamorphosis of a Sibling:
When History Changes

By Sharon E. Kotula

Change is often a good thing—a time of growth and new awareness. But what is it about change that sometimes terrifies or even cripples people? Most people thrive on routine and an existence of status quo. There is a certain sense of comfort and security derived from predictability. When events beyond our control force us to accept change and eventually embrace that change, we go through a form of metamorphosis of our own.

Our family consisted of Mom and Dad, six girls, and one boy. I was my parents third daughter. My sibling Dean back then was known as "Deborah" or "Debbie" (this name is fictitious, to honor Dean's privacy). Debbie was just one year younger than me. Two years later followed our one and only brother, or so we thought at the time. He was succeeded by two more sisters, each a year apart. Sadly, one baby sister died unexpectedly of a sudden illness at only 6 months of age. Even though I was very young, I remember this as an extremely difficult, grief-stricken time, especially for my parents.

We were the typical middle-class Midwestern Catholic family. Both parents were schoolteachers. Our mother took time off from teaching to raise us children until the youngest was in high school. Both parents were also very active in the community. Our father was the town mayor for several years. We went to church every Sunday, followed by Sunday dinner, a family outing, and the Walt Disney TV show. We enthusiastically celebrated all the major holidays together. Summers were spent traveling, camping, or up at our lake cabin. When our older sisters were in their teens, our father trained for a new job in Hawaii. This enabled the whole family to live for six glorious months on prime, breathtaking, oceanfront property, followed by two incredible years living overseas in Bangkok, Thailand.

Debbie and I were the "middle kids" and therefore frequently paired together. We always shared bedrooms, went to the same schools, and played endless hours together. We drove our parents crazy with our unending nighttime giggling or tumultuous sibling arguments. At times we treated each other mercilessly, taking out our growing pains on one another; but beneath that competitive boisterous facade, we had a very strong, unwavering sibling bond and genuine love for one another. This bond grows stronger every day.

This is where most of our similarities ended. I delighted in the matching, frilly, fanciful dresses our mother would adorn us in, whereas Debbie, although enjoying the attention lavished on us, inwardly abhorred them. She was too polite a child to blatantly express her disgust, especially if our mother had painstakingly sewn them. As soon as possible, though, the dresses would be discarded, along with the intense loathing she felt.

Debbie was often teased about being a "tomboy." I, on the other hand, was Miss "femme fatale" herself. Our father, though well-meaning, often rejected Debbie's heartfelt pleas to accompany him and our brother on hunting trips, Canadian fishing excursions, and other "manly" activities. Although Dad had always hoped for more than one son, he felt he should encourage Debbie to act like a girl. This was the beginning of a very jealous, envious relationship toward her brother.

I vividly remember playing house together. We rarely argued about our assigned roles since Debbie always wanted to be the "Dad." She received plenty of baby dolls like myself but never really became attached to them. I remember many a time tearfully reprimanding her for blatantly dropping the "baby" on its head.

I also learned at a very young age to avoid a physical fight with my younger sibling. Debbie fought like a boy, punching with closed fists, and even though I was a year older, Debbie grew taller and much more muscular, well before we reached adolescence. I would defend myself just long enough to turn around and run like hell!

The adolescent years yielded incredible signs of inner turmoil in my younger sister. The sibling I once felt so connected and close to became a virtual stranger. I felt an intense uneasiness disrobing in front of her. My girlfriends felt this same uneasiness. These unnerving sensations didn't exist with my other sisters. Debbie seemed to be looking at us through the eyes of a male, not that of another young woman. Her affection for one of our female friends seemed almost obsessive, more like a crush than mere admiration.

The growing repulsion for her own developing body was also apparent. She wore loose, masculine styled clothes, adamantly refusing to ever be caught dead in a dress again! And I think now, as I reflect back, that even though she expressed verbal scorn for frequently being mistaken for male, inwardly she found this somewhat pleasing. (Since writing this, Dean has told me his anger was always directed toward those who "corrected" the "mistake" by saying he was a she and about the fact that he didn't have a male body.)

There was a time, while shopping together at a local mall, when "he" was given a sam-

ple of cologne while I was given a sample of perfume. This upset me but didn't cause Debbie to skip a beat. Another time a saleswoman forbade "him" to enter the women's dressing room until I defensively stood up for my sister (thinking it was the right thing to do).

During this period of time, Debbie did not go out of her way to look masculine but simply wore jeans and went without makeup. She possessed very angular features, a deep voice, and her figure, although developing, always had a masculine quality about it. "Curvaceous" and "feminine" were not words used to describe her.

Her high school years were a *living hell*. Debbie attempted to anesthetize her confusing, conflicting emotions in a swirling sea of drugs, alcohol, and eventually, suicide attempts. Our parents were beside themselves with worry and concern. I felt helpless and fearful, not ever knowing what I could do to help my sister deal with the demons inside her. At times I felt an actual animal-like fear toward this person. I had no idea who this drug-riddled, crazed stranger was.

Following a succession of drug treatment programs, hours of therapy, and a constant personal search for who she was, Debbie adopted the belief that she must be homosexual. She knew she was sexually attracted to women and therefore felt this must be what was "wrong" with her.

The family, although with some difficulty and wishful thinking that this "phase" would pass, finally came to accept Debbie's revelation. The family's concern for her was always centered more around her well-being and happiness than her sexual orientation. I think their concern was not one of embarrassment, or thoughts that Debbie would never marry, but, rather, that society would be very cruel to her.

Debbie became involved in a long-term loving relationship with a woman, and I noticed a sense of calm and well-being had developed within her that hadn't existed for many years.

The quest, however, for her identity did not end there. Debbie embarked on numerous fascinating career endeavors, ranging from taxidermy to chimney sweeping to renovating several homes to commercial fishing to policing large crews of foreign fisherman fishing off our coasts to pursuing her love for black-and-white photography.

Her travels took her all over the United States, to India, South America, and finally to a new awareness of who she in fact was. *Homosexual* no longer fit the image of who Debbie felt she was. She saw this as a temporary, partial solution to the problems she faced. This was the simplest and most obvious way of dealing with her attraction to women, but it didn't address the fact that she didn't identify with being a woman herself. My sibling came to realize "he" was in fact *transsexual*. Simply put, a man trapped in a woman's body.

He dressed and adopted the role of a man, going so far as to change his name to Beryl. This asexual name, he felt, would help put an end to the embarrassing questions and bewildered looks he received, since his name didn't fit his outward appearance. Later he would go on to call himself by his new middle name, Dean.

Taking care of his physical needs in public rest rooms, however, was a constant source of anxiety and trepidation. He developed the most advanced case of bladder control I've ever seen. Swimming, a much loved sport as a child, was also avoided like the plague. Through surgical intervention he is now able to enjoy a fuller life and has resumed his passion for scuba diving.

Today, Dean is a very accomplished, talented photographer and writer. His remarkable ability to capture poignant details and paint intricate pictures through his mastery of the human language is truly awe-inspiring.

I feel blessed and honored to claim this person as my *brother*. It brings tears to my eyes to think that this beloved sibling of mine would not even exist today if his attempts at suicide had been successful—what an incredible loss, not only to me but to society.

I have accompanied my sister/brother on this incredible, often heart-wrenching journey. We have shared tears, frustrations, and "sick humor," enabling each other to accept and embrace this new awareness. I have mourned the loss of my "tomboy" sister, not unlike dealing with another death in the family, and have transcended to a place where I can celebrate the birth of my new brother.

I wish I could say the rest of our family, especially our parents, accepted and celebrated this metamorphosis as readily as myself, but I can't. I have spent a great deal of time with my sibling, in person, surrounded by his community of friends, and talking long-distance on the phone. I have experienced firsthand how others, unrelated by blood, only see his maleness and humanness. This has helped me tremendously to move beyond the history we shared and accept Dean as he is today. I know and understand, only too well, the painful journey my parents and other siblings must travel in order to get beyond their denial, put history as we once knew it aside, and embrace the birth of our new son/brother. This is a process that doesn't happen overnight.

I am also painfully aware of the prejudice and hateful feelings that so many people harbor toward transsexuals due to ignorance. Humans have a cruel propensity to judge and condemn that which they do not understand. Because I have a loved one who has been afflicted by this cruel "birth defect," I have been motivated to educate myself and others. No one *chooses* to be transsexual—a life filled with anguish, prejudice, fear, and self-loathing.

It has been difficult for me to write this, fluctuating from female to male pronouns. I felt a certain betrayal toward my brother, with whom I have traveled on this transitional journey. I have come to fully accept my brother as male, in every sense of the word. His new awareness has answered many of my own perplexing questions throughout our years of growing up together. To refer to him in the female context, now, seems a mockery. It would not paint a clear picture, however, to write this in any other way. I think it emphasizes just how difficult this journey has been.

Unlike a "normal" death in the family, history is changed forever.

Part Six
Perspectives and Viewpoints III

The Female-to-Male Transsexual Transition as a Creative Act

By Jeff Brody, MPS, ATR

"If" acts as a lever to lift us out of the world of actuality into the realm of imagination.
—Stanislavsky

Transition has been likened to a "vacuum" (Ebaugh, cited in Devor 1997, p. 50), a limbo where nothing is certain. Limbo can also give rise to great creativity and growth. My intention is to look at the life-affirming, self-determining aspects of the female-to-male transition. I will offer a model for envisioning transition as a dynamic growth process, a model that derives from the subjective FTM experience of self-actualization. I will provide a theoretical framework for seeing transition as a creative act and will describe the relevance of the arts in general, and of creative arts therapies in particular, to support the process. I will also propose that transition is a synergistic, holistic transformation of the mind, body, and spirit that can be optimized through visualization and other imaginative, integrative techniques.

Transition is a generative act, like growing a garden, training for the Olympics, or shaping a sculpture. It is the literal embodiment of an idea and the enactment of an imaginative vision. While there is ample pain that accompanies the process, I will look at transition in a purposefully positive light to urge conscious and conscientious attention to maximizing the experience with every cell in one's body. If transition is thought of as a creative project, like redesigning a landscape, one can work with nature to optimize the effects of hormones and surgeries. Regardless of how much transsexuals may dissociate from or hate their original

bodies, my hope is to encourage respect for the vessel one is born into and to nurture it lovingly through change.

In this essay, "transition" will mean medically assisted FTM transsexual transition. Although my emphasis on creativity as a way of life can be generalized to all people, gender-variant or not, I will focus on the medically assisted route to manhood as a dramatic and relatively discrete biological metamorphosis. Thus, my comments will be in keeping with the scope of this book and with the current immersion in my own transition process.

While the essay is informed by my experience as an FTM, I am writing as an artist and art therapist as well. Art therapy is a discipline well-suited to complexity, paradox, and to integrating suppressed aspects of the self (Dalley et al. 1987; Robbins 1989; Rubin 1987; Virshup 1993; Wadeson 1980). Its creativity-based perspective can shed new light on the creative potential of the FTM experience. Art therapy also provides tools for self-expression and coping with change, in the form of metaphor and imagery, to interpret and shape experience. This process is exemplified by Milligan (1996), an art therapist who used art to come to terms with feelings about her FTM son.

As an art therapist, my intention is to offer a theoretical framework and clinical tools to support the idea of a mind-body-spirit metamorphosis. The creative arts therapies—dance, drama, poetry, music, and art—provide a structure within which to modify one's defenses and foster the integration of mind and body through the simultaneous engagement of logic, intuition, emotion, spirit, and libido. Creative expression promotes healing in itself, like fertilizer on the self-as-garden, and offers an immediate, concrete form of self-reflection, which sharpens self-awareness.

Many people have an intuitive understanding of the term *art therapy*. It seems somehow to make sense that the creative and therapeutic processes should be natural allies. We think of creative activity as enlivening: It releases pent-up energy and generates new energy. Art making engages all of our senses—brings out our playfulness, spontaneity, and feelings of self-esteem and mastery. In art, unlike in speech, harmonious and clashing elements are experienced simultaneously as part of a nonlinear whole.

The arts can help us circumvent the cognitively proscriptive gender concepts by facilitating the intuitive expression of thoughts and feelings about gender, desire, and the body (Brody and Redfield 1997), and the coalescing of disparate parts of the self during transition (Thomas and Cardona 1997). Art therapy uses the arts to envision, advance, and document change intrapsychically and interpersonally. In concert with the introspective uses of art for internal integration, the use of symbolic ritual to mark a transformation in one's social gender role is a powerful tool as well (Dennison 1997).

FTM is a category that most people do not even know exists. It needs to be understood on its own terms, as a new paradigm. How many people can conjure up a mental FTM image? Not one 10th the number that can call up a mass media image of an MTF. There

has not even been enough FTM imagery to create a cultural stereotype. The photographs by Dean Kotula and in *Body Alchemy* by Loren Cameron are original enough to be considered archetypes. These important documents are a powerful form of communication: FTMs exist, thrive, and demonstrate the reach of self-invention.

All forms of gender expression can be observed through imagery, as aesthetic statements. People exhibit varieties and combinations of manliness or womanliness through aesthetic choices in clothing, body language, and speech patterns. Fashion magazines endlessly promote ways to enhance and dramatize gender presentation. But gender goes much deeper than fashion: There is a "psychoaesthetic" stratum to our beings: "Therapy can be viewed as an art form that embodies the principles of aesthetics" (Robbins 1989, p. 8). Robbins uses the term *psychoaesthetic* to describe the metaphoric interpersonal place where the internal energy of individual personalities turns to form the shape, texture, and rhythm of the depth-oriented therapeutic relationship. The same concept can be generalized beyond the clinical setting. When a 3-year-old craves sturdy gray corduroy or lacy pink frills, s/he is responding to an aesthetic yearning that is an expression of personality. Regardless of the roots of our predispositions and longings, there is something deep, internal, and inchoate that says, "This is me. This is me."

Transsexualism "is about the private experience of profoundly important and complex subjective states" (Wilchins 1997, p. 142), especially the awareness of dissonance between mind and body and between self and society. "One can recognize society's gender attribution and not see it apply personally; individuals seem to come to 'know' if they are male or female by a different process" (Diamond 1997, p. 103). Consciousness is at the heart of transsexual experience, demonstrating that *how we think about something* informs our responses to it. Often what we think about something is seemingly intrinsic to the object of our thoughts. When we find out, for example, that "Melissa" is really "Mel," we have to change our mental picture of that person. One might say, "I have to think of 'her' as a man now." This is common sense but implies the creative power of thought and mental imagery.

We can seek out and adopt images that serve as goals through visualization, "the conscious, volitional creation of mental sense impressions for the purpose of changing [ourselves]" (Fanning 1988, p. 2). The stereotypical image of the lonely, freakish, tortured transsexual was not useful in envisioning my transition. Instead, I have used poetic concepts of active reconfiguration to shape how I think and talk about my masculinizing process: I am building, sculpting, growing, collaging, alchemizing, cultivating, germinating, sprouting. Like a caterpillar wintering in its shelter, I am composting and metabolizing elements of my former self to emerge from the cocoon transformed. In this vein, Cameron wants to convey "the joy of the experience. That's the bottom line. It's not about failing. I didn't fail to be a woman" (Stryker 1996, p. 78). He also decided to document that experience with words and photographs, making it more real by giving it artistic form (Cameron 1996).

Transition is an act of profound imagination that begins with opening the Pandora's box of "if," which "arouses an inner and real activity" (Stanislavsky 1936, p. 44). It is a volitional act of wishing something into being and then concretizing it through a series of decisions by taking on the burden and freedom of self-invention. "The subjective experience of gender, as well as being read or experienced by another as gendered, is not a *being,* but a *doing*" (Wilchins 1997, p. 154). "Being oneself" is a kind of performance art, a "performance of internal visualization" (p. 155) into which one can put intentional, joyful, creative energy, envisioning oneself as a work in progress and performing one's gender with grace, imagination, and presence, from the core of one's being.

Transsexual decisions are not ordinary decisions. They lead to a gray area, a liminal, transitional space (Winnicott) where the internal, subjective experience of "feeling like a man" translates into observable phenomena, where energy transmutes into matter, spirit becomes flesh, and fantasy becomes reality. The metaphysical implications of body alteration (Vale and Juno 1989) suggest the need for faith in order to stay grounded while transitioning. Transition requires faith that *reality* is malleable and that one has the *power to manifest a vision.* It requires faith in the unknown as well, the belief that an order will emerge and that a visible aesthetic pattern will take hold with an internal kinesthetic pattern of sensations that the brain has craved forever. Transition requires faith in nature and in other human beings. Ultimately, it is faith in *one's own nature* and in one's choice to live and be seen in a way that is consonant with it.

Ettner (1998) describes these internal, intangible realms as essential to the transsexual or transgender quest. "Soul retrieval, a shamanic voyage," she states, "is the task of therapy. Transgendered people need to reclaim their imaginations, to reclaim the lost 'soul part,' the frightened child, the part that gets sent away between ages three and six. We need to create a community in alignment with our souls." Imagination is not a luxury or a God-given talent but a critical resource when one is reengineering the body and reclaiming one's dormant inner self. To turn oneself inside out and show others how one should be seen takes an exquisite vulnerability that is both terrifying and rejuvenating. Because of the increased number of options inherent in a state of flux, many transsexuals make changes in work, living situations, and relationships. This raises questions that merit further study: Does transition open the mind to greater risk taking and self-actualization? How is the FTM "shaman" transformed by the awareness of his power to conjure up a reality so strong that others are convinced by it?

While I am emphasizing the life-affirming aspects of transition, I want to give some attention to the healing necessary to get to this point. The reclaiming of self for transsexuals shares a common ground with the process of recovery from trauma. I am not equating transsexualism with trauma or saying that transsexuals are necessarily victims of abuse. However, when the authentic self is banished and replaced by a falsely gendered, socially coerced persona, a kind of spiritual violence is committed, however unwittingly, resulting in

dissociation (Seil 1997). To regain possession of the self, according to Herman (1992), one must pass through three phases: safety, remembrance and mourning, and reconnection. Transsexuals may need to work through the first two stages, but it is the third, especially "reconciling with oneself" (p. 202), that links trauma recovery to transsexual transition.

" 'I know I have myself' could stand as the emblem of the third and final stage of recovery," writes Herman, specifying that "the creation of an ideal self involves the active exercise of imagination and fantasy" (p. 202). Aesthetic, metaphysical, and clinical approaches overlap in healing the wounds inflicted in the name of gender conformity. The powers of dissociation acquired to cope with an unbearable situation, whether trauma or sex dysphoria, are defensive adaptations that can be turned to the goal of positive imagination. While creativity demands introspection, it needs to be balanced by a commitment to mind/body health care, the support of other FTMs, professional and personal allies, and a sense of humor.

For this essay I was asked to discuss my impetus to transition medically, a transition that follows 40 years of enduring the "fundamental plight of transsexuals, that the world relates and responds to them as though they are a shell," living in a "continuous ecology of forever feeling misunderstood and having to act uncharacteristically to meet society's expectations" (Ettner 1996, p. 89). My transition also comes in the context of a holistic approach to health care, nutrition, and my body. Until recently, I dismissed the medical path out of hand as foreign to my way of living. I can recall a pivotal moment when I told my holistic chiropractor that I was afraid of the long-term effects of synthetic testosterone, and he said in an almost offhand way, "It depends on how you direct it." This was the action metaphor I needed to make it imaginable that I could *grow* my manhood. It lifted my self-imposed obligation to tolerate the body dissonance, which I had heretofore managed through imagination and dissociation. I could now visualize my FTM process as akin to organic farming or molding clay. I could optimize the effects of the medical tools, *actively facilitate the integration of masculinity,* and direct the energy flow through breathing, bodywork, exercise, nutrition, and relaxation, bringing every cell and pathway of my body into the metabolic confluence of hormones, lymph, nerves, blood, and muscles.

I also decided to transition because I needed a *comprehensible* persona. It is exhausting not to have a readily readable social presentation. I was a straight man trapped in a lesbian's life and I wanted out. I could no longer pay the psychic price of keeping up even a nominally female shell. I needed to be seen simply and unequivocally as the man I've always felt myself to be. This is an *organizing* act that clears away the psychic clutter and allows me to be socially authentic. Being perceived as female means that I was called upon, however obliquely, to perform femaleness. I can see now the extent to which I was always in character and didn't even know it. My former female identity was, of necessity, an approximation or facsimile that kept me from fully knowing myself and showing my real self to others.

The most significant fact about transition, however, is not the route but the *decision to*

live as a man, whether full-time or part-time. No matter what one's morphology before or after, the decision marks the pivotal psychological step of taking control of one's life and declaring the intention to live in one's chosen social role. Even I, visibly gender-transgressive and acutely conscious of gender since early childhood, didn't know how deeply gender roles reach into our psyches until I decided to change from being "seen as female" to being "seen as male"—or more accurately, like many FTMs, change from being seen as ambiguously masculine to unambiguously masculine. I didn't know how small a closet I was in until I got out and felt the deep physical and emotional relaxation resulting from the awareness that I don't have to hold myself in or pretend I'm someone else. Whatever medical interventions an FTM decides to use, each FTM is his own artist, alchemist, and farmer. Remaking oneself is not a mechanical process of "treating" a "gender condition." It is fundamentally a growth process, a melding of science, poetry, and nature.

When the early growth process is thwarted, an individual goes through the stages of "normal" human development with a fundamental dissociation. The FTM child does not see the self he knows being subjectively reflected in the mirror or in the eyes of others. The true self goes into suspended animation and remains developmentally frozen. For some, transition can be seen as a step toward maturation, a psychic and social shift from boy to man, in concert with the more visible physical shift from female to male. One FTM stated that he had to transition in order to grow up (Schermerhorn and Cram 1997). He could not envision adopting an adult female social persona but had to be seen as a man to live as an adult. For FTMs and their therapists, transition presents the challenge of addressing the developmental tasks of all the life stages of masculinity simultaneously: to resume psychic repair of the preschool child while growing a teenage boy's body and negotiating a male adult social role.

Transition has traditionally been defined as a physical, medical process, with the result that transsexuals, professionals, and society in general have not paid enough attention to its intangible aspects. This essay has briefly looked at some new ways to think about the intrapsychic aspects of the FTM experience and has suggested some new directions for developmental theory and personality theory in exploring the complexity of the transsexual experience.

The challenges of transition necessitate "a level of responsibility for one's own life most people never have to confront" (Stryker 1996, p. 78). My wish is for FTMs to embrace the awesome freedom of this responsibility and make the most of it, to see transition as an active organic growth process for remaking the self biologically, psychologically, socially, and spiritually. The conscious use of imagination enriches the new paradigm of FTM culture and imagery. Visualization, metaphor, and other psychoaesthetic tools enhance the expression and integration of authentic gender identity. Simply put, transformation is art and art is transformative.

References

Brody, J., and Redfield, S. C. (1997). A different vision: The art of sex, gender, and sexual orientation. Unpublished manuscript.

Cameron, L. (1996). *Body alchemy: Transsexual portraits.* Cleis Press.

Dalley, T., Case, C., Schaverien, J., Weir, F., Halliday, D., Hall, P. N., and Waller, D. (1987). *Images of art therapy: New developments in theory and practice.* Tavistock/Routledge.

Dennison, S. P. (November 1997). A rite of passage. *FTM Newsletter.* San Francisco: FTM International.

Diamond, M. (1997). Self-testing: A check on sexual identity and other levels of sexuality. Pp. 103–125 in *Gender Blending,* edited by B. Bullough, V. L. Bullough, and J. Elias, Prometheus Press.

Ebaugh, H. R. F. (1997). In *FTM: Female-to-male transsexuals in society,* edited by H. Devor. Indiana University Press.

Ettner, R. (1996). *Confessions of a gender defender.* Chicago Spectrum.

Ettner, R. (1998). Keynote speech at Tiffany Club "First Event" conference, Boston.

Fanning, P. (1988). *Visualization for change.* New Harbinger.

Herman, J. L. (1992). *Trauma and recovery.* Basic Books.

Milligan, L. (1996). "A mother's journey of healing: When a child changes gender." *Art Therapy: Journal of the American Art Therapy Association* 13(4): 282–285.

Robbins, A. (1989). *The psychoaesthetic experience: An approach to depth-oriented treatment.* Human Sciences.

Rubin, J. A, ed. (1987). *Approaches to art therapy: Theory and technique.* Brunner/Mazel.

Seil, D. (1997). Dissociation as a defense against ego-dystonic transsexualism. Pp. 137–145 in *Gender blending,* edited by B. Bullough, V. L. Bullough, and J. Elias. Prometheus Press.

Stanislavsky, C. (1936). *An actor prepares.* Translated by E. R. Hapgood. Theatre Arts Books.

Stryker, S. (July/August 1996). Portrait of a new man. *Utne Reader,* pp. 76–78.

Thomas, J., and Cardona, A. (1997). The use of dance/movement in the adjustment to a new gender role. Pp. 405–412 in *Gender blending,* edited by B. Bullough, V. L. Bullough, and J. Elias. Prometheus Press.

Vale, V., and Juno, A. (1989). *Modern primitives: An investigation of contemporary adornment and ritual.* V/Search.

Virshup, E., ed. (1993). *California art therapy trends.* Magnolia Street.

Wadeson, H. (1980). *Art psychotherapy.* John Wiley & Sons.

Wilchins, R. A. (1997). *Read my lips: Sexual subversion and the end of gender.* Firebrand.

Winnicott, D. W. (1971). *Playing and reality.* Tavistock/Routledge.

You don't know Dick: Courageous hearts of transsexual men videotape. (1997). Produced and directed by C. Schermerhorn and B. Cram. Boston: Northern Light Productions.

A Parent's Perspective

By E.C.

Let me begin by saying that L.C. is only 15 years old. He has been struggling with depression since preschool, when he informed me that life was just not worth living. This is the first time in about 10 years that L.C. has a smile on his face and is speaking of a future. Because we are hoping that L.C. will successfully graduate from high school, we are choosing to remain anonymous.

As an individual and as a family, we have been in counseling since L.C. was in kindergarten. He was always depressed, and we were searching for an answer. In his short lifetime, he has tried to kill himself five times. For a long time things looked very hopeless. Every day when I went to work, I had the fear that when I came home I would find him dead.

At the age of 13, L.C. told me what he thought the problem was. I could not imagine that someone this young could know that he was trapped in the wrong body. I let this go for about another year. Then one night after a terrible few days, L.C. took a lot of pills. Before falling asleep, L.C. was able to put into words how he felt.

He told me that he would never be "right" and that God must have made a mistake with him. Even if he had surgery, he felt so empty inside that nothing was going to make it OK. He truly wanted to die that night, and I was very scared. I wanted to call for help, but he made me promise not to. He said he had done this before and knew he did not take enough to kill him. I stayed with him all night watching for labored breathing. He just seemed to sleep a long time.

At this point we sought help from a gender therapist. With our insurance, this was a nightmare in itself. We got through this and were finally able to get the help L.C. so desperately needed.

I have to say that this is the most difficult challenge of my life. I lost both parents when I was very young. With death, the body dies but the spirit goes on. It is the way life is supposed to be and is easier to accept. In this case, you lose your child's spirit but the body goes on. It is much harder to accept and the mourning takes much longer. Eventually the tears lessen. I'm not sure they ever fully disappear.

Changing L.C.'s name was traumatic for me. I cried myself to sleep the night before and cried most of the next day. For L.C. this was just a correction that needed to be taken care of. For my husband and I this was the beginning of an end.

I handled getting L.C. hormone shots much better. We were hoping this would change his life for the better. We are not sure at this point if it is psychological or if something physiological is actually happening to make L.C. more content. We are talking about his going back to school this fall. This will be a big step in finding the person he is meant to be.

The feeling of anger has entered into my life more than I could possibly have imagined. First, I am angry at God. I cannot believe that someone who is supposed to love you would do this to you. Because of what a so-called God has done to L.C. and our family, my religion is practically nonexistent. Second, to society as a whole for not being more accepting. No one should have to hide who they are in fear of retaliation from others. Third, to the health professionals who make you go through what they believe are correct time frames. Even a 15-year-old should be entitled to the surgery he so desperately needs to be able to go on with life. L.C. will not be able to return to school this fall without the surgery he needs. Once again, I will have to be the fall guy for something that is out of my control. The fourth part of my anger is directed at the government for not getting it through their heads that this is corrective surgery and should be made a part of insurance coverage. A lot of tears have been shed over this. I have never been one to express anger or carry a grudge, but this experience has changed my life forever.

We know that the future will always hold a challenge, but it is nice to think that there may be a future for L.C. I try to get through one day at a time.

I want to end by saying how proud I am of L.C. and what a privilege it is to be a part of his life.

Self-Portrait Drawing of L.C. at age 10

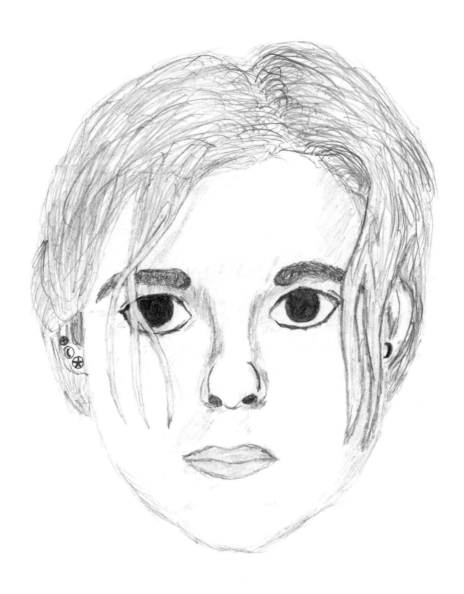

A Poem Written by L.C. at age 10

The friendly call that calls to those in need
Hasn't called my name.
The helping hand that helps those in need
Hasn't helped me up off the floor.
So I'll sit and wait
Until sunlight breaks through the darkness,
And a strange call comforts me,
And a hand helps me to my feet,
And I'll walk proud and free.

Postscript

By Emily Yoffe

Emily Yoffe is a nationally published magazine writer who met Dean Kotula when she profiled him for Details *magazine.*

When I began working on an article about female-to-male transsexuals, I was allowed to attend a support group meeting for FTMs at a transgender conference in Portland, Ore. I was the only non-FTM there until a middle-aged couple came in. The wife was attractive, and the husband, heavyset and balding, reminded me of Ernest Borgnine with a beard. They held hands and whispered seriously to each other at various points, and I knew exactly why they were there. Their daughter had told them she wanted to become a man, so they sought out this meeting to try to understand what she was going through. After the meeting broke up, I went over to talk to them. I asked why they were there, expecting to hear them elaborate on my assumptions. But what they told me shattered every assumption I had about transsexuality. The husband, one of the most utterly masculine-looking people I had ever seen, was an FTM. Not only that, in his previous life, he had given birth to four children.

My face betrayed my shock. The wife laughed and said, "A lot of my friends don't understand. I'm a heterosexual. But you can see his masculine energy. That's what I relate to."

When I start working on an article, more often than not I usually end up far away from the initial assumptions I start with—that's part of the pleasure of journalism. When I was given the assignment to profile the lives of some female-to-male transsexuals for *Details* (November 1994), I assumed that I would be meeting with a lot of desperately unhappy people who would look like women trying unsuccessfully to pass as their own brothers. I was not prepared for how totally the FTMs—through the combination of their certainty of

their true identity and the elixir of testosterone—were able to seamlessly take on a male identity.

As for desperate unhappiness, there certainly was some of that (of course, there's some of that in every life). It is an almost universally agonizing process to decide to change one's sex. One young FTM I spoke to was lucky to be alive; as a teenager he shot himself because he felt he would never bring anything but shame to his family. But what struck me far more than the pain of being transsexual was the remarkable good humor, and sense of humor, the FTMs had about their situation. At one meeting at the conference I attended, everyone gathered around a box of male genital prostheses. The box, which once actually held mining equipment, was labeled "Rock Tools"—to everyone's great amusement. One FTM, handling a set of fabric testicles, commented that not only were they convincing in a pair of pants, but "you can juggle with them too." Everyone I interviewed, even people who'd been through terrible, failed surgical procedures to try to construct male genitalia, expressed a sense of the cosmic absurdity of what life had handed them. As Dean told me, "It's not a matter of what I wanted. It's a matter of what is."

There is, as yet, no answer to that "what is" to the question of why some people have the unshakable conviction they were born in the wrong gender. The experts who study such matters have moved away from the purely psychological view—there was something wrong with one's parenting—to a more biological explanation, although we still have no answer as to what goes awry. One therapist I spoke to, who primarily treats transgendered people, had strong empirical evidence for the "nature" side of the argument. She said that, by and large, her transvestite clients did have a consistent pattern of disturbed parenting; it was easy to construct an argument as to why these men (the vast majority of transvestites are men) sought psychological relief in wearing women's clothes. But she said there was no pattern of upbringing for her transsexual clients. Some had abusive parents, some had loving parents. Some had weak fathers and strong mothers, and some had strong fathers and weak mothers, and every other permutation. She was convinced that for her transsexual clients, no amount of therapy was going to change their conviction that they had to change sexes.

FTMs have truly lived an experience the rest of us can only fantasize about: They know what it is like to exist as members of both sexes. I was struck by the desire of the FTMs I interviewed to not be the kind of male jerks that they hated when they were women. But I appreciated the honesty of one who told me that sometimes being a man means you have to—you want to—talk together in crude terms about women. And Dean came away with a powerful insight in the war of the sexes. Women, he discovered, don't really want a man who understands them the way a woman does. To women, such total gender empathy just doesn't feel right.

As I was finishing the article, I had an experience that made me realize how much the assumptions with which I began, about how impossible it would be for a woman to become

a man, had been changed. Dean had called and left a message on my answering machine. A male friend was with me when I played it back. "Who's that?" he asked. I explained the caller was one of the people I interviewed for my article. My friend's face looked as shocked as mine must have at the first support group meeting. "But she sounds just like a man," my friend said. And I answered, "That's because he is."